L'idée enfin d'inventer quelque chose d'insincère me traversa l'esprit et je me mis aussitôt au travail. Au bout de trois mois, je montrai ma production à Ph. Edouard Toussaint le propriétaire de la galerie

Saint Laurent. Mais, c'est de l'Art, dit-il et j'exposerais volontiers tout ça. D'accord lui répondis-je. Si je vends quelque chose il prendra 30%. Ce sont, paraît-il des conditions normales

Marcel Broodthaers

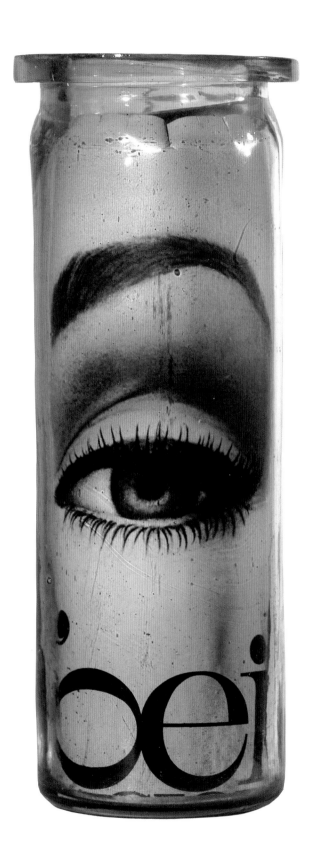

Marcel Broodthaers

Introduction by

Marge Goldwater

Essays by

Michael Compton

Douglas Crimp

Bruce Jenkins

Martin Mosebach

Walker Art Center, Minneapolis
Rizzoli, New York

Published on the occasion of the exhibition *Marcel Broodthaers*, organized by Marge Goldwater and Michael Compton for Walker Art Center, Minneapolis, in association with the Palais des Beaux-Arts, Brussels.

Major funding for *Marcel Broodthaers* has come from: Commissariat général aux Relations internationales de la Communauté française de Belgique, the National Endowment for the Arts and Sabena Belgian World Airways. The exhibition is supported by an indemnity from the Federal Council on the Arts and the Humanities.

Major support for the Walker Art Center exhibition program is provided by The Bush Foundation. Additional support is provided by the Dayton Hudson Foundation for Dayton's and Target Stores, the First Bank System Foundation, the General Mills Foundation, the Honeywell Foundation, The McKnight Foundation, The Pillsbury Company Foundation and the Minnesota State Arts Board, through an appropriation by the Minnesota State Legislature.

First published in the United States in 1989 by Rizzoli International Publications, Inc., 597 Fifth Avenue, New York, New York 10017.

Library of Congress Cataloging in Publication Data

Marcel Broodthaers.
Introduction by Marge Goldwater; essays by Martin Mosebach [et. al].

Bibliography: p. 221
1. Broodthaers, Marcel—Exhibitions
I. Broodthaers, Marcel
II. Goldwater, Marge.
III. Mosebach, Martin, 1951-
IV. Walker Art Center.

NX555.Z9B76235 1989
700'.92'4—dc 19 89-3449

ISBN 0-8478-1051-8
ISBN 0-8478-1057-7 (pbk.)

Designed by Craig Davidson.
Printed and bound in Japan.

(endsheets)
Announcement for exhibition at Galerie Saint-Laurent, Brussels, 10–25 April 1964.
Moi aussi, je me suis demandé si je ne pouvais pas vendre quelque chose. . .
("I, too, wondered if I couldn't sell something and succeed in life. I had for quite a little while been good for nothing. I am forty years old. . .The idea of inventing something insincere finally crossed my mind and I set to work at once. At the end of three months I showed what I'd done to Ph. Edouard Toussaint, the owner of the Galerie Saint-Laurent. 'But this is art,' he said, 'and I will gladly show it all.' If I sell something he'll take thirty percent. These, it seems, are normal conditions; some galleries take seventy-five percent. What is it? In fact, only some objects!")
Collection Benjamin Katz

(front cover)
Moules sauce blanche 1967
casserole, mussel shells, paint
50 x 36 x 36 cm.
Collection Mr. and Mrs. Isy Brachot

(back cover)
Casquette "museum" 1970
canvas hat, marker
Collection Harry Ruhé

(frontispiece)
L'Oeil 1966
glass, magazine reproduction
29 x 9 cm.
Private collection

The following illustrated works are not included in the exhibition:

Fémur de la femme française (p.116), *Un coup de dés* (p.138).

Dimensions are in centimeters; height precedes width precedes depth.

Contents

UN COUP DE DES JAMAIS N'ABOLIRA LE HASARD.....................

(L'alphabet est un dé à 26 faces.)

UN DE A 26 FACES ,MODELE : L'ALPHABET

A B C D E F G
H I J K L M N
O P Q R S T U
V W X Y Z....

I would like to draw the attention of those who would interpret the work of Marcel Broodthaers to the words of a follower of Hypatia in the fifth century:

> One who loves wisdom is obliged to disguise the truth in order to have it accepted. . .There is a strong analogy between light and truth just as there is between our eyes and our intelligence. If the eye suddenly receives too much light it is blinded. . .It is for that reason, I believe, that *fictions* are necessary. . .

Critics should not be too certain in attributing thoughts to Broodthaers, even when they quote extracts from his own words. And too many have tried to fit him in the mold of the thought of fashionable theorists. If that mold is political it has not fitted his compassion nor his realism, if didactic or philosophical it has not been able to encompass his simplicity, nor his beauty, nor his universality. Broodthaers tried to transmit an ultimate message to a world in danger.

I myself have no master key to his work. Any explanation that I may offer will be equally partial. I can only offer the phrase: "L'esprit est la racine de la forme." (The spirit [mind, wit, intelligence] is the root of the form.)

—Maria Gilissen

Untitled poem, 1966–1968

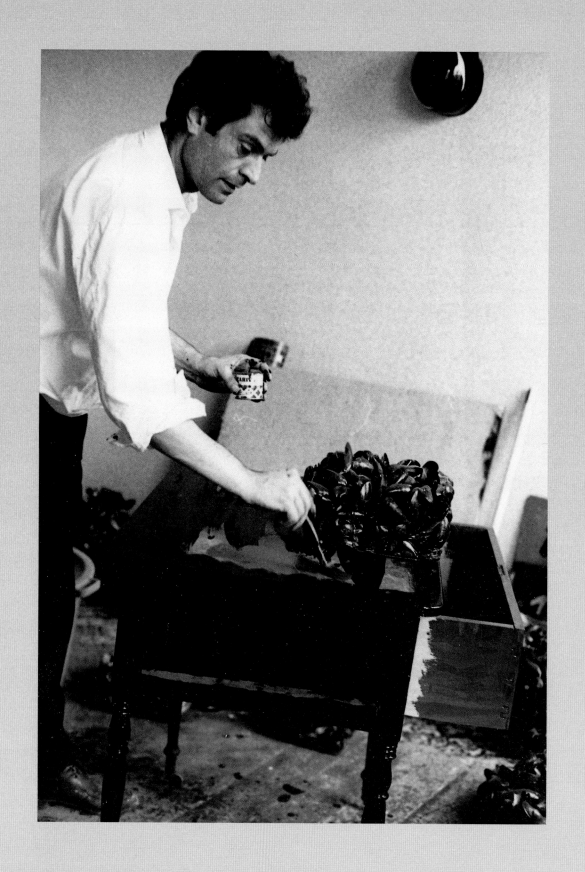

Introduction

Marge Goldwater

Marcel Broodthaers was both the elegant face and elusive figure of which legends are made. Born in 1924 in Brussels, he spent the last decade of his life in peripatetic fashion— primarily in Brussels, but also in London, Düsseldorf and Cologne, where he died of liver disease in 1976. A reserved and private man, he spoke little about his often hermetic art, and this reticence has prompted legends about his life and work that accumulate like the mussel shells on his tabletop. Even when he forsook the privacy of the writer's garret for the sometimes harsh glare of the art gallery, he retained an air of mystery. That air still lingers, making it difficult to penetrate the myths. Nevertheless, what has emerged posthumously is a portrait of an artist who managed to forge an existence for himself and his family that merged art with life, so that the two became as memorable as they were inseparable.

Broodthaers was an artist who moved easily from typing paper to painting to sculpture to film and back again, freely incorporating everything within his reach, from his child's tabouret to his wife's coffee pot. He made critical, provocative, enigmatic art, whose ideas and rich visual imagery were all suffused by his great wit.

Nearly a decade and a half after his death, this exhibition, the first comprehensive showing of Broodthaers's work in the United States, introduces American audiences to an extraordinary oeuvre by one of Europe's most prominent postwar artists. Although well known and celebrated in Europe for two decades, Broodthaers has remained relatively unknown and his work unseen in the United States for a variety of reasons. Primary among these is the fundamentally enigmatic nature of his art and the inherently unrecoverable character of his museums and decors, which constitute a major portion of his artistic output. But those who had the good fortune to see Broodthaers's *Un jardin d'hiver* installation in the Art Institute of Chicago's 1977 traveling exhibition *Europe in the Seventies* were stunned. Moreover, Documenta 7 (1982), well attended by Americans, presented a posthumous recreation of the 1975 *Décor* he had installed at the Institute of Contemporary Arts, London. This installation as well as the occasional gallery

Marcel Broodthaers in 1966, working on *Bureau de moules.*

show have tantalized the American art audience with hints of the artist's remarkable range.

Broodthaers began his career as a visual artist in 1964 with works that were prompted by his response to American Pop Art. In a Pop mode, his early objects had a distinctly European inflection in their imagery and their relationship to Magritte. Their underlying ideology was clearly evident in the oft-quoted statement that Broodthaers published on the occasion of his first exhibition: "I, too, wondered if I couldn't sell something and succeed in life The idea of inventing something insincere finally crossed my mind, and I set to work at once." This didactic creation of "insincere" works for commercial purposes became even more obvious as the years went by. In 1968, with the transformation of his own living quarters on the rue de la Pépinière in Brussels into the first of many fictional, or invented, museums, Broodthaers clearly raised questions about the very nature of art and its repositories, even if the precise meanings of his many installations and various other gestures remained more difficult to pinpoint.

The increasing preoccupation with language that characterized much of Broodthaers's later work comes as no surprise in view of his earlier career as a poet. The enormous influence of the French poet Stéphane Mallarmé is seen in a number of pieces that are installed together in this exhibition. The abundance and richness of this material suggests that the relationship between these two men deserves a more detailed, focused look. Many of Broodthaers's other individual works and series have explicit literary references: the *plaques en plastique* with their cryptic texts, which he produced from 1968 to 1972, are perhaps his most visually compelling series; certain of the sets of nine-word paintings of the early 1970s recite the names of various writers whom he admired; Charles Baudelaire also figures in several works.

Elsewhere Broodthaers explores the problematic nature of language, the sometimes arbitrary conventions upon which it rests, and the ways in which it shapes our experience. By so doing, he gives artistic form to linguistic concepts. In various colorful alphabet paintings, for

example, he breaks language down into bite-size pieces. By creating full-scale rooms whose physical perception is partially dependent on language, as in *La salle blanche*, he uses art to tell us about language. Conversely, in *MTL-DTH* of 1970, with its typed and handwritten poetry manuscripts, or in the open letters (the latter, Broodthaers's unique version of correspondence art) he succeeds in using language to tell us about art.

The exploration of language, characteristic of the later work, was also Broodthaers's means of reflecting, in metaphorical fashion, upon social, political and economic issues and their inter-dependence. In his installation *Section of Figures (The Eagle from the Oligocene to the Present)*, for the *Musée d'Art Moderne* in Düsseldorf, Broodthaers encourages us to see the possibilities—and the pitfalls—in any system of logic or governance. The installation—part of his *Musée d'Art Moderne, Département des Aigles*—was, in its Düsseldorf exhibition, an extravaganza for which he gathered under one roof more than three hundred different representations of the eagle that he had located in museums

in Europe and abroad. Like Joseph Beuys, to whom he addressed two open letters, Broodthaers sought to illuminate the conditions that determine different aspects of our lives, including our understanding of art. While he was as determined as Beuys, his efforts are not marked by Beuys's activism.

For his last works, a series of retrospective exhibitions he called *Décors*, Broodthaers placed his informal, individual objects of early vintage within the context of newer paintings and sculptures that often possessed a more finished look. In the *Décor* exhibitions in Basel, Paris and London, these arrays of objects, new and old, were seen in juxtaposition with ambitious installations: in Basel, with *L'Entrée de l'exposition*; in Paris, with *La salle blanche*, both represented in the Walker exhibition; and in London, with an environment that also served as the set for his film *The Battle of Waterloo*. These final works demonstrate, once again, Broodthaers's belief that context affects content in art and confirm that at the time of his death he was truly hitting his stride—only twelve years after he had set

out on his course to make "insincere objects."

Throughout his life, Broodthaers was deeply involved with the organization of his exhibitions, from the basic decisions about their overall scope to the arrangement of objects in cases. Because each exhibition constituted a special installation or environment, a comprehensive museum exhibition offers unusual challenges. We have attempted to remain faithful to Broodthaers's general approach to installation design by using, for example, the old-fashioned museological cases he favored. However, we have also recognized that one can never again achieve the same sense of *Gesamtkunstwerk* that made each of Broodthaers's own presentations unique adventures, and so we have avoided trying to do perfect re-creations.

For this exhibition, we have had the great fortune to be able to include a large number of individual paintings and sculptures, drawings, artist's books and prints, as well as three large installations. Several photographic works are also included in the exhibition: *toiles photographiques* (images printed on

photosensitive canvas) and several series that combine photographs with texts. But the complete corpus of Broodthaers's photographic work has yet to be catalogued, and it is hoped that this exhibition will encourage further research.

While certain aspects of Broodthaers's art can never be fully recaptured, fortunately his films have been preserved or restored. Films represent an important part of his oeuvre, one that, as Bruce Jenkins notes in his essay, predates his career as an artist. A great deal of work was done on the films in preparation for this exhibition, including the creation of internegatives and new release prints. In order to underscore the significant relationship between his films and the complete oeuvre, *Le Corbeau et le Renard*, his second film, will be projected continuously in the galleries on a screen that Broodthaers designed.

There is a built-in irony in organizing a museum exhibition of the work of an artist for whom a central concern was the nature—and perhaps the subversion—of museums. One runs the risk of becoming, as it were, grist for the mill. In the case of Broodthaers, the endeavor inevitably adds a

new layer of irony to his already dense art, thereby again proving his point that the context of art always provides part of its essential meaning.

The present catalogue surveys the various components of Broodthaers's career as a complement to the exhibition itself. Michael Compton's essay offers a more extensive outline of Broodthaers's life and the chronology of his career than has been previously available. Douglas Crimp and Martin Mosebach delve into the *Musée d'Art Moderne*, whose various and changing sections and installations most fully embody Broodthaers's mature artistic concerns, but which remain, of course, the least recoverable part of his career. Crimp explores the intellectual affinities of the museum while Mosebach stresses its poetic character. The accompanying photographic section represents the first attempt to assemble in one volume images of the different museums and decors, making it possible, in particular for the American audience, to gain some appreciation of their visual character. Finally, Bruce Jenkins's essay on Broodthaers's films, the first examination of this oeuvre by a film

historian, sheds new light on the relationship between the films and the rest of his career.

Although many important tasks lie ahead if we are to come to terms with Broodthaers's work, this exhibition provides the broadest overview to date. It also enables us to place in better perspective the work of many younger artists today, who, like Broodthaers, are concerned with the issue of art as commodity. Most important, the study and appreciation of Broodthaers's work challenges us to expand our ideas about what art is, how it thrives in our world, and why.

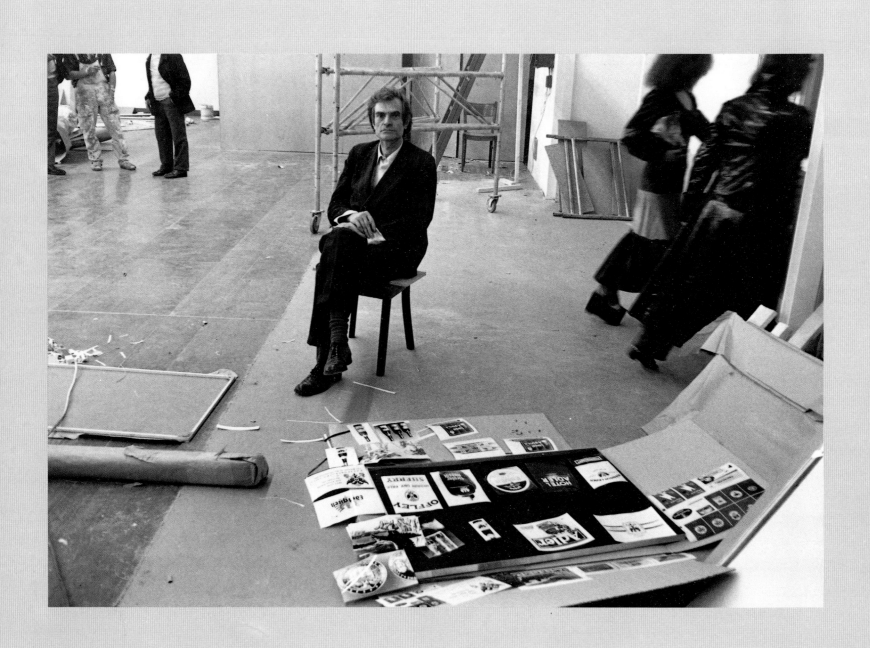

In Praise of the Subject

Michael Compton

Dites partout que je l'ai dit.

(Say everywhere that I have said it.)— Marcel Broodthaers, 1974

Marcel Broodthaers was born on 28 January 1924, in the parish of St. Gilles, Brussels, the son of Charles Emile Broodthaers (d. 1961) and Bertha Annecour (d. 1950).[1] Among several fragments of fictional autobiography by Marcel Broodthaers is one which may be real.[2] The "I" character recounts how his father had taken him to museums on Sunday afternoons until he rebelled at the age of fourteen. By this time he was already writing poems. About 1939 Marcel caught hepatitis and, unaware of the long recovery period necessary, resumed his regular way of life too soon. That mistake started the damage to his liver that would eventually cause his untimely death.

Broodthaers's father, a maître d'hôtel, had wanted him to work in a bank; Marcel had thought of history and mathematics but, following the advice of an aptitude tester, enrolled in 1942 at Brussels University to study chemistry. Though intrigued by the materials and apparatus, he soon abandoned the course and, not long after, began to write seriously and to regard himself as a poet. Café friends continued to call him "Marcel the chemist." At this time or soon after he met the painter Armand Parmentier, the writer Paul Colinet, and the poet brothers Piqueray, as well as Theodore Koenig, the future editor of the review *Phantomas*.[3]

During these war years, Broodthaers played a small, and apparently inefficient, part in the Resistance. He would recount later how he committed a serious blunder by taking a

Broodthaers during the installation of his work at Documenta 5, 1972.

1. Unreferenced information in this text derives generally from conversations with Maria Gilissen Broodthaers over many years. Where information published elsewhere is derived from the same source, no citation is given.

2. Documents which, like this, are not credited in notes are in the Marcel Broodthaers archive in the collection of Maria Gilissen. Most are in manuscript or in typescript with autograph emendations, but undated. They are almost all in French, here translated by the present author.

3. Theodore Koenig in Marie-Pascale Gildemyn, "Hommage à—Hulde aan—Homage to—Huldigung für: Marcel Broodthaers: Interviews," + − 0, no. 47 (June 1987), p. 21.

message to a house number in the rue du Lac instead of in the rue de la Vallée. By 1944 he had formed his first relationship with a woman, a mondaine called Moune. She was a beautiful woman in the style of a 1930s actress, but older than Broodthaers, and a denizen of high and low society as well as a friend of artists and poets.

Brussels was liberated by the Allies in September 1944. Soon after, Broodthaers made his first recorded public appearance. It was in an institution that was to be the scene of many activities, the Palais des Beaux-Arts. At a gala devoted to the poetry of the Resistance, he shouted from the balcony of the auditorium: "Louis Aragon, when will you stop compromising French poetry?" The sense of this characteristically concise phrase, addressed to an immensely famous French Communist poet, remains ambiguous.[4] Broodthaers himself joined the Communist Party and remained a member for some years.

Broodthaers had by now met the leading Belgian poets, Paul Nougé—whom he saw very often from 1946 on—and Marcel Lecomte. When, in 1945, he made his first appearance in print, it was in the Surrealist-oriented paper *Le Ciel Bleu*. But the poem published there, "L'île sonnante" ("The Sounding Island"), was Symbolist in feeling and title. It was followed by the poems "Le rêve d'un jeune homme malheureux ou l'anarchiste anodin" ("The Dream of an Unhappy Young Man or the Harmless Anarchist"),[5] also from 1945, and "Projet pour un film,"[6] 1948; both were published in journals with Surrealist and Communist affiliation.

Surrealism and Marxism dominated the artistic and intellectual life of Brussels in the aftermath of the war. Broodthaers was present at a number of meetings of a group that combined these tendencies,[7] a combination identified with Magritte's notion of "Surrealism in daylight," that is, a Surrealism in which neither the psyche nor art are given precedence over the whole range of experience and action. He was invited to be one of three editors of a journal to be called *La Centrale*, but it never appeared. He was also one of the signatories of the eventual manifesto of this group, *Pas de quartier dans la révolution* (*No Quarter in the Revolution*), 1947,[8] which criticized the shamanism of André Breton, the leader of international Surrealism, and rejected the tendency to interiorize or individualize Surrealism. The *Pas de quartier* manifesto demands "the recognition of the Communist Party as the sole instance of revolution," but does not call for a purely propagandistic art.[9]

4. J. Van Lennep, "De Magritte à Broodthaers: Le Surréalisme en Belgique quarante ans plus tard," *Musées Royaux des Beaux-Arts de Belgique, Bulletin*, vols. 1–3 (1981–1984), p. 208.

5. "Le rêve d'un jeune homme malheureux ou l'anarchiste anodin," *Le Salut Publique* (Brussels), 1945–1946.

6. "Projet pour un film," *Le Surréalisme Révolutionnaire* (Paris), April 1948.

7. Marcel Mariën, *L'Activité surréaliste en Belgique (1924–1950)* (Brussels: Lebeer Hossmann, 1979), pp. 342, 407.

8. Manifesto dated 7 June 1947, in *Le Drapeau Rouge*, vol. 9 (July 1947).

9. "Dix mille francs de récompense," in *Marcel Broodthaers: Catalogue-Catalogus*, exh. cat. (Brussels: Palais des Beaux-Arts, 1974), p. 64. The quotation is from André Breton, "Second manifeste du Surréalisme," *La Révolution Surréaliste*, no. 12 (15 December 1929), p. 1. This is the same issue in which Magritte published the article cited in note 11.

Broodthaers summed up his position relative to Surrealism nearly thirty years later in the form of a quotation and repudiation of Breton's second Surrealist Manifesto: "'Everything leads us to believe that there exists a state of mind where life and death, the real and the imaginary, the past and the future, the communicable and the incommunicable, high and low, no longer seem contradictory.' I hope I have nothing in common with that state of mind."

Among the other signatories of this document was Magritte, who had also recently joined the party.[10] In conventional political terms, Magritte's position seems sometimes to the left and sometimes to the right of Breton's but, though he is considered a leading Surrealist by virtue of the quality of his work, his preoccupations were always some distance apart from those of the other Surrealist painters. His well-known contribution to *La Révolution Surréaliste* in 1929[11] seeks to dissolve the conventional relationship of words to things. Later he would explain that he "had made pictures where objects were represented with the appearance they have in reality" but "situated where we would never meet them. This is the expression of real desire, even if unconscious for most men." Magritte worked in this way because he shared with the Surrealists a "violent disgust for all bourgeois ideological and social values which keep the world in its present ignoble condition"—that is, he hoped to free the relationship between men and things from the imposed ideology of commercial interests.[12]

A similar position was to be taken by Broodthaers in many later writings, but, when the two met in about 1945, Magritte gave Broodthaers a copy of Mallarmé's poem "Un coup de dés jamais n'abolira le hasard" ("A Throw of the Dice Will Never Abolish Chance"). Magritte's gesture cannot be fully explained, but this poem was to remain, together with the work of Magritte himself, a lasting point of reference for Broodthaers, both as a poet and later as an artist. Mallarmé is seen as a master of symbolism, but Broodthaers, in his work, was to credit him with a universal role in the arts.

By 1946 Broodthaers was installed as a bookseller in the rue Notre Seigneur, with showcases on the street and an apartment above. He had a barrow from which he would sell at street markets. He married Reine Leyson and had a daughter, Pierrette, in 1946. After the marriage broke up, Reine lived with, and eventually married, Nougé. Broodthaers formed a liaison with Susanne Van Hiel, by whom he had two children, Sylvie and Constantin, born in 1957 and 1958, respectively.

On 25 March 1950, Broodthaers, now of 9 rue van Bemmel, Brussels, sold by auction at the Galerie Thémis, 340 "lots from the libraries of collectors." They are described in the

10. Van Lennep, "De Magritte à Broodthaers," p. 212.
11. René Magritte, "Les mots et les images," *La Révolution Surréaliste*, no. 12 (15 December 1929), pp. 32–33.
12. The quoted passages in this paragraph are from René Magritte, "La ligne de vie," *L'Invention Collective*, no.2 (April 1940) n. p.

catalogue as "Autographs, First Editions, Fine Illustrated Books—History—Heraldry—Hippology—Modern Literature and Fine Books in German." When, much later in life, he had some money to spend, Broodthaers was to collect for himself books of the same sort, and so we may deduce that one of the reasons for dealing in them was to possess them for a while. At this time he remained extremely poor and his associates criticized him for not taking employment.

The end of 1956, but especially the year 1957, in which his second daughter was born, saw a sharp upsurge in Broodthaers's public activities. He learned to use a camera in order to practice photojournalism and worked for a week as a laborer on the site of the Brussels World's Fair to report in a newspaper, *Le Patriote Illustré*, on the preparations; later he lectured to guides for the associated exhibitions at the Palais des Beaux Arts. He introduced several programs of films in the auditorium of the Palais under the title "Exploration of the World," and traveled with the program to other cities in Belgium. He took two balloon rides from Aerschott near Brussels and reported them with his own photographs in the paper *Germinal*.[13]

Broodthaers's most significant achievements, however, were the publication of his first thin volume of poems and the making of his first film. The film, *La Clef de l'Horloge* (*The Key of the Clock*), was an enthusiastic response to the Kurt Schwitters exhibition at the Palais des Beaux-Arts and is based on works in the show. It was exhibited at the 1957 International Festival of Independent Film at Knokke le Zoute. The book of poems, *Mon livre d'ogre* (*My Ogre Book*), published in September 1957,[14] contains a series of short poems and poetic proses, rather Parnassian in character:

> O Tristesse envol de canards sauvages
>
> Viol d'oiseaux au grenier des forêts
>
> O mélancolie aigre château des aigles
>
>
> (O sadness flight of wild ducks
>
> Rape of birds at the granary of the forests
>
> O melancholy bitter castle of eagles)

13. *Germinal*, 24 September 1957.
14. For *Mon livre d'ogre* (Ostend: à l'Enseigne de l'Arquabuse du Silence, 1957), see Maria Gilissen et al., *Marcel Broodthaers: Catalogue des Livres/Catalogue of Books/Katalog der Bücher 1957–1975* (Cologne: Galerie Michael Werner; New York: Marian Goodman Gallery; Paris: Galerie Gillespie-Laage-Salomon, 1982), pp. 8–9. The drafts of the poem have sometimes, for example, "vin aigre" (bitter wine = vinegar), with the association wine = château.

Drafts show that Broodthaers had been contemplating a considerably longer poem, with several stanzas, each marked by variations on the last line. But, typically for him, in the process of refining the poem he whittled it away to this highly compressed form. The refrain, "O mélancholie aigre château des aigles," had been first sketched some ten years earlier[15] and, as we shall see, was to become a leitmotif of Broodthaers's later work as a visual artist.

His public activities continued into 1958, when he acted as a guide to the art exhibition associated with Expo '58 that took place in the Palais des Beaux-Arts. The following year he selected and presented a program of films, under the title *Poésie cinéma*, again at the Palais. In the announcement, he described it as a painting. It comprised films or sequences from films by other filmmakers (he introduced one about Scotland to the audience while wearing a kilt) and a slide show by Livinus, a contemporary artist. About the same time, he made a second film, now lost except for the script, called *Le chant de ma génération* (*Song of My Generation*) and based on a montage of news footage.

In 1960 Broodthaers brought out a second volume of poems, *Minuit* (*Midnight*). Thirty-three of the 183 copies had monotypes (potato cuts) by the Belgian abstract artist Serge Vandercam.[16] The character of these poems is, if anything, more Symbolist than before; some have a carefully constructed layout on the page, recalling that of Mallarmé's "Un coup de dés."

In March 1961, after two years of isolation, separated from Susanne Van Hiel, and withdrawn from most of his associates, Broodthaers met Maria Gilissen. She had recently arrived from rural Limburg and could speak virtually no French, while Broodthaers knew little Flemish. But, after she went home, he sent her letters in the form of images to which he added words. The relationship ripened very quickly. On the first of April, Broodthaers announced his new volume of poems, *La Bête Noire*. It is stated to have been printed under the sign of Taurus, Maria Gilissen's sign, and is dedicated to her.[17]

The poems form a bestiary in the tradition of the *Fables* of La Fontaine, but they are highly abbreviated, each having little narrative and only a cryptic moral. Although the animals do stand for human characters or predicaments, the metaphors became so condensed in Broodthaers's process of rewriting that their meanings cannot be decoded simply. This sixteen-page volume was published by Broodthaers himself in a special edition, decorated with etchings by Jan Sanders, at 350 Belgian francs, and also in a plain edition at 100. He sold the copies privately, mainly to his friends and acquaintances, and probably barely covered his costs. The poems appeared old-fashioned in language and form at a time when the dominant influences were the Beat poets and Dylan Thomas.

15. Inscription on the back of a plastic relief in the Daled collection. The date given is 1947.
16. For *Minuit*, see Gilissen, *Marcel Broodthaers: Catalogue des Livres*, pp. 10–11. It may have been for this publication that Broodthaers received his only grant from the Ministry of Culture.
17. Ibid., pp. 12–13.

Broodthaers traveled to London several times between April and June 1961 in order to write a series of short articles for the *Journal des Beaux-Arts*, each under the title "Un poète en voyage" ("A Poet Travels").[18] He was introduced by the editor as one who "haunts the places where art is found." In the essays he writes about Madame Tussaud's and some London galleries, but he does not mention the galleries in which the most interesting contemporary art was being shown, nor does he notice the emerging Pop Art. The written style is playful and without any sharp political feeling. Yet such writing was no way to make a living; the ménage at the rue de Villers remained one of extreme poverty—there was no water, no electricity, and only a few pieces of furniture in the apartment, principally a stove without fuel, a bed, a table, a chair, and a cupboard. There were only two or three books, including Rodolphe Toepffer's charming *Voyage en zig-zag*, illustrated by the author.

In the summer of 1961, Broodthaers went to Paris with Maria and Pierrette. They stayed first in the tiny apartment of the Spanish painter Fernando Lerin, whom Broodthaers repaid by writing an article on his wall paintings.[19] He worked for a few weeks as a plumber's laborer on a building site. In September, Pierrette went to boarding school in Brussels while Broodthaers and Maria moved to the Hôtel du Nord in the Latin Quarter, where the room cost 10 francs a night. Broodthaers was earning 20 francs on each of six nights a week as a night porter in another hotel, so there was little left for food and nothing for going out to meet people. In October they learned that Broodthaers's father had died and they returned for a while to Brussels. Nearly all of the proceeds of the sale of his father's house were spent on the education of Broodthaers's children.

During the period 1962–1963 Broodthaers, writing for a French press agency, had a series of articles illustrated by his own photographs published in *Le Magazine du Temps Présent*, a syndicated weekend supplement. The topics included: the rise of plastics and computers, and the introduction of luncheon coupons, which might be a means of encouraging people to eat daily in restaurants and thus save a basic French custom. He generally supported the preservation of the old ways against the threat of excessive commercialism, bringing in Baudelaire, for example, both to defend the glass bottle against the plastic container and to lament the incursion of modern architecture into old Amsterdam. Among these articles, one touches more directly on Broodthaers's own preoccupations: he visited Brassaï, wearing his own camera on a strap over his shoulder, and asked that great photographer about amateur photography. Brassaï emphasized to Broodthaers that it teaches people to see.[20]

18. For a complete list of these essays, see Marie-Pascale Gildemyn, "Bibliography," *October*, no. 42 (Fall 1987), p. 199.
19. "Le Mur de Fernando Lerin," *Journal des Beaux-Arts*, no. 974 (20 April 1962), p. 8.
20. Brassaï, "Piéton des nuits de Paris," *Le Magazine du Temps Présent*, no. 449.

Broodthaers wrote some art criticism for the *Journal des Beaux-Arts*, the organ of the Palais des Beaux-Arts, where he also gave tours. Introducing the 1962 Rothko exhibition there, he wrote, "The painting gives me a headache, but is it really the painting?" This apparently flippant comment probably refers to Rothko's hope that his work would affect the mental state of the viewer directly; that is, without cultural conditioning, a possibility which Broodthaers always discounted entirely.

In 1962, the year his daughter Marie-Puck was born, he renewed his friendship with the poet Marcel Lecomte. Other friends included the painter Emile Salkin[21] and Claude Vermeylen, in whose apartment he once stayed with his family when looking for a place to live. Vermeylen was an assistant to Pierre Jeanlet, director of the Galerie Aujourd'hui at the Palais des Beaux-Arts, and it was here that Broodthaers saw the exhibition of works by the Italian artist Piero Manzoni. It included tins of "Merda d'artista" ("Artist's Shit") and "Achromes" ("No Colors") of artificial white fur. Broodthaers was impressed with Manzoni's personal charm and gaiety no less than by his work, and Manzoni wrote his signature directly on Broodthaers and issued one of his certificates of authenticity (p.22), declaring the poet to be a work of art. Broodthaers described this meeting later:

> Nous nous sommes rencontrés comme si nous étions des comédiens. Cette rencontre avec Manzoni, le 25.2.62, date du certificat selon lequel je suis "objet d'art," m'a permis d'apprécier la distance qui sépare le poème d'une oeuvre matérielle mettant en cause l'espace "fine arts." Autrement dit, la valeur du message avec seulement la notion de marchandise du message identifié à la marchandise.

> (We met as if we were actors. This meeting with Manzoni on 25.2.62, the date of the certificate which states I am a "work of art," allowed me to appreciate the distance which separates the poem from a physical work which implicates the space "fine arts." To put it another way, the value of the message with the notion of the message as merchandise alone identified with merchandise.[22])

That is, apparently, a work of art is an idea absolutely embodied in an object to be sold, whereas a poem is not identical with its printed manifestation. In Manzoni's case the idea expressed is that of art as merchandise, whose idea is sold as a work of art.

In the spring of 1963 Broodthaers went back to Paris for several months, during which he continued to write articles on art and on topics of general interest. He returned to Paris again in October, when Vermeylen offered him a lift there. He saw works by George Segal at

Piero Manzoni
Declaration of Authenticity
No. 71 1962

21. Broodthaers wrote an article on Salkin's wife, "Francine Salkin, Maître des Colliers," *Germinal*, no. 630 (2–8 December 1961), p. 19.
22. Marcel Broodthaers quoted in *Piero Manzoni*, exh. cat. (Brussels: Galerie des Beaux-Arts), 1987.

the Galerie Sonnabend, which had been showing the work of some of the younger American artists in Europe. He was sufficiently aroused by this show and a subsequent exhibition of Jim Dine's paintings in Brussels to write an article entitled "Gare au défi!" ("Beware the Challenge!").[23]

This article seems to be hostile to Pop Art, but there remains some doubt about Broodthaers's position; he is not sure whether the menacing quality he perceives is in the works he describes or in himself, whether they destroy the imagination or liberate it. However, later in the article, he describes the work of Segal, Dine, and other American Pop artists (at this point he makes no reference to Warhol, Lichtenstein, or Rosenquist) as a "challenge to harmony and good taste." In this they are the descendants of his own hero, Magritte, who also "denies the aesthetic character of painting." In passing, he quotes the French critic Pierre Schneider: "the author of these pictures . . . has no other means of expressing his individuality than the choice of consumer goods that is offered him—that is, he is you." He ends by saying that American Pop "is only possible in a context of societies devoted to publicity stunts, overproduction and horoscopes."

During 1962 and 1963 Broodthaers worked hard on his fourth book of poems. It was to be, like *La Bête Noire*, a bestiary. He wrote it at a small table in his room and in the Central Station café, producing draft after draft of each poem. The general tendency of the drafts is to abbreviate and compress the sense, but it is not just a matter of eliminating and refining; often the metaphor is entirely reconstructed or even completely redirected. The essential kernel of a poem may be an image, a title, a phrase, or even, perhaps, a single word. The poem would continue to evolve right up to the moment it went to press (and after); the result was a huge pile of paper. But, when the volume came out as *Pense-Bête* in 1964,[24] it was again a slim volume that concealed the work in brief verses, highly wrought in a language redolent of the nineteenth century.

The poems are again cryptic metaphors, constructed on the basis of qualities and characters of animals and humans. Several of them seem to deal with the issues of self-perception or self-creation, and of being perceived, named, and determined by others; that is, they deal with one of the central concerns of existentialism. Among the most compressed in this vein is "Le Cancrelat et le Boa" ("The Cockroach and the Boa"):

23. "Gare au défi! Le Pop Art, Jim Dine et l'influence de René Magritte," *Journal des Beaux-Arts*, no. 1029 (14 November 1963), p. 9.
24. Gilissen, *Marcel Broodthaers: Catalogue des Livres*, pp. 14–15.

Enfin, je vois clair en moi-même. J'ai peur d'être vu.

Je suis un boa,

c'est la chose la plus terrible qui puisse arriver à un serpent.

(At last I see into myself. I'm afraid of being seen.

I am a boa

it's the most terrible thing that could happen to a snake.)

Both metaphors apparently deal with being "the other." More explicit are "La Moule" ("The Mussel") and "La Méduse" ("The Medusa"):

La Moule

Cette roublarde a évité la moule de la société.

Elle s'est coulée dans le sien propre.

D'autres, ressemblantes, partagent avec elle l'anti-mer.

Elle est parfaite.

(The Mussel

This clever thing avoided society's mold.

She's cast herself in her very own.

Other look-alikes share with her the anti-sea.

She's perfect.)

La Méduse

Elle est parfaite

Pas de moule

Rien que le corps....

(The Medusa

She is perfect

With no mold

Only a body....)

"The Mussel" turns on the play in French between *la moule* (mussel) and *le moule* (mold), and on the fact that a mussel secretes the shell which shapes it. This mussel plainly creates itself and so is perfect, that is, authentic. It occupies, therefore, the condition of self-determination which Heidegger had attributed only to individual humans. But, paradoxically, there are thousands of other individuals (mussels or humans) just the same as each other. The medusa, or jellyfish, on the other hand, is perfect in having no mold, and no mind that could cause it to submit to the perceptions of others. Conversely, the mythical Greek figure Medusa turned those others to stone by looking at them. Broodthaers also makes an equation between perfection and invisibility. He wrote later that "an object is invisible when its form is perfect. Examples: the egg, the mussel, chips."[25] In this case, perfection and invisibility seem to arise when there is an exact and familiar relation of object to function or desire. It may be an implied criticism of the notion of perfection as conformation to an ideal, that is, a geometric form.

The title of the book, *Pense-Bête*, is a French term for a mnemonic device, like putting a knot in a handkerchief,[26] but when pronounced suggests also the meanings "think animal" and "think stupid." Like *La Bête Noire*, *Pense-Bête* was published by Broodthaers himself. After selling a few copies, he had parts of the text in each remaining copy covered with rectangles of children's colored paper. In some cases the sheet is glued all round, in others only at one edge, so that it can be lifted, like the plates in old books, to reveal what is underneath.

One of the texts so obscured is a sort of preface, which the proofs show to have been added last, "Art poétique" ("Ars Poetica").[27] It begins by admitting a taste for secrecy and hermetic practices—for concealing things—but reveals "my sources of inspiration," which are stated to be an obsession with the unnatural precision of legal language. The text on the facing page quotes a law prohibiting, on pain of imprisonment, the publication of "writings, whether printed or not, of figures or images contrary to morality" (*bonnes moeurs*, also "good manners"). He goes on: "It serves as an example to us, it is a model statute . . . in which I see the father and mother of my writings and the mother of my illustrations." Typically for Broodthaers, this statement must be understood both ironically and literally.

Soon after, he attracted a small circle of poets, artists, and philosophers who were described as a fringe establishment.[28] It was this group that was to take part in his later Happening.

25. *Moules Oeufs Frites Pots Charbon*, exh. cat. (Antwerp: Wide White Space Gallery, 1966).

26. See Anne Rorimer, "The Exhibition at the MTL Gallery in Brussels," *October*, no. 42 (Fall 1987), p. 104 n. 12.

27. The text of "Art poétique" is reproduced in "Selections from *Pense-Bête* 1963–64," transl. Paul Schmidt, *October*, no. 42 (Fall 1987), pp. 14–15.

28. Jacques Meuris, in Gildemyn "Hommage à . . . Marcel Broodthaers," p. 21.

Broodthaers's next decisive move was to partially embed the fifty still wrapped copies that remained of *Pense-Bête,* together with two small spheres, in plaster (1964; p.26). The effect was to make it difficult to read any of the poems, while at the same time create a mystifying object; it was his first act as an artist. He recalled: "You could not read the book without destroying the visual effect. . . . But to my surprise the reaction of the spectator was quite different from what I had imagined . . . he saw the object either as an artistic expression or as a curiosity . . . no one was inquisitive about the text."[29]

Within a short time he made several other pieces by assembling or transforming objects and submitted them to the juried exhibition *Jeune Sculpture Belge* early in 1964. One was exhibited and he received a commendation. Then, in July 1964, he had his first one-man show. To have such an exhibition with no formal training and only seven months' practice as an artist must be almost unprecedented, but it was not an accident. Broodthaers recognized in Pop Art an art made for its market and he set out to steal its clothes; that is, he would incorporate into his work familiar objects, as some Pop artists had done, and so allow himself to be seen as a Pop artist and to attract some of the attention given to those he had written about in 1963. Hidden within would be his own art and his cryptic, subversive message.

The exhibition, *Moi aussi, je me suis demandé si je ne pouvais pas vendre quelque chose . . .,* was at the Galerie Saint-Laurent, Brussels. Broodthaers wrote an introduction that served as the exhibition announcement. Printed on pages of advertising torn from popular magazines, it is one of his most quoted writings:

> I, too, wondered if I couldn't sell something and succeed in life. For quite a while I had been good for nothing. I am forty years old. . . . The idea of inventing something insincere finally crossed my mind, and I set to work at once. At the end of three months I showed what I had produced to Philippe Edouard Toussaint, the owner of the Galerie Saint-Laurent. "But it is Art," he said, "and I shall willingly exhibit all of it." "Agreed," I replied. . . . If I sell something, he takes 30%. It seems these are the usual conditions, some galleries take 75%. What is it? In fact it's objects.

Perhaps the crucial word here is "insincere." It means that he would do something that was determined by others: by the market, by the art market in particular, with its "isms" defined by critics. He would not be like the mussel described in his poem.

29. "Dix mille francs de récompense," p. 66. For the sake of conciseness I have used the word "artist" throughout to mean "visual" or "plastic" artist. The *Pense-Bête* sculpture is discussed at length by Dieter Schwarz in "'Look! Books in Plaster!': On the First Phase of the Work of Marcel Broodthaers," *October,* no. 42 (Fall 1987), pp. 57–66.

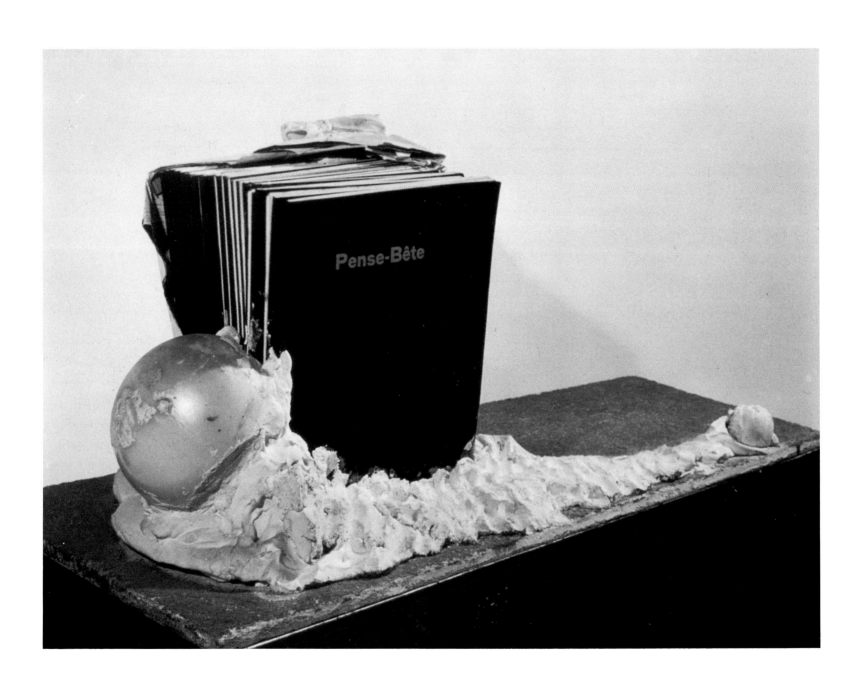

Broodthaers thereby allowed himself to be caught in a trap, to use one of his own favorite words. He made art for exhibition and sale while thinking: "whenever others become aware of it—isn't that the height of inauthenticity?" and "in the visual arts, my only possible commitment is to my adversaries." This situation is contrasted sardonically with that of writing poems, which are "concrete signs of commitment since [they are] without payment."[30] These phrases were written much later but are quoted here because they make quite clear his distinction between the visual artist, making things for sale ("commitment to his adversaries"), and the poet, who can be fully committed to his own vision because he is virtually unpaid. But the basic notions are already signaled by more contemporaneous statements,[31] as well as by the work itself. And it is that work, rather than the writing, which makes the converse point that the work of art can nevertheless be authentic and even beautiful. The quality of authenticity is guaranteed by the imagination and judgment of the artist and also by the appeal to older traditions: the Classicism of the seventeenth and eighteenth centuries and the Romanticism of the nineteenth. Broodthaers was certainly aware of the historical circumstances of the individual artists he respected in this way, like Baudelaire, but he credited them with a power undimmed by academicism and uncorrupted by the deliberate commercialism that he imitated in his own visual art.

Between 1963 and approximately 1967, Broodthaers was specifically and historically confronting Pop Art and Nouveau Réalisme, both of which made use of commonly sold commercial products. The objects he chose to incorporate into his own works were associated with the traditional good things of life: simple foods and household objects, often his own. The physical relationships between his objects stand for relationships of common practical usage: mussels to cooking pots, chips to serving dishes, eggs to tables on which they are eaten, etc. The way that his mussels are massed together on surfaces may also refer to the way they are massed on rocks in their natural habitat; some are colored sea green. But all these things are related in addition to elements derived from the field of art: geometric forms, panels and canvases, diptychs and triptychs, plaster and oil paint, frames and pedestals. They are exhibited in galleries and introduced in catalogues.

Two quotations mark the difference between, on the one hand, what is authenticated by natural feelings, such as hunger and familiarity, and by tradition—

> Four forms are necessary for me, mussel, egg, the pot which I already feel capable of filling. And the Heart. . . . What attaches me still to the heart is respect for certain values. Rimbaud. Especially Arthur Rimbaud, the model of revolt.[32]

30. "Dix mille francs de récompense," p. 66.
31. E.g., "Marcel Broodthaers par Marcel Broodthaers," *Journal des Beaux-Arts*, no. 1086 (1 April 1965), p. 5.
32. *Phantomas*, no. 62 (February 1966), p. 8; special number devoted to Broodthaers.

—and, on the other hand, by the manipulated appetites he sees reflected in the works of Nouveau Réaliste and Pop artists, which are

> directly connected to the reality that everyone experiences. Because everyone goes to
> department stores, everyone witnesses the industrial accumulations that our age produces.
> Only the Restany movement [i.e., Nouveau Réalisme] is rather quietly assenting to the
> forms of modern civilization. Almost a glorification.[33]

Les frites 1968
photographic image on four
canvases
each 21.5 x 16 cm.
Courtesy Marian Goodman Gallery,
New York

Later he added that his own early objects could not be confused with those of Nouveau Réalisme because the latter conveyed "a pure and simple acceptance of progress in art . . . and everywhere else as well."[34]

Simple acceptance of progress is a form of barbarism for Broodthaers not only because it devalues the human achievements of the past, but because the form of progress that is accepted is no more than empty change. He does not see fashion as a positive force in the way that Baudelaire had, because it has now been taken over by large institutions that are not concerned with individual needs. But Broodthaers believed he could not combat the power of such fashion by attacking it directly; he would have to become a part of it to understand it functionally: "I have fabricated instruments for my own use in comprehending fashion in art, in following it, and finally in the search for a definition of fashion."[35]

Following fashion, that is, allowing every new consumer attraction to devalue the last, is no doubt the cause of the "disavowals" in the text in which Broodthaers made his clearest objection to Pop Art during this period:

> Pop Art is an original expression of our times. . . . [It] developed first in American society.
> American life presents a character—due to the industrial factor—which invades absolutely
> every aspect of private existence. In America nothing happens anymore on the level of
> individual life. American life consists of a whole series of disavowals which build up,
> neutralize themselves, and finally annihilate completely the pleasures of existence which a
> human being normally possesses.[36]

One of the less obvious manifestations of modern commercialism that Broodthaers consistently attacks is aestheticism, the preoccupation with purely pictorial considerations such as space and composition. This theme illuminates a feature of his early objects. Although they contain many references to the field of art and were made to an exacting standard, they are almost devoid of the kind of internal composition that was typical of painting at the time.

33. Jean-Michel Vlaeminckx, "Entretien avec Marcel Broodthaers," *Degré Zéro* (Brussels), no. 1, transl. Benjamin Buchloh in "Open Letters, Industrial Poems," *October*, no. 42 (Fall 1987), p. 73.
34. "Dix mille francs de récompense," p. 66.
35. Ibid.
36. Vlaeminckx, "Entretien avec Marcel Broodthaers," p. 73.

There is no carefully contrived asymmetry, for example. Eggshells are arranged in simple rows or randomly; they completely cover a surface or are piled up. Broodthaers uses the traditional contrast between light and dark (chiaroscuro); however, he does it not by shading but intrinsically—with the black shells of mussels and the white shells of eggs. To this extent his work has something in common with that of many other postwar artists, but his intention is not just to invent a new mode of expression in art. Rather, his concern is for real objects in the world, that is, objects as they relate to human use. Mere representation is as mistaken as abstraction. On the other hand, poetic metaphor is not excluded (although it is tinged with humor):

> All is eggs. The world is an egg. The world is born of the great yolk, the sun. Our mother, the moon, is covered with eggshell. And the belly of a wave is white. A heap of eggshells, the moon. Dust of eggshells the stars. All, dead eggs.[37]

When Pierre Restany, the champion of Nouveau Réalisme, put it to him later that he was a predator of trash cans, Broodthaers rejected the intended compliment in order to assert that his materials were not waste but desirable and of use. He said that, although he had taken steps to dispossess himself of any inheritance from his father, he had some regret: "a sort of desire to be an owner of something even if this should be shells of mussels, shells of eggs and pots in which images are enclosed."[38] He did not choose to add that none of these shells were in fact picked out of trash cans. The eggshells, for example, were obtained from an individual, Mme. Fernande, the cook of the restaurant La Boue, who was the only one who could break them just the way he wanted and whom he treated with grateful courtesy.

He took Magritte as his principal mentor in the campaign against Pop Art, even though Magritte was generally considered in Belgium to be the ancestor of American Pop Art, a view now difficult to sustain. Magritte had sought to make works of art that would liberate things from the defining language of the bourgeoisie. But Broodthaers would dispense with the residual poeticism that he thought was exemplified in Magritte's titles,[39] and with it the last traces of Surrealism. However, when the writer Marcel Mariën saw two of Broodthaers's works, one a leg bone painted in the colors of the Belgian flag (1965; p.117) and the other a spade covered with period wallpaper, he commented that these objects were "quite simply Surrealist" but failed to hear the sarcasm of Broodthaers's reply: "Right, but don't tell anyone." Broodthaers would allow people to misunderstand and then he would teach them how to understand. He would rarely contradict or defend his work directly.[40]

Ovale d'oeufs 1234567 1965
eggshells, wood, paint
100 x 80 x 12 cm.
Private collection

37. "Evolution ou l'oeuf film," *Phantomas*, nos. 51–61 (December 1965).
38. "Marcel Broodthaers et Pierre Restany parlent de peinture et de braconnage," *Journal des Beaux-Arts*, no. 1122 (13 March 1966), p. 6.
39. "Interview imaginaire de René Magritte," *Journal des Arts Plastiques*, no. 30 (January 1967).
40. Mariën, *L'Activité surréaliste en Belgique*, p. 44.

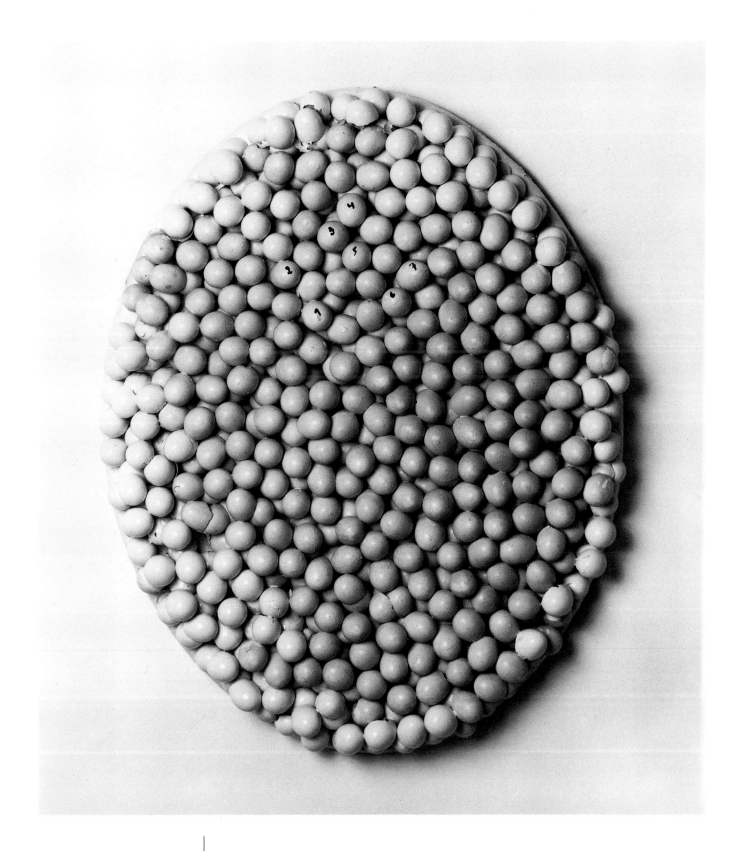

On the same day that the 1964 exhibition *Moi aussi. . .* closed at the Galerie Saint-Laurent, Broodthaers put on a *Sophisticated Happening* at the Galerie Smith, also in Brussels. It was on the theme of money and of nationalism, and apparently proposed a national "Pop Art." There were readings and objects, including a chair with eggs attached, painted in the colors of the Belgian flag, which was ceremonially unveiled to the strains of the Belgian national anthem. Later in 1964, he directed his own exhibition. Seeing that there were musicians playing informally in the Parc du Mont des Arts, he thought of having an *Exposition surprise.* With several young poet friends, he carried his pieces into the park and set them up near the musicians. In this effort can be seen the small beginnings of his taking over for himself the institutions of the art world.

In February 1965, a work by Broodthaers was included in the show *Pop Art, Nouveau Réalisme, Etc. . . .* at the Palais des Beaux-Arts. The catalogue included an introduction by Jean Dypréau, whose reading of Pop Art was essentially the optimistic English one, quite unlike that of Broodthaers's text "Gare au défi." In April 1965 he had his first exhibition in a non-commercial gallery, the Galerie Aujourd'hui. At the opening Broodthaers put on a Happening, *Nationale Académie: Une leçon de national pop art.* It took the form of a spoof class, in which the "students," his friends, brought him works of art to comment on. To whatever he said they would have to respond deferentially "yes, master" or "no, master." Only one received praise, and she brought forward a block of mussels. The invitation contains a mildly ironic statement:

> Pop Art? Ask Jean Dypréau. For my part, like the God I used to be, I shall tolerate no
> doubt. I make Pop. . . . What dreams! What maneuvers! How have I succeeded? Easily.
> I have just followed the footprints left in the artistic sands by René Magritte and Marcel
> Duchamp and those new ones of George Segal, Roy Lichtenstein and Claes Oldenburg.
> Faithfully in spite of the winds that blow. I, too, am an apostle of silence.

About this time, Dr. Hubert Peeters, the important Belgian collector of Pop Art, bought two works by Broodthaers, having been directed to him by the gallery owner Michael Sonnabend.[41] So, by 1965, Broodthaers had achieved the ironic position to which he aspired in his first gesture as an artist (as described in the introduction of the exhibition at the Galerie Saint-Laurent); he was able to write:

> of course now I have a job, and I'd have a hard time escaping it. In my naiveté, I really
> believed I could postpone choosing a profession until my death. How have I fallen into the
> trap? . . . Yes, like all artists, I'm now an integral part of society.[42]

41. Peeters, in Gildemyn, "Hommage à . . . Marcel Broodthaers," p. 22.
42. "Marcel Broodthaers par Marcel Broodthaers," p. 5.

Une pelle 1965
spade, adhesive paper, paint,
marker
115 x 19.5 x 5 cm.
Private collection

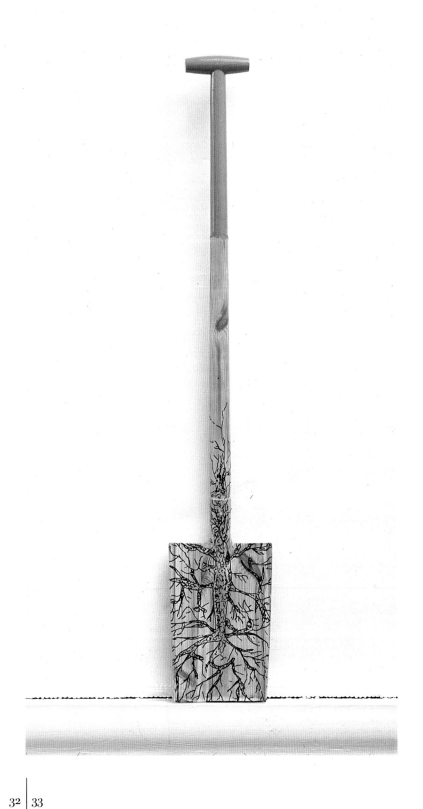

He was also writing criticism and articles in the *Journal des Beaux-Arts* and *Journal des Arts Plastiques.* One of these is an interview with Peeters, another on de Chirico.[43] But the poet Broodthaers, who was not making things for sale and so was not part of society and had no job, remains as the manipulator of the artist, giving significance to his work. However, he saw that he had not managed to formulate his ideas completely in this work as quickly as he had expected and would be obliged to go on for several more years before they would become clear to himself or to others.

In 1966, after several changes of lodging, Broodthaers and his family settled at 30, rue de la Pépinière, where they occupied four floors of a house that was to play a conspicuous part in Broodthaers's practice as an artist. By this time almost all the furnishings of the house had been turned into works of art, not only because they were materials that did not have to be purchased, but also because they were of basic types, formed by tradition and human usage.

The same year saw Broodthaers's first one-man exhibition outside Belgium. It was in Paris at the Galerie J, whose owner was Janine de Goldschmidt, wife of Pierre Restany. In addition to pieces with egg- and mussel shells were some in which repetitious eyes or mouths, clipped from advertisements, were placed in glass preserve jars. However, the jars are also containers in which food is kept and sold, so Broodthaers was preserving a commercial illusion instead of a real commodity.

Broodthaers was sought out by Anny De Decker, who was starting a gallery in Antwerp, the Wide White Space. His May-June 1966 exhibition there, *Moules Oeufs Frites Pots Charbon,* comprised objects that were generally of the same type as before, but also featured a series of *Casseroles de moules.* The catalogue (p.35), which may be considered an integral part of the exhibition, contains a sort of poem in which the words "pot," "oeuf," "moule," and "coeur" are repeated over and over again, manufactured as it were, but also handmade, that is, as reproduced handwriting. The words cover the surface of the paper in the same way that the shells cover other surfaces. Repetition is itself a theme. A text, which must be considered a poem, is reprinted from *Phantomas.*[44] A whole text and its illustration are repeated on facing pages. The whole catalogue was reprinted later with additions, including the title *Le Perroquet (The Parrot),* a metaphor of repetition. Another text in the form of a beautiful poem "explains" the exhibition:

43. "A Propos d'une émission de Jean Antoine sur Giorgio de Chirico," *Journal des Arts Plastiques,* no. 28 (1966) and "Interview d'un collectionneur: Hubert Peeters," *Journal des Art Plastiques,* no. 32 (1967).
44. See note 37 above.

Moules Œufs

Frites

Pots Charbon

v a n

MARCEL BROODTHAERS

van 26 mei tot 26 juni 1966

vernissage op Donderdag 26 mei te 20.30

WIDE WHITE SPACE GALLERY

PLAATSNIJDERSSTRAAT 1 (achter het museum) - ANTWERPEN

open op Donderdag-, Vrijdag- en Zaterdagnamiddag
van 14.30 tot 18.30 en op afspraak (tel. 38.13.55)

Moules Œufs

Frites

Pots Charbon

Perroquets

MARCEL BROODTHAERS

van 26 mei tot 26 juni 1966

vernissage op Donderdag 26 mei te 20.30

WIDE WHITE SPACE GALLERY

PLAATSNIJDERSSTRAAT 1 (achter het museum) - ANTWERPEN

open op Donderdag-, Vrijdag- en Zaterdagnamiddag
van 14.30 tot 18.30 en op afspraak (tel. 38.13.55)

Exhibition catalogue for Wide White
Space Gallery, Antwerp, 1966,
designed by Broodthaers.
First version.

Revised version, with addition of
Perroquets in red, for 1974
exhibition.

Rhétorique[45]

Moi je dis je Moi je dis je

Le Roi des Moules moi Tu dis Tu

Je tautologue. Je conserve. Je sociologue.

Je manifeste manifestement. Au niveau de

mer des moules, j'ai perdu le temps perdu.

Je dis, je, le Roi des Moules, la parole

des Moules.

(Rhetoric

Me I say I Me I say I

The King of Mussels me You say You

I tautologize, I preserve, I sociologize.

I manifest manifestly. At the sea level

of mussels I have lost time lost.

I say, I, the King of Mussels, the word

of Mussels.)

At the opening Anny De Decker arranged for packets of *frites* (french fries) to be offered to the guests from a barrow in the street and Isy Fiszman, who was to become a collector, obtained permission to play a part in the event: he would buy a preserve jar if he could smash it in the entrance.[46] He did so and Broodthaers politely swept up the remains and put them in a box.

In July 1966, Broodthaers contributed *Le salon noir* (p.37) to an exhibition of rooms by various artists at the Galerie Saint-Laurent. It comprised a coffin, black gauze, a chair, and a table with a glass bell on it containing silvered objects, including the only thing he had kept that belonged to his father, a fork. It was an image of a lying-in-state; in the coffin, which stood on end like a set of store shelves, were dozens of preserve jars. This time they contained only profiles of his poet friend Marcel Lecomte. When Broodthaers had asked his permission, Lecomte, wondering no doubt whether this might be prophetic, consulted the Tarot cards and consented, but he died soon after.

At the end of 1966 Broodthaers put on a Happening, *Au pied de la lettre* (*Literally*). It took place in his house in the rue de la Pépinière, where he set up a bank counter that he had rescued from the street and previously made into a work of art. Poet friends declaimed poems through the tellers' windows, another person sat reading on the chimney piece, with a dove

Broodthaers seated at his piece *Le salon noir*, Galerie Saint-Laurent, Brussels, 1966.

45. In the reissue of the catalogue, this poem is titled in red, which implies that it is a new title according to the new introduction; however, the same title appears in black in the rare original.
46. Anny De Decker, in Gildemyn, "Hommage à . . . Marcel Broodthaers," p. 22.

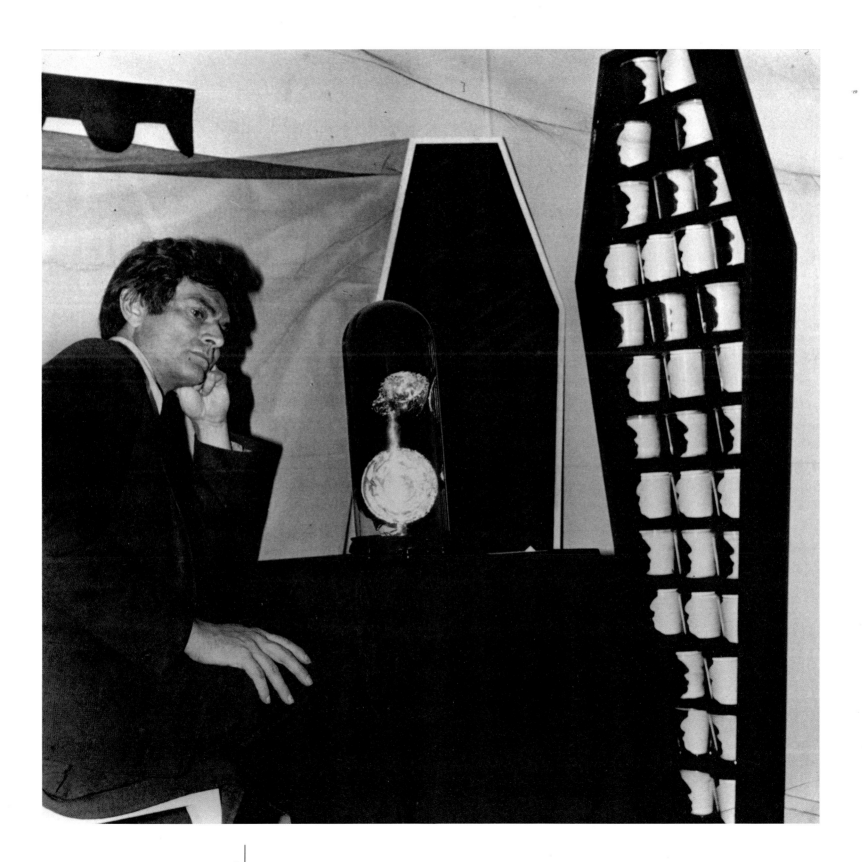

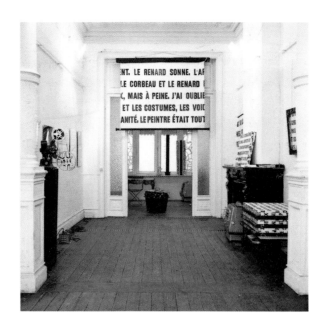

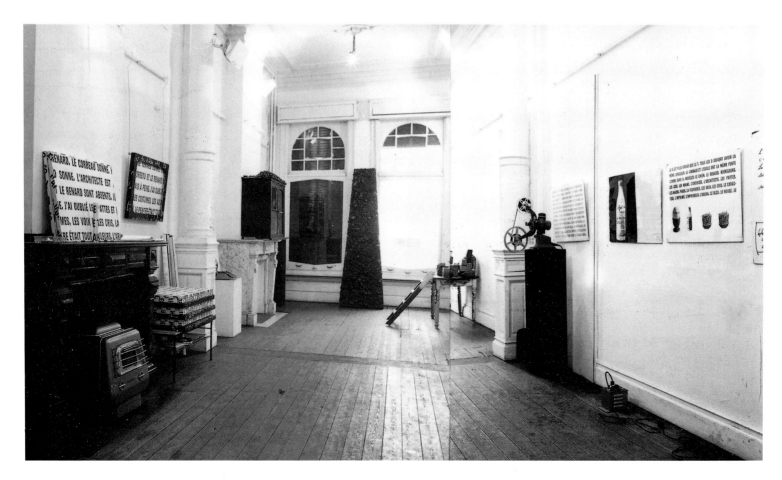

Two views of the installation
Le Corbeau et le Renard at Wide
White Space Gallery, Antwerp,
1968

on his shoulder, and other friends whispered into the ears of the visitors. Walter Swennen, an artist, painted the alphabet on a mirror. The Happening was reported in a poetry journal, which said that Broodthaers's event confronted the impossibility of poetic communication.[47]

About this time Broodthaers discovered and began to make use of canvas coated with photographic emulsion. This allowed him to make "paintings" of things, by means of a technique that was evidently not dependent on his own manual representational skill. The work was generally done by Maria in their basement. She printed images from smallish negatives, so that the results were both grainy and in high contrast. It would be difficult for people to endow them with the mystique of the painter. But Broodthaers used the medium to reproduce texts, either handwritten or already printed. Replication is associated with manufacture and so with marketing, and also perhaps with copyright.

In the spring of 1967 Broodthaers had his first retrospective; it took place at the Palais des Beaux-Arts, under the title *Le Court-Circuit (The Short Circuit)*. The catalogue contains an introduction by Restany. The pieces shown cover the three and a half years of Broodthaers's work, from mussels to photo-canvas, ending with "*Le Système D*, a poem on three cards on the theme of the reproduction of the reproduction of a reality reproduced."[48] One of the pieces, *La lecture*, includes a glass jar in front of a printed text beginning "Le corbeau et le renard" ("The crow and the fox"). This was part of the material prepared by Broodthaers for a film which he was making and which was to be shown at Knokke le Zoute. He described it to an interviewer:

> It was an attempt to deny, as far as possible, meaning to the word as well as to the image. When I'd finished with the camera, I realized that once the film was projected onto a regular screen, I mean a plain white canvas, it didn't exactly give me the image I had intended to create.
>
> There was still too much distance between object and text. In order to integrate text and object, I would have to print on the screen the same typographic characters I had used in the film. My film is a rebus, something you have to want to figure out. It's a reading exercise.[49]

This film, together with two prepared screens and other elements associated with it, packed in a box, was issued as a book and formed the material of his exhibition *Le Corbeau et le Renard*, at the Wide White Space Gallery in 1968 (p.38). The catalogue mimics a sales brochure, complete with endorsements of normal banality: "I find this film a unique experiment in adding a new dimension to cinema. Bravo." The cover of the catalogue

47. *Le Journal des Poètes*, no. 10 (December 1966), p. 11.
48. *Le Court-Circuit: Marcel Broodthaers*, exh. cat. (Brussels: Palais des Beaux-Arts, 1967).
49. "An Interview with Marcel Broodthaers by the Film Journal *Trépied*," *October*, no. 42 (Fall 1987), p. 36.

resembles a blackboard, which suggests that one is being taught a very simple lesson. La Fontaine's *Fables* themselves are a means of teaching children how to behave and how to write their own language beautifully. The exhibition also included the text of La Fontaine's own poem, written out in Broodthaers's hand. At the opening, musicians played Vivaldi and Bach.

In an open letter to the magazine *Art International* and the directors of the first Lignano Biennale, Broodthaers described these works in which the elements represent one another:

> I have been using since 1967 photo-canvases, films, slides, to establish the relationships between the object and the image of that object, and also those that exist between the sign and the meaning of a particular object: writing. Today, when the image destined for current consumption credits itself with the subtleties and violences of Nouveau Réalisme and Pop Art, I would like the definitions of art to support a critical view as much of society as of art and of art criticism itself. The language of forms must be reunited with that of words. There are no "Primary Structures."[50]

Broodthaers here seems to repudiate the then current American notion of an art object which just is what it is, having no other meaning, and he also opposes idealism. *Primary Structures* was the title of an exhibition at The Jewish Museum, New York, in 1966, which included the art that was to be called Minimalism. Both were being heavily promoted in Europe at this time and the associated texts in *Artforum*, etc. were widely read. Broodthaers saw the exhibition *Minimal Art* at The Hague Gemeentemuseum in the spring of 1968, but for him complexities of meaning, deriving from all possible relations between the world and the means by which it is represented, were the essential material of art.

The deteriorating condition of Broodthaers's liver was causing him to feel seriously ill, though he was given no plausible diagnosis. Nevertheless, early in 1968, he began to work in a new medium that he had discovered in the street—vacuum-formed plastic—but he was interrupted by an event which troubled him deeply. Generally he reacted philosophically to the dramas of the world. They were the normal product of a faulty system. But now an event took place in a field for which, as an artist, he recognized he must have some responsibility, and it led him to modify his own methods. For some months, the demonstrations, strikes, and occupations of 1967–1968 had been rising to a crescendo, especially in Paris. In the intellectual and art worlds the theme was often control of the institutions that mediated one's work. In Belgium there was only one large institution in the field of contemporary art, the Palais des Beaux-Arts. Artists debated occupying the building, and in June they moved in. Out of a core group of about thirty, four artists, including Broodthaers, were delegated to negotiate.

Il n'y a pas de structures primaires 1968
oil on canvas
77.5 x 115 cm.
Courtesy Galerie Michael Werner, Cologne

50. Open letter, dated Lignano, 27 August 1968, *Lignano Biennale 1*, exh. cat. (Lignano: 1968).

In his view, no change in the institutions of art could be seriously effective, since that field was only a dependent phenomenon of the greater social and economic world. Besides, he had no personal demands to make of the Palais des Beaux-Arts. However, he did have some ideas to put forward and wanted to stand with the others. So, with Raoul d'Haese, Serge Creuse, and Roger Somville, he set out to negotiate with Pierre Jeanlet, director of exhibitions, and Paul Willems, the general director. They agreed that only one gallery should be occupied, the Marble Hall. A discussion group was organized there, but when other activities, including the production of works of art, were set up, Broodthaers left. He had been there only eight or ten days (the occupation lasted much longer). He had helped to write the manifesto, which "condemns the commercialization of all forms of art considered as objects of consumption."[51] But Broodthaers must have thought this simpleminded, since in our world such commercial exploitation was inseparable from art and he had become an artist specifically to participate in the trade (while hoping to undermine it). He also produced a personal declaration in the form of an open letter "To my friends," which was the first of a series. It is dated from the Palais, during the occupation, but seems to announce his departure:

> Calm and silence. A fundamental gesture has been made here that throws a vivid light on culture and on the ambitions of certain people who aspire to control it one way or another: what this means is that culture is an obedient material.
>
> What is culture? I write. I have taken the floor. I am a negotiator for an hour or two. I say I. I reassume my personal attitude. I fear anonymity. (I would like to control the *meaning/direction [sens]* of culture.) I have no material demands to present except that I surfeit myself with cabbage soup. Through all that to protect a form of liberty of expression, newly acquired, that seems to me precious, for our provincial capital.
>
> One word more for all those who have not participated in these days or who have scorned them: don't feel sold before you have been bought, or only just.
>
> My friends, with you I cry for ANDY WARHOL.[52]

I take the first half of the letter to be an expression of unease about the tendency of everyone, including himself, to try to manipulate the situation for his own purposes.

At any rate, Broodthaers turned to a medium that was explicitly personal. In the atmosphere of fevered public debate and of the emerging Conceptual Art, he published a series of open letters, which may be considered a new art form. The next letter was addressed

51. Quoted by Benjamin Buchloh, "Open Letters, Industrial Poems," p. 82.
52. Open letter, dated Palais des Beaux-Arts, 7 June 1968, published in *Museum in Motion: Museum in Beweging: Het Museum voor Moderne Kunst ter Discussie* (The Hague: 1979), p. 249.

from Kassel, 14 July 1968,[53] where abstract and Minimal works, together with those of Pop Art, dominated the current Documenta exhibition. Broodthaers was present at the opening because he was in a fringe exhibition there organized by the Wide White Space. The letter contrasts two groups of terms. The first includes terms such as "a cube," "a sphere," etc., as well as some apparent relics of Romantic art—"like dreams of which one remembers little." This group is headed "Academy III" and designated "Limited Edition" (that is, apparently: "having artificial value" as well as "of limited scope"). The other group is a list of cities that had been the sites of demonstrations. These are headed "The Black and the Red" (presumably "anarchism and communism" as well as "church and army") and designated "Unlimited Edition."

In the latter part of 1968 and in 1969, Broodthaers returned to his recently found medium of vacuum-formed plastic reliefs (*plaques en plastique*).[54] Exhibited once under the title *Industrial Poems*,[55] these works involve the labor of craftsmen from the world of industry: those who interpreted his sketches to make the forms, those who did the vacuum forming, and those who painted the reliefs. The reliefs could be multiplied almost indefinitely, but Broodthaers chose to contradict their intrinsic character by generally limiting the edition to the seven typical of, say, bronze castings of sculpture.

These reliefs are nearly all of a standard size, 85 x 120 cm, and little less than 1 cm deep. The raised forms on them represent a variety of letters, printers' signs, other signs, and images. Their surfaces are painted, each one in two combinations of colors, one the reverse of the other. For example, one might be black on white and the other white on black. Some years later Broodthaers described them as "Rebuses. And the subject, a speculation about a difficulty of reading that results when you use this substance." "Reading" here seems to refer to the ambiguity of status between art and non-art, since vacuum forming is normally used specifically to make signs that must be easily read. But he goes on: "Reading is impeded by the imagelike quality of the text and vice versa." And then:

> The stereotypical character of both text and image is defined by the technique of plastic.
> They are intended to be read on a double level—each one involved in a negative attitude
> which seems to me specific to the stance of the artist: not to place the message completely
> on one side alone, neither image nor text.

53. *Museum in Motion*, p. 249.
54. Benjamin Buchloh deals with the relationship of the open letters to the plastic reliefs at length in "Open Letters, Industrial Poems."
55. The exhibition was in the Librairie Saint-Germain des Prés, Paris, October–November 1968. "Dix mille francs de récompense," p. 64, describes the reliefs under the heading "Signalisations Industrielles."

And finally:

> The way I see it, there can be no direct connection between art and message, especially
> if the message is political, without running the risk of being burned by the artifice.
> Foundering. I prefer signing my name to these booby traps without taking advantage of
> this caution.[56]

This text is itself a sort of rebus. The "stereotypical character" and the "double level" both seem to refer literally to the fact that the letters and other figures are raised to a uniform level above the background. Whatever is positive at one level is negative at the other. Broodthaers, in addition, had each relief painted in two ways, one the negative of the other. Similarly, "not to place the message completely on one side alone" may refer not only to image and text, but literally to the fact that the message appears reversed on the underside of the relief, where he sometimes adds another message—the signature, for example. So the facts of the medium are as much an intelligible part of the work as the combinations of writing and images on them. The connection between art and political message avowed in his last line is to be found more at the level of the medium, where people are not as likely to look for it, than in that of the imagery. The political message seems to be about art itself:

> According to their mechanical production [the reliefs] seem to deny their status as art
> objects, or rather I should say, they tend to prove art and its reality by means of
> "negativity."[57]

Parts of some of the reliefs are identical with parts of the open letters, especially the references to primary structures and to other geometric forms, which appear as both words and diagrams. Such words and images may be shown in rectilinear arrays as certain Minimalist sculptures are. The reliefs themselves seem destined to be displayed in the same way. Other devices in the reliefs are drawn from the abstract structure of writing (e.g., punctuation marks) and from the commercial uses of the vacuum-formed medium. However, especially when seen en masse, these reliefs have a more vivid and direct character than any other of Broodthaers's works.

Broodthaers's open letter of 7 September 1968,[58] headed "Cabinet des Ministres de la Culture," announces the "opening of the *Department of Eagles* of the *Museum of Modern Art.*" (The only official museum of modern art in Belgium was a department of the Musées Royaux des Beaux-Arts.) His next letter, on 19 September, is headed "Département des Aigles" and declares his intention "to play on reality and its representation on the basis of an industrial technique." This will be done through the media. He feels a "solidarity with all

56. "Dix mille francs de récompense," transl. Paul Schmidt, "Ten Thousand Francs Reward," *October*, no. 42 (Fall 1987), p. 42.

57. Exhibition announcement, quoted in Buchloh, "Open Letters, Industrial Poems," p. 96 n. 31.

58. *Museum in Motion*, p. 249.

Section XVIIème Siècle 1969
paint on vacuum-formed plastic,
two panels
each 120 x 85 cm.
Courtesy Galerie Michael Werner,
Cologne

approaches that have the goal of objective communication, which presupposes a revolutionary critique of the dishonesty of those extraordinary means that we have at our disposal: the press, radio, black [*sic*] and color television." He is saying again what he had said before, but the style is inflected by the political preoccupations of the day and is bracketed by phrases which throw its literalness in doubt:

MUSEUM

. . . A rectangular director. A round servant . . .

. . . A triangular cashier. A square guard . . .

and

To my friends,

. . . no people allowed. One plays here everyday until the end of the world.

On 27 September 1968, on the ground floor of his house on the rue de la Pépinière, Broodthaers opened his own museum with the "Section of the Nineteenth Century": *Musée d'Art Moderne, Département des Aigles, Section XIXème Siècle*. He was himself the director—a director of a museum of packing cases in which works of art had once traveled, postcards of pictures belonging to other museums, some slides being projected, and an empty, motionless transport truck. All this was to be a forum for discussion. Broodthaers later described his museum as "fictional. It plays the role at one time of a political parody of art institutions and at another of an artistic parody of political events."[59] Among the latter were the occupations of museums and other institutions. The debates during the occupations as well as the official openings of museums would be parodied naturally by those he invited to the inauguration—collectors, artists, relations, critics, friends.

Broodthaers made a drawing that showed his museum standing back to back with the museum of the reigning Belgian dynasty. The royal heraldic device is the lion; Broodthaers chose another, equally associated with domination, the eagle. But the eagle was also himself: the recurring motif of one of his early poems and a metaphor for the artist.

The museum works mimic in particular the tendency of all museums to organize objects according to classes, to situate something in a department of Italian painting rather than of Greek sculpture. Broodthaers recognized this activity as an essential aspect of the museum's role in the general social process of classification, a process treated at length by Michel Foucault. Though Foucault's earliest discussions of this activity center on the treatment of "natural" phenomena, even there he emphasized the relation between social interests and the intellectual justification of the establishment of analytic classes. Broodthaers's museums ask

59. Press release for the exhibition *Section des Figures (Der Adler vom Oligozän bis Heute)*, Städtische Kunsthalle Düsseldorf, May 1972.

us to think about whose interests are served in organizing these objects in any given way.[60]

During the year the museum remained open, Broodthaers continued to work as before on the plastic reliefs, which he exhibited widely, but he also made more films. Two, *La pipe (René Magritte)* and *La pluie (Projet pour un texte)*, were shot in the small back garden of the house. In the former, smoke from Magritte's pipe slowly obliterates the view, and in the latter rain constantly washes out Broodthaers's attempts to write. The devices are simple, witty, and original. Time is presented directly as a linear structure, characteristic of the medium.

In the same period, Broodthaers's range of international contacts widened. Artists, critics, gallery owners, and curators came to his door, including two from Germany, the gallery owner Michael Werner and the Düsseldorf Kunsthalle director Jürgen Harten, each of whom wanted to put on an exhibition. He began to buy books again, including, over the following years, titles by Heidegger, Barthes, Goldman, and Lacan. The major part of his library comprised works of French literature, including Rabelais, Hugo, Balzac, and Heine, together with volumes with fine illustrations. He attended the seminars of Lucien Goldman on Baudelaire. When he was out of the house he would leave little notes on the door:

> I am at the WWS Gallery because it is obvious that the infrastructure of museums rests on
> the activity of galleries. It's a pity.

or

> I am with a visitor at the Museum of Ancient-Modern Art (opposite). The visitor has come
> specially from NY (USA). It is James Lee Byars, so true is it that the structure of one
> museum like this depends on the structure of another museum.

The museum opposite is presumably the Musée Royale des Beaux-Arts, round the corner, on whose facade is a winged figure representing the aspiration of art.

During 1969, Broodthaers returned to his point of departure and prepared a work based on Mallarmé's "Un coup de dés." It was itself a book, to be published by the Wide White Space Gallery, Antwerp, and the Galerie Michael Werner, Cologne, under the title *Un coup de dés jamais n'abolira le hasard. Image. (A throw of the dice will never abolish chance. Image.)* (p.152).[61] He went further than he had with La Fontaine in stripping the words of meaning and turning them into an image: the lines of type are reduced to simple bars, occupying the same physical space as the type had occupied in the first edition of the poem. Broodthaers's book exists in three forms: as a series of engraved metal plates (like printing plates), as a book printed on translucent paper, and as a book on ordinary paper.

60. Although Broodthaers respected a number of such intellectual mandarins as Foucault and sometimes sought to meet them, they usually felt an instant mutual repulsion.
61. Gilissen, *Marcel Broodthaers: Catalogue des Livres*, pp. 24–27.

Broodthaers credited Mallarmé with being the founder of modern art. This was a sincere but double-edged compliment since it implied that he was responsible for the tradition which had led to the almost complete dissociation of the image from the object, that is, abstraction. Broodthaers's book also formed the basis of his *Exposition littéraire autour de Mallarmé* at the Wide White Space in December 1969. The following month, Broodthaers used variations on the material (with additions) to create a different show, *Exposition littéraire et musicale autour de Mallarmé*, at the Galerie Michael Werner. It included a carpentered model of a piano with a tape recorder inside.

The important exhibition *MTL-DTH* at the MTL Gallery in Brussels (March–April 1970) included transcriptions of *Le Corbeau et le Renard* and *Un coup de dés*, but the bulk of it comprised his own poems in corrected typescript and drawings resembling doodles.[62] There was a film dealing with the show itself. A number of the poems, published and un-published, were hidden in a folder. Perhaps the exhibition sought to contrast the circumstances in which poetry is read (or not read) by the public with the circumstances of exhibition and sale of works of visual art, which are looked at and acclaimed, but not really perceived. The renewed preoccupation with literature is signaled by the change in the printed heading of the open letters at the end of the year, from "Section XIXème Siècle" to "Section Littéraire." One may conjecture that, in all the works, Broodthaers is subtly criticizing Conceptual Art, which often uses words of limited imagination and treats them as objects by contrasting them with the careful choice and personal use of words by poets.

An open letter of 10 May 1969[63] hints that he saw a chance to extend the scope of his activity; it says "I love Düsseldorf" and speaks of places and artists, including Joseph Beuys, who was becoming the most respected German artist of his day and whose work Broodthaers respected. Broodthaers had been instrumental in the filming of Beuys's *Eurasienstab*, an Action at the Wide White Space. By the end of the year it seemed that the house in the rue de la Pépinière would be pulled down, and Broodthaers, with Maria and Marie-Puck, moved to Düsseldorf. Various people helped them with lodging in Germany, including Michael Werner in Cologne and the filmmaker Tony Morgan, from whom they rented rooms in Düsseldorf. Broodthaers planned a *Section Cinéma* of his museum, which opened early in 1971 in a basement room on the Burgplatz in Düsseldorf. It comprised a large space in which a Charlie Chaplin film and a film about Brussels were projected onto a screen inscribed with stenciled letters—"fig. 1," "fig. 2," etc. From this time on, Broodthaers's preoccupation with film at least equaled that of his visual art and his output greatly increased. In a small adjacent space he set up the work *Théorie des figures*. This major work, which Broodthaers

62. The exhibition is fully discussed in Rorimer, "The Exhibition at the MTL Gallery," pp. 101–125.
63. *Museum in Motion*, p. 249.

wanted to have preserved, was sold to the Städtisches Museum Mönchengladbach. In Düsseldorf it was exhibited with other elements, including the piano from the last show at the Galerie Michael Werner, altered for the occasion. *Théorie des figures* was an epitome of Broodthaers's work up to this date; it included a box containing objects: a pipe, a mask, a clock, and a piece of the equipment that he was using to make films. This winder had to be taken out and replaced as required, just as pieces of his furnishings had found their way into works and sometimes out again: this is one more way in which he called into question the accepted definitions of life and art.

He wrote a dedication to a publication of the Galerie MTL,[64] which now reintroduced the economic theme but did so more directly. It reproduced his 1964 text for the Galerie Saint-Laurent and continued:

> The aim of all art is commercial.
>
> My aim is equally commercial.
>
> The aim of criticism is just as commercial.
>
> Guardian of myself and of others,
>
> I do not know truly who to kick. I can no longer serve all interests at the same time
>
> all the more because unexpected pressures are at this moment influencing the market
>
> (which has already suffered)

Broodthaers studied political and financial columns and sometimes got his young daughter to read the exchange rates and gold prices to him. He advised Maria to spend the small remainder of her modest inheritance on a single gold bar, which he predicted would soon repay her in increased value for all that had been spent. He stamped this gold bar with the sign of the eagle, and he devised a contract under which a number of such ingots would be sold at double the current market price of gold.[65] That is, the price would be set so that half would be due to the market in gold and an arbitrary half ascribed to its value as art. Broodthaers scrutinizes both value systems and also the critique which too simply subsumes the market in art to that in all other commodities. The gold bar became the subject of a print in two parts, in which repeated images of it are captioned with the names of great artists and of basic commodities, and with words denoting the conditions of authenticity and inauthenticity.[66]

Pursuing the economic theme under the title *Musée d'Art Moderne, Département des Aigles, Section Financière*, at the Galerie Michael Werner showing at the Cologne Kunstmarkt,

64. *Art Actuel* (Brussels: Galerie MTL, 1970).

65. Published posthumously as *Musée d'Art Moderne/Section Financière/Département des Aigles* (Düsseldorf: Galerie Konrad Fischer, 1987).

66. The print is described in *Marcel Broodthaers: Editionen (1964–1975)* (Munich: Galerie Heiner Friedrich, 1978), no. 9.

Broodthaers announced, "Museum of Modern Art for Sale as a Result of Bankruptcy." The announcement was wrapped around copies of the catalogue of the art fair and offered for sale.

In 1970 Broodthaers had exhibited at the Städtische Kunsthalle Düsseldorf some actual nineteenth-century paintings, borrowed from the city's Kunstmuseum, as *Section XIXème Siècle (Bis)* and, with the help of one of his collectors, Dr. Herman Daled, had dug out the ground plan of a museum on the quiet Belgian beach of Le Coq as *Section Documentaire*. More ambitiously, he began to prepare for the Kunsthalle the monumental *Section des Figures (Der Adler vom Oligozän bis Heute)*. The objects in *Section of Figures (The Eagle from the Oligocene to the Present)* were images of eagles, mainly borrowed from museums (including Broodthaers's own) and representing a wide range of periods, cultures, and functions, not to mention aesthetic qualities and values. The selection replaced the traditional museological classifications of art (period, school, etc.) by that of the object represented. The exhibition seems to parody the insatiable appetite of museums for acquisitions, which results in the stripping of objects from their natural or historical contexts in order to place them in that of the museum culture.

A short text seems to define the purpose of the project,[67] with a shade of irony:

1 To baffle every ideology which can be formed around a symbol (it is false).

2 To study objectively these symbols (the eagles) and particularly their use in artistic representation (eagles are useful).

3 To use the discoveries of conceptual art to illuminate objects and pictures of the past.

Conclusion: The eagle is a bird.

The eagle itself has been used historically to symbolize almost anything, but, taking the exhibition as a whole, it may surely be understood to stand both for the myth of the free artist and for the power of the systems which control him. Broodthaers's strategy was close to one which he recognized in a passage he marked in a book by Lucien Goldman:

It is necessary to frame the object studied in such a way that one can study it as the deconstruction of a traditional structure and the birth of a new structure.[68]

But Broodthaers would never use language like this because he was a poet and an artist. He had a great affection for art and literature and did not want to see them trapped in a net of critical jargon.

Broodthaers's own eagle is associated with Romantic melancholy—not, as for most people, with military pride. But everyone may have his eagle and his characterization of other people's eagles, a point he makes in the form of a schoolchild's conjugation:

67. Typescript, dated 2 November 1971.
68. Lucien Goldman, *La création culturelle dans la société moderne* (Paris: Gonthier, 1971), p. 21; copy in library of Marcel Broodthaers.

Theory

Museum at the [present?] time

I am the Eagle

Thou art the Eagle

He is the Eagle

We are the Eagle

You are the Eagle

They are cruel and indolent

intelligent and impulsive like

lions, like remorse, like

rats. . . .[69]

Every object in the Düsseldorf exhibition *Section des Figures* was numbered with a label saying either in French, German, or English "This is not a work of art" (which he says in the catalogue means "Public, how blind you are!") The catalogue and press release explain that the method is to conflate the example of Duchamp's urinal (*Fountain*) with that of Magritte's painting *La trahison des images (This is not a pipe)* (p.85). Duchamp had brought the urinal into a museum, thus declaring the artist's right to turn it into a work of art. Broodthaers reverses the process, which has been vulgarized by commerce: he brings objects into the museum, including works of art, and declares them not to be works of art. His comment on Magritte takes the form of directing the reader to Michel Foucault's essay "Ceci n'est pas une pipe," which at that time existed only as a published lecture that Broodthaers had almost certainly not yet read.[70]

In its scale and thoroughness, as well as in the philosophical character of the texts with which it was presented, the Düsseldorf exhibition reflects Broodthaers's view of the new people with whom he was working. It is probably for this reason that political argument, up to this time expressed briefly and eliptically, begins to appear in a lengthier and more explicit form. Broodthaers would regularly take on a style of criticism that seemed in vogue in order gently to subvert it, just as he did with styles of art itself.

The last manifestation of the *Musée d'Art Moderne* took place at Documenta 5 in Kassel in the summer of 1972. This swan song took the form principally of a black rectangle, painted on the floor and surrounded by a barrier of chains, inscribed in three languages in an ugly script "private property." (One is left to wonder whose property.) This would be changed

69. Draft of a text in the Broodthaers archive, apparently to be addressed to Jürgen Harten; the queried word is illegible.
70. "Ceci n'est pas une pipe," first version published in *Cahiers du Chemin*, 1968.

later in the exhibition to an inscription with the words "to write," "to paint," "to copy," etc., in an elegant style. Broodthaers's comment identifies the first set of inscriptions as a satire on the identification of art with private property and says that, since he had failed to assert his power to replace that of the curator, the second would allow him a little subversion of the organization of the exhibition. In fact a large part of his remaining work took the form of directing his own exhibitions.[71]

In Germany (principally Düsseldorf and Cologne) Broodthaers found himself treated as a member of a community of equals. At home, he had been something of an outsider in a country whose provincialism he had laughed at affectionately and would laugh at again, representing Belgium as the country that produced pirated editions of French literature, rather than its own.[72] But at this time the region including Düsseldorf and Cologne was cosmopolitan, attracting artists as Paris had done for a hundred years, so he was no longer a provincial. Nevertheless Broodthaers was not considered to be quite serious. For one thing his work and conversation had too much wit and ambiguity; for another, it was difficult to consider him the protagonist of any movement and he resisted demands to make major works, such as could dominate in collections and museums and would define his style. He always avoided the obviously heroic gesture. Ten years earlier he had written in *Pense-Bête:*

La Maison

Ou Tranche-Montagne creuse l'abîme, elle fait son trou.

(The House

Where Mountain-Slicer carves out the abyss, she makes her [little] hole.)

Tranche-Montagne was a Renaissance literary name for one who talked too big. I believe that Broodthaers had always felt that, while art might help to dissolve false concepts of reality (ideologies), an artist should not imagine that he could, through his art, directly attack the social or economic systems that were their principal source. Efforts would be futile and would soon be absorbed by the academies and museums. They would be damaging to art itself. Above all, he felt that an artist should not consider that his own achievement put him in a position to lead others. He remained in agreement with the position of Magritte:

The real value of art is a function of its power of liberating revelation. And nothing confers on the artist any superiority in the order of human work. The artist does not exercise that priesthood that bourgeois duplicity alone tries to confer on him.[73]

71. *Interfunktionen*, no. 10 (1973), pp. 76–80.
72. E.g., in *Pauvre Belgique*, 1974; see Yves Gevaert, "'Pauvre Belgique': An Asterisk in History," *October*, no. 42 (Fall 1987), pp. 185–195.
73. Quoted in Mariën, *L'Activité surréaliste en Belgique*, p. 362.

The theme of the impropriety of the artist-magician-politician is beautifully set out in the second open letter Broodthaers wrote to Beuys.[74] He casts Beuys as Richard Wagner and himself as the entertainer, Offenbach, who points out that both have been accepted by the king (the Guggenheim Museum), while Hans Haacke, cast as a composer of flute pieces, has been sent away. The allusion is to the Guggenheim's rejection for exhibition of Haacke's 1971 *Real-Time Social System*, but Broodthaers's attack is not against the museum, which was behaving as should be expected in excluding work that could discredit donors or trustees, but is instead against any artist who tries to make himself both a shaman and a political leader.

Early in 1973, Broodthaers moved to England where, he said, no one would notice him for at least two years. That prediction was not entirely vindicated. He had a show at the Jack Wendler Gallery at the end of 1972 and another at the Petersburg Press at the beginning of 1973, both in London, and he had already made some friends there, including the Pop pioneer Richard Hamilton and the Argentinian artist David Lamelas; he also knew Gilbert and George. But London was indeed quiet compared with Germany. Broodthaers had discovered, while in Germany, the extensive damage to his liver and was warned to change his diet and to drink no alcohol, which made social life in England difficult. But he found that a quiet life gave him a better contact with the city and its people, and he was pleased to escape discussions on art.[75] The family lived in a small house in Queen's Park, where he began to produce a prodigious amount of work that seems to manifest a slight change in direction or emphasis.

We see, in particular, a renewed attention to painting. This does not mean of course that Broodthaers would set out to paint pictures of things in any traditional sense (since he claimed no professional skill of this sort), but rather that he would make use of the tradition of painting as an art. He saw each of the different branches of Western art in a different way. He wrote in the book *Magie*, cryptically:

> Being an artist
>
> 1 sculpting—to drown like the son of a god! What glory! . . . It's better to fake.
>
> Properties: a diver's outfit. Several fish. Flowers.
>
> 2 painting—witnesses appearing on the stage, the merchant with his friend the art lover.
>
> Swearing allegiance.
>
> 3 drawing—the artist's writing complements or replaces his images. He signs.
>
> 4 engraving—Market study.[76]

74. Gilissen, *Marcel Broodthaers: Catalogue des Livres*, pp. 38–39. The letter is published in three languages in *Magie: Art et Politique* (Paris: Multiplicata, 1973).

75. Letter to Karl Ruhrberg, published in *Marcel Broodthaers*, exh. cat. (Cologne: Wallraf-Richartz-Museum/Museum Ludwig, 1980), p. 17.

76. For *Magie*, see note 74 above.

e f g h
j k l m n
p r s t

In his sculpture Broodthaers does reject the godlike in favor of "faking" with objects. He does indeed draw as he writes, and with his own hand: he signs in this way and also literally, by writing his name or initials—which may be the whole drawing. His prints and other multiples are very often about, and function as, marketing devices. But his definition of painting is the most enigmatic. It may refer to painting's position as the most mysterious of the four and, more obliquely, to illusion. Broodthaers's paintings in this period are generally true to the medium, being pigment on canvas, but their image is most often lettering. The magical, autographic uniqueness of the oil painting tradition is often partially subverted. Letters may be printed or stenciled. A reason for this non-painterly device seems to be that, by interchanging conventional elements of different media, Broodthaers could illuminate the specific assumptions that are associated with each of them. In every case it is the elementary structure that he treats as a key to the relationship between the representation and its designated reality:

> We pass from the alphabet to the word, from the word to the elementary phrase and from
> there to the object, which has become dependent on the word (praise of the subject), that
> is to say, the subject.

This implies that we begin with the elementary structure of written language and from that pass eventually to the real world. That reality is understood through words and so made dependent on them; it becomes their subject both in the grammatical sense and in the sense of what is governed—like the subjects of a king. Broodthaers imagined an identity of image, or word, and object, an identity that was the expression not of forces which, like commerce, are imposed on people, but of the real needs of people; this identity would be created by the free imagination, especially of artists. In the meantime he could only disturb the existing relationships.

In a draft statement headed "A Mole's Work," he rejects the possibility of a retrospective of the *Musée d' Art Moderne* because social and political circumstances have changed and the eagle has been reduced to a symbol only of imperialism and nostalgia. He continues:

> All human action is political. That is false. It becomes true when the image of natural
> objects is constructed and guided by a social class which intends them to serve the
> preservation of its privileges. What is political in the profession of art or of other things is
> to reveal this way or in any case not to conceal it.

And in another statement, apparently written about the same time:

> The method I have employed is to introduce and establish falsehoods in (artistic) reality.

That is, he would introduce falsehoods into a falsehood. However, they would not be simple errors of fact, they would be structural faults. Elements of verbal, written, and pictorial language would be deployed without the linear relationships which permit facts to be asserted or orders given.

Untitled 1975
paint on canvas
50 x 50 cm.
Private collection

Among the most elegant of the works that treat the matter of painting are the sets of nine canvases which Broodthaers began to produce in 1972. The first set was exhibited at the Galerie Yvon Lambert in Paris, October–December 1972, in a group exhibition called *Actualité d'un bilan (News of a Balance Sheet)*. The canvases were arranged in three rows of three. Words, dates, and printers' devices are printed on them in carefully chosen display type, forming short sentences, generally the name of a French writer and an apparently arbitrary verb—"André Gide fume" (smokes), "Paul Valéry boit" (drinks), "René Magritte écrit" (writes). Both Lautreamont and Isidore Ducasse "copy;" they were the same person. In the catalogue, Broodthaers queries the need to "write and photograph after having pretended to paint the series of pictures exhibited."[77] The catalogue is illustrated with reproductions of photographs of the writers named (not of the paintings), and then reproduces the same reproductions. Broodthaers goes on: "the Plastic Arts in an outdated linguistic framework serve only as a practice field for maneuvers of a more military than scientific type. The subject is denied by its use as the operational means for the conquest of space." The conquest of space here seems to have, as one of its meanings, purely abstract physical arrangement.

Taking on what he parodies, as usual, Broodthaers arranges his canvases like a platoon of soldiers, sometimes in one order, sometimes in another. Everything seems arbitrary: an order for order's sake, as self-justifying as the competitive conquest of space—the space race was then at its height. But the arbitrariness is not just a function of parody. The tabulated structure and the strangeness of the relations between subject and verb in the printed phrases suggest a reference to the two-dimensional structure of contemporary linguistics, those of syntax and association. Plainly much more important, however, is the fact that the names inscribed in such an exemplary script are those of writers who have created language ranging from the revolutionary, Baudelaire, to the academic, Gide, who appears in his Academician's uniform. Although Broodthaers, to transform his own phrases, does parody art in terms of theory, he also parodies theory in terms of art.

The most elegant of all the series, perhaps, is that which contains, in delicate typography, words associated with the practice of painting itself: *Peintures (Série l'art et les mots)* of 1973 (p.57). Subtly mixed with them are other words denoting the reality which is the subject of paintings: eyes, skin, hair, and numbers, apparently denoting the imposed ideal structure. The elegance and style connote the high tradition of art and its concern for fine execution. It may be considered a critique of the simplicities of Minimalism that is hinted at in the layout described above. Moreover the dissolution of the conventional syntaxes that give meaning to combinations of words, images, and sounds in languages and arts forces viewers to reconstruct the relationships and consequent meanings, which they may do in an infinite number of

Peintures (Série l'art et les mots)
1973
nine paintings on canvas
each 85 x 100 cm.
Courtesy Galerie Isy Brachot,
Brussels

77. *Actualité d'un bilan*, exh. cat. (Paris: Galerie Yvon Lambert, 1972), p. 37.

le sujet

cheveux onyles oreilles

clou châssis

couleur

valeur prix pinceau

la peau

châssis pinceau ... chevalet

le sujet

style dessin prix

image figures couleur

la peau

la perspective

peau chevalet clou

figures style

couleur

sujet image pinceau

le prix

châssis pinceau peau brosse

le sujet

style dessin prix

image figures couleur

le prix

les figures

1 2 3

4 5

6 7 8 9

le style

le pinceau

châssis chevalet clou

figures appui

sujet

couleur perspective prix

la brosse

cheveux pinceau brosse chevalet

le prix

style sujet perspective

image figures couleur

l'image

le sujet

châssis chevalet clou

figures composition

couleur

valeur prix pinceau

l'image

yeux peau oreilles cheveux

la brosse

style sujet prix

image figures couleur

l'image

ways. Such a reconstruction is quite different from the reconstruction of object from idea required by much Conceptual Art, having more to do with the meaning of structures of languages (and of the cultures in which they operate) than with the meaning of words. This work may be considered the prototype of *La salle blanche* (1975; p.207).

The other group of major paintings comprises, principally, stenciled letters arranged in alphabetical order. The canvases may arrange themselves, according to art historical convention, into diptychs or triptychs, the letters into typographic compositions or into words and names. Letters may be black, monochrome, or multicolored (metonym of visual art). There may be a reference to Rimbaud's poem "Voyelles," which allocates colors to the vowels. In one work Broodthaers seems to confront these magical correspondences with the more literal *"A Field,"* lettered in green. A much earlier work, *Langage de fleurs* (1965; p.114), had represented the vowels in black and white, with, among them, an artificial flower in color. The relentless use of the alphabet has, of course, another resonance: that of teaching children to read; in 1972 Broodthaers had made a book of a school exercise book. But there had almost always been an element of ironic didacticism in his work. The alphabet is used to teach, but the alphabetic ordering of letters used to impose them on children robs them of real meaning. The only reference in the alphabet itself is to the history of dead alphabets.

A triptych, *The Ballad of a Star over Reading Gaol* (1974; p.150), laments the poet Oscar Wilde, who was imprisoned as a result of defying conventions, but the most beautiful may be the diptych *Les très riches heures du Duc de Berry* (1974–1975; p.59). One part is an alphabet in brown and white, headed with the title in colored letters; the other part contains twelve postcards of the wonderful illuminations of the fifteenth-century manuscript of the same name, the finest of its period. The first panel represents the second in words, the second, in turn, represents the illuminations of the book in pictures, disregarding its words. The book, the real work of art, is absent, in another place. The reality of the book is absent, in another time. Broodthaers's own painting is without the air of an artistic fetish and points to the real qualities of craftsmanship, imagination, and luxury of its subject.

His concern for painting is attested in at least two other groups of works characteristic of these years: sculptures comprising piles of stretched canvases, and numerous palettes. The edges of the canvases may be painted in color or in black and white; the topmost one inscribed with a date or a printer's rule—an emblem of style. He does not presume to paint an image on them. But the palettes, with their curves and thumb holes, often resemble heads or skulls and are drawn or painted upon as if they were pictures and not just the means of holding and mixing paint.

During the period he was living in England, Broodthaers had a little more money and began to buy old books ranging in date from the sixteenth to the twentieth century. Apart from great literature, they deal with animals and plants, with calligraphy and military drill.

les tres riches heures

a b c d e f

g fleurs i j k l

m n o or r

s t u v w x

du duc de berry... etc...

y xyz

*Les très riches heures du Duc
de Berry* 1974-1975
diptych: oil on canvas, postcards
on card
canvas: 126.5 x 96 cm.
card: 53.5 x 58.5 cm.
Courtesy Galerie Michael Werner,
Cologne

There are many children's books and others which teach good style and behavior. Above all they are handsome, stylish, or charming, with interesting illustrations. He also collected children's toys, especially those associated with teaching children to write, to make pictures, to learn literature, geography, and any aspect of their culture deemed suitable to their age. Looking at these together one can have no doubt that they were collected with love, discrimination, and a sense of fun. They were used by him to make slide projections and other pieces, which were often included in subsequent exhibitions. Broodthaers hoped perhaps to teach the world something, but his method was to invite us to learn.

During 1974 Broodthaers spent six months in Berlin on a fellowship. While there, he underwent radical surgery to bypass his liver, which was now quite useless. Realizing he might die during the operation, he produced a handwritten "will," indicating in only forty words that Maria should have sole responsibility for the estate, and should have sole right to reconstruct a totality ("faire un tout") with the help of enlightened connoisseurs. She should also have the sole right to say what was authentic and what was fake.

In 1973 and 1974 Broodthaers's output of one-man shows and manifestations had been prodigious, eleven and thirteen, respectively. But he had in mind a series of works which would consummate his career and sum up his achievement; he was determined to live long enough to complete them. This was the series of great exhibitions that began with *Catalogue-Catalogus* at the Palais des Beaux-Arts, Brussels, 27 September 1974, and ended with *L'Angélus de Daumier* in Paris, which closed on 10 November 1975. The same prolific period saw the creation of two of his grandest films, *Figures of Wax*, 1975, and *The Battle of Waterloo*, which seem to point to the direction he might have taken if he had had another ten years.

The germ of the idea for these exhibitions, usually called collectively *Décors*, may already be seen in the single works *Le catalogue et la signature* (1968; p.61), and *Ma collection* (1971; p.84), which make a work of art out of a fictive collection or exhibition, and in all those exhibitions and catalogues which he had devised with wit, ingenuity, and care for art during the preceding ten years. The *Décors* are retrospectives in part, but earlier works are revised by means of their inclusion in new works and in the totality of the exhibition. Broodthaers was always aware that even after a very short time, the context of art changes quickly, not only because of events in the art world and the world at large, but as a consequence of the artist's own achievements. He understood that although a painting by Ingres is forever a great work, it will never be the same work for all people at all times; Broodthaers's own works would seem to change even more rapidly because of the awareness of the most contemporary social circumstances that was one of the conditions of their creation and which is expressed in them. This may have been among the reasons why he so often used objects, words, and names that had a rich history of use and affection, one that he was aware

Le catalogue et la signature 1968
photographic image on canvas,
slide projections
125 x 125 cm.
Private collection

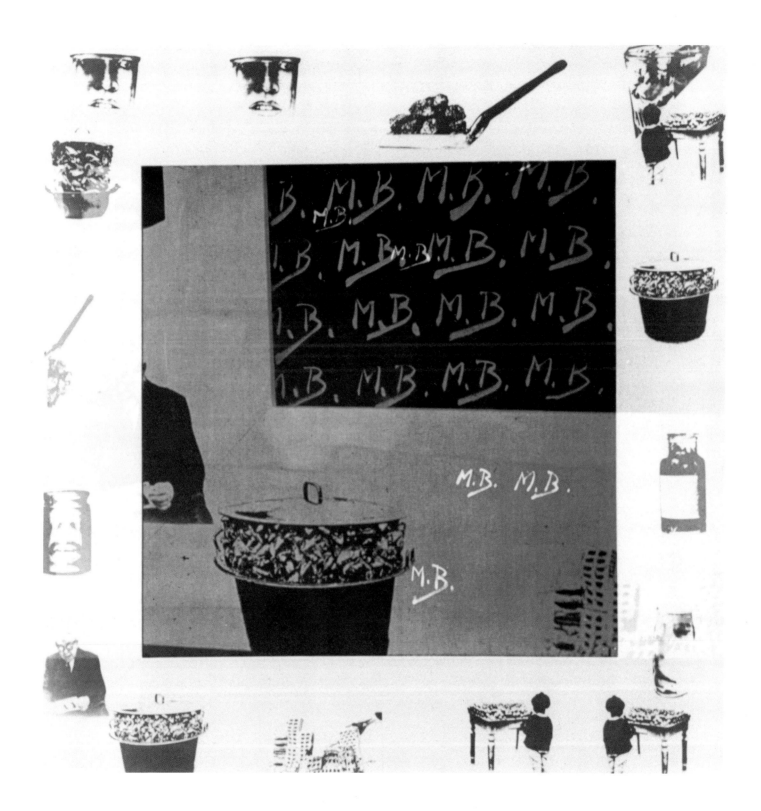

Le tapis de sable 1974
palm tree in pot, sand, paint and
printing ink on cloth
cloth: 107 x 51 cm.
carpet: 225 x 180 cm.
Private collection

of and knew was widely shared. It is as if what was traditionally conceived and made would
have a sort of humanity that would protect it from the historical contingencies exemplified by
conditions in the market.

All these big exhibitions in Broodthaers's last fifteen months were in museums or other
similar publicly funded institutions, and they took on something of the character of such
institutions in general and of the particular institution in which the exhibition was mounted.
Broodthaers would have a guiding idea for each one and would bring together or prepare the
material out of which it would be created. Once this material was delivered to the galleries
where the show was to be, he would rapidly and deftly create the exhibition.

The first of these exhibitions, *Catalogue-Catalogus* at the Palais des Beaux-Arts,
represents a retrospective. It has an elaborate but conventional catalogue with a list of works,
an interview with the artist, texts on the artist, and reproductions of works in the show. The
interview constitutes the longest text by Broodthaers on his own work, since both the
questions and the answers were so rewritten by him after the recording that it has the status
of an independent essay dealing with the questions that he wanted to raise.[78] Most of them
are left open. Answering the question "Isn't artistic activity . . . the height of inauthenticity?"
he says that "it is perhaps possible to find an authentic means of calling into question art, its
circulation etc. And that might . . . justify the continuity and expansion of production." Next
question: "In such a game of roulette, how do you keep from losing your bet?" Answer:
"There's another risk no less interesting to the third or fourth degree. And you don't have to
get burned: that is. . . ." Broodthaers appended a note to this response: "10,000 francs reward
to any reader who can replace the dots with a suitable formula."[79] Again we are faced by an
ambiguity that forces us to think. Does Broodthaers really know another way of calling art
into question than by continuing in the way he had pioneered? Is it in fact before us in the
catalogue or in the exhibition? What can it be? The whole article may be read as a work of
art, not as a straightforward explanation, since it raises questions but does not resolve them,
even though others, and I too, have used it quite literally. The exhibition title, *Catalogue-
Catalogus*, implies that the catalogue should be identified with the exhibition, not that it is
a description of it.

One of the features of the exhibition was a variation of the whole room that Broodthaers
had contributed to a group exhibition (*Carl Andre, Marcel Broodthaers, Daniel Buren . . .*)
at the Palais des Beaux-Arts a few months earlier: *Un jardin d'hiver* (*A Winter Garden*). It
comprises palm trees, borrowed for the occasion, and garden chairs, with prints of tropical
animals on the walls. It was a sort of setting, a decor, and was placed in contrast to another

78. For a complete English translation, see Broodthaers, transl. Schmidt, "Ten Thousand Francs Reward," pp. 39–48.
79. Ibid., p. 46.

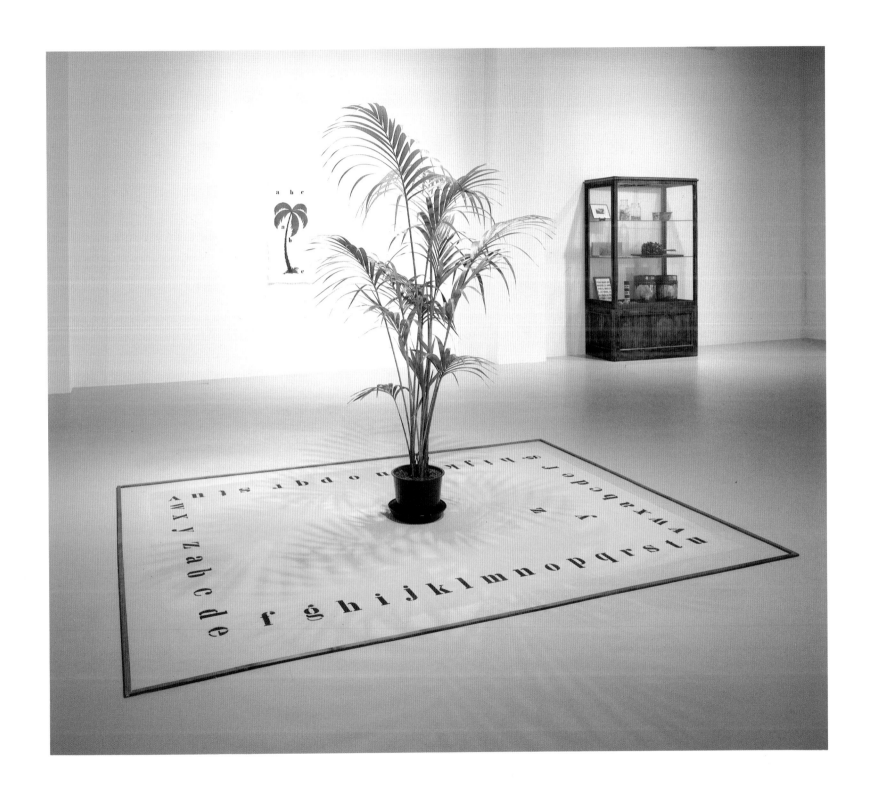

room in which paintings on the walls and objects in showcases confronted one another in conventional museum fashion. In *Un jardin d'hiver* one does not look for the hand of the artist in each object and might even overlook it in the whole. It was a sort of oasis in the aridity of the museum, but it was also calculated to elicit a nostalgia for that period when a promenade in a gallery like the Palais des Beaux-Arts was a comfortable weekend pleasure for the middle classes. It seems to manifest that point at which works of art lose their individuality to the context of the museum. In another room of the Palais, Broodthaers installed a kind of counterpart, *Le tapis de sable* (*The Sand Carpet*) (p.63). A single palm of umbrella shape was set in a carpet of sand, edged with the letters of the alphabet created in colored sand by an elderly craftsman, almost the last of his kind, using stencils. Perfectly executed, this piece was in a material that is proverbially ephemeral. Both *Le jardin* and the sand carpet are works of such an attractive quality that, above all, they do not invite the kinds of theoretical interpretation that I and others have given to Broodthaers's art.

In the room with the paintings and showcases was a convex mirror with a gilt frame of the Regency period. A work in itself, it reflects a reduced image of the whole room, comprehending it under the sign of the eagle, the frame's principal decorative motif. Mirrors occur quite regularly in Broodthaers's work, but this one, being convex, may be a reference to such mirrors in early Netherlandish paintings, especially the one in Van Eyck's *Arnolfini Wedding*, in which the subjects are seen in reverse with two figures representing probably either the artist and a friend or witnesses to the event (again perhaps Van Eyck and another). In the exhibition, the mirror reflects the viewer, likewise, as the witness of the work.

The next of Broodthaers's great exhibitions was in the Kunstmuseum Basel (Bâle in French). He wrote of it:

> I have invented a calf's head—said the artist . . .
>
> But it is a calf's head of gold—said the dealer
>
> Good heavens, that's true—said the museum director who remembers the priests of Baal.

Basel was of course the home of the great international Art Fair. The exhibition was called *Eloge du sujet* (*In Praise of the Subject*, honoring Erasmus's *In Praise of Folly*) and objects carried labels which recall Broodthaers's Magrittean preoccupations, for example, a palette is labeled "the pipe." At the entrance was *L'Entrée de l'exposition*. This installation work comprised palm trees and, on the walls, framed photographs of works forming a miniature retrospective and prints dealing with exhibitions and finance. It is at the same time a delightful decor and a critique of the conditions of art, for everything is presented as a quotation. One of the key elements is a design for a classical frame drawn on a panel that he found in the museum storage area. Within the frame he stenciled the letter "a" in oil paint. It is indeed a fine painting, but it is presented as an illustration and calls into question the relation between the "real" palms and the photographs of works, etc.

Broodthaers's exhibition in the Nationalgalerie, Berlin, a building designed by Mies van der Rohe, was called *Invitation pour une exposition bourgeoise.* He introduced it:

> Everything depends on its definition (that of art) and it is fragile, what will become of it, in fact, when the artist who paints or speaks is robed in a ceremonial costume? To be invited is to take part in official life. In Berlin I have the feeling that I am a diplomat. I must be efficient and better than a duck on the river Spree. That is the only way I have found to resolve the childish problem of being at the same time Belgian and Prussian.
>
> The definition of Berlin is just as fragile as that of art. If the artist is first of all an imitator of reality, an actor who has his point of contact with society by means of the intermediary of the art market, Berlin is a stage set [*décor*] in a troubled world. Berlin is the eye of the storm.
>
> You must know, reader, that the artist is more interested in the world outside than in art itself and still less in the content of exhibitions and in museums.[80]

He finishes by speaking of money and gold.

The exhibition was accompanied by a film, *Berlin oder ein Traum mit Sahne (Berlin or a Dream with Cream)*, which seems to have been the outcome of a project he had described to the curator, Karl Ruhrberg, in May 1973.[81] It was to have been based on filming in the basements of two art museums where large numbers of works are stored on shelves and in glass cases, out of sight of the public. This can be considered the real museum in relation to the small selection of masterpieces put on display. The theme was to be "museums and museography as I conceive them—beginning from a double negative." However, he goes on to think of filming instead Berlin's Isle of Peacocks, whose romantic character could be depicted as the fundamental backdrop (again *décor*) to the city. Broodthaers is himself present in the film, at a sunlit table with a green parrot. It is romantic, even nostalgic.

The exhibition contained many objects in museum glass cases. Among them are quite a few that seem to be associated with teaching children, such as late nineteenth- and early twentieth-century picture bricks. In some cases these were mixed up, as if they had been thrown like dice, so as to form random assortments of the pictures. They might be arbitrarily inscribed with stenciled letters of the alphabet. There were also heaps of jumbled letters, cut out carefully from the printed paintings, that is, the sets of nine canvases. The names of the exemplary writers and artists are quite scrambled and could be formed into the names of anything. Earlier, Broodthaers had condemned the support of institutions as pure chance, but in the seventies he saw it as "the only light that falls on an undertaking such as this one. It

80. Introduction published in Wallraf-Richartz-Museum/Museum Ludwig, *Marcel Broodthaers*, p. 12.
81. Ibid., p. 17.

liberates and at the same time lets one progress more or less casually, so that in an unexpected way one becomes aware of what one has taken on."

Back in England he arranged with Nicholas Serota, director of the Museum of Modern Art, Oxford, for an exhibition called *Le privilège de l'art*. The catalogue contains Broodthaers's short, often quoted statement in French and English, headed "Etre bien pensant ou ne pas être, être aveugle" ("To be a straight thinker [i.e., conventional, a 'square'] or not to be, to be blind.") Broodthaers says: "I do not believe it is legitimate to define Art other than in the light of one constant factor—namely, the transformation of art into merchandiseArt is a useless labor . . . [but] if the errors are mine I will derive a kind of guilty pleasure from the fact: a guilty pleasure because it would depend on victims—those people who have believed me to be right." This statement implies that art cannot be defined in terms such as truth, beauty, representation, subject matter, or medium, but it does not follow that these are themselves empty matters, only that they are not constant. If art is useless, the artist does it because he must. Others, on seeing it, may experience similar feelings. But Broodthaers seems to hope that his pessimistic view may be wrong.

At the London Institute of Contemporary Arts in April–June 1975, he created an exhibition *Décor: A Conquest by Marcel Broodthaers*. He described its theme as "the relationship of war to comfort."[82] The show contained modern automatic rifles, two antique cannons, a jigsaw puzzle of the Battle of Waterloo, artificial grass and garden furniture, together with other objects. The windows of the ICA overlook the Mall, along which pass the great ceremonial processions of state; the parade ground where the elite Guards Regiments Troop the Colour; and Green Park, where the civil servants watch the ducks on their lunch hour.

The guns exhibited were real and capable of being fired, so the title *Décor* seems ironic. The same word had appeared several times in Broodthaers's recent writings, where it seems to connote specifically a theater or film decor. For the ICA exhibition, many of the components were hired from a supplier of theater and film props, so the title can be taken literally. At the same time, the maker of "decor" recalls Magritte's account of seeing the world as a theater curtain hanging in front of him.[83] It implies illusion, unreality.

Broodthaers's exhibition is a sort of stage set, but where is the action? The film he based on it, *The Battle of Waterloo*, shows the objects in the exhibition and hands assembling the jigsaw puzzle, all but the last piece, while the soundtrack brings in through the windows the shouted commands and the music of the Trooping of the Colour. We hear Wagner's *Tristan und Isolde*. The sounds are martial but melancholy, redolent of the death of men long ago.

82. Press release for *L'Angélus de Daumier*, Centre National d'Art et de Culture, Paris, October 1975.
83. Magritte, "La ligne de vie."

Again, what is real? Is it the melancholy, the death or the conquest, is it today's ceremony or is it the work of art and its power over us?

Broodthaers's last great exhibition, *L'Angélus de Daumier* (October–November 1975), carries the theme of decor another step forward. The exhibition took place in a former Rothschild house, which had been converted into the galleries and offices of the Centre National d'Art et de Culture in the rue Berryer, Paris. Broodthaers, however, decided to incorporate the remaining luxurious interior, the salon of the Baronne de Rothschild, which could be looked at through a roped doorway.

Its counterpart in the exhibition was a reconstruction of half of the three petit bourgeois rooms in the rue de la Pépinière that had housed the *Département des Aigles*. This was made of unpainted plywood and pine; its inside surface was an exactly measured replica, while its outside looked like the back of a film set or even a packing case. It was as empty as the mussel and eggshells with which Broodthaers had started out. On its inner surface words from the vocabulary of the art world were scattered, elegantly painted by a sign writer. It was roped off and lit like a film set. Broodthaers had fancifully considered a reconstruction of the museum as early as the summer of 1969, when it was still open. He had thought of putting his packing cases in larger packing cases and of sending them to exhibit in another house like no. 30.[84] Now, he consented at first to a literal reconstitution of the museum and its objects but, perhaps because the times had changed, he decided instead to replace the packing cases and postcards with words.

Apart from these two set pieces, the exhibition contained paintings and objects singly or combined into greater works. Broodthaers described them in terms of a sort of fragmented continuity, "parallel to the method of working of cinematographic montage." He explains by means of an apparent paradox: "I have tried to put together objects and pictures created at dates ranging from 1964 to this year, in order to form rooms in the spirit of a decor. That is, to give back to the object or picture a real function. The decor not being an end in itself."[85] But he gives a more homely image too: "I have often made art in the way that one does one's mantelpiece." But Broodthaers wants, as always, to offer the alternatives of trenchancy and comfort.

The quantity, quality, variety, and imaginative brilliance of Broodthaers's work over the twelve years from the end of 1963 to the end of 1975 is astonishing, but one can still lament the works that were not achieved. One of these, a permanent writing room for Isy Fiszman,

84. Jacques Charlier, typescript letter to Broodthaers recording an interview with him, in the Broodthaers archive.
85. See note 81 above.

Décor

XXᵗʰ century →

Flower Ball/Décor 1975
dried flower, ribbon, printed card
ball: 24 cm. diameter
card: 45 x 45 cm.
Courtesy Galerie Isy Brachot,
Brussels

was devised in 1967, but most were conceived in the years of superabundance, 1972 to 1975. He proposed taking over the salon of the museum of Aachen, now housing a part of the Ludwig collection of modern art, and setting it up as a gaming room. This was in the period of the *Section Financière* of the *Département des Aigles*. He thought of exhibiting carpets and chocolates and other commodities in a commercial display case of a shopping arcade in Brussels, during the times when several nearby galleries would be having their openings. He began to negotiate an exhibition on a paddle steamer on the Vierwaldstattersee, Lucerne. He planned a gastronomic tour, following Mallarmé's accounts of visits to French towns and the menus sampled there. At the end he was talking about an exhibition of palm trees and pyramids for the museum at Ghent.

In spite of these unachieved projects, the character of the work of 1974–1975 gives one the feeling that in twelve years he had completed what he had set out to do in the field of visual art. In the last three months of 1975, he turned to shopping for food and cooking, something he had never done before.

In early 1976, he went to Cologne, saying to his family that he had some business there and would go to the hospital for a checkup, and insisting that they should stay behind in London. He took with him books by Gide, Villon, and Rabelais. After a few days, Maria followed. Many friends visited him in his hospital room and were welcomed genially; most of them departed apparently unaware of the danger of his condition.

After a few days in the hospital, Marcel Broodthaers died on his birthday, 28 January 1976, and was buried in Brussels.

He had given Maria no detailed instructions as to how to manage his artistic estate, although he was, of course, utterly conscious of the immense difficulty of the charge conveyed in his brief will made more than a year earlier. His larger works are made up of parts of different dates which may have been wholly made by himself, or adjusted by himself; they may have been made by others under his direction or merely chosen by him. They may have been at times parts of various other works. The insights and thoughts that link them are subtle, ironic, and parodoxical; the results very often deliberately ambiguous. His texts are poetic traps for the unsubtle, prejudiced, and unwary. Above all, everything he did and wrote is more than usually attached to time, place, and social context. All these characteristics make the judgment of what constitutes a complete work, and of what should be exhibited with what, much more difficult than is the case with the work of most painters and sculptors. Yet Broodthaers's work has the quality of self-definition and the permanent power to speak that distinguish great works of art in any medium. Thirteen years later, his work demands to be shown in exhibitions of contemporary art, even of art of the eighties.

Ne dites pas que je ne l'ai pas dit. (Do not say that I have not said it.)—Marcel Broodthaers, 1974

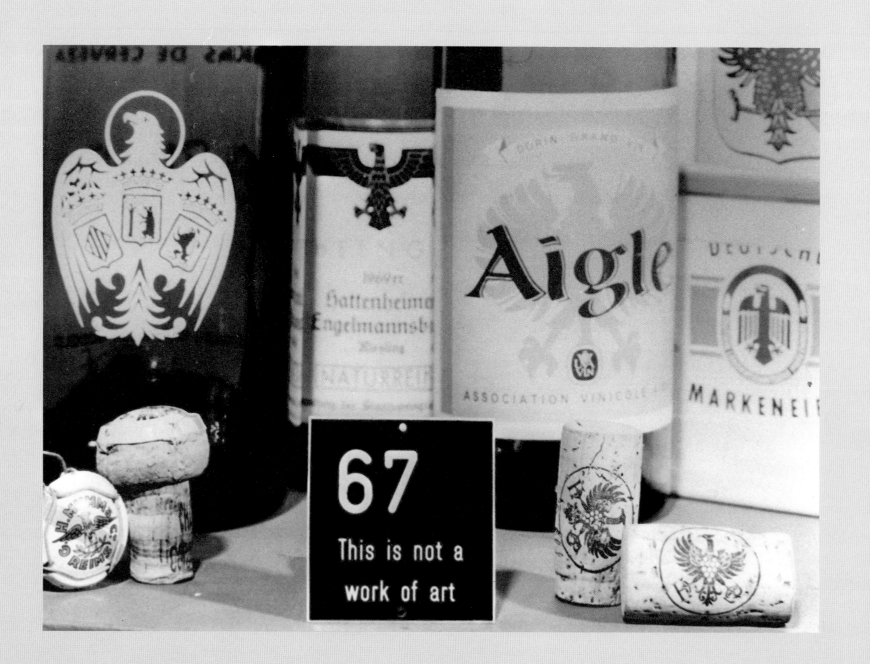

This Is Not a Museum of Art

Douglas Crimp

Fiction enables us to grasp reality and at the same time that which is veiled by reality.
—Marcel Broodthaers

One "fictions" history on the basis of a political reality that makes it true; one "fictions" a politics not yet in existence on the basis of a historical truth.—Michel Foucault

Contrary to the romantic ideal, the artist is not, like Marcel Broodthaers's "perfect" mussel, a "clever thing" that can "avoid society's mold and cast herself in her very own."[1] Thus when Broodthaers decided, in "mid-career," to become an artist, he offered two explanations. The first and most often quoted appeared as the text of an announcement for his 1964 exhibition at the Galerie Saint-Laurent in Brussels:

> I, too, wondered if I couldn't sell something and succeed in life. For quite a while I had been good for nothing. I am forty years old. . . . The idea of inventing something insincere finally crossed my mind, and I set to work at once.[2]

The second was written the following year and published in the Belgian journal *Phantomas:*

> In art exhibitions I often mused. . . . Finally I would try to change into an art lover. I would revel in my bad faith. . . . Since I couldn't build a collection of my own, for lack of even the minimum of financial means, I had to find another way of dealing with the bad faith that allowed me to indulge in so many strong emotions. So, said I to myself, I'll be a creator.[3]

While we might suspect "insincerity" and "bad faith" on the part of many "creators" nowadays, such negative qualities are rarely so frankly admitted as the necessary stance of

Musée d'Art Moderne, Département des Aigles, Section des Figures, Düsseldorf, 1972. Detail of the installation.

1. "This clever thing has avoided society's mold. / She's cast herself in her very own. / Other look-alikes share with her the anti-sea. / She's perfect;" Marcel Broodthaers, "The Mussel," transl. Michael Compton, in "Selections from *Pense-Bête*," *October*, no. 42 (Fall 1987), p. 27.
2. Marcel Broodthaers, text of exhibition announcement, Galerie Saint-Laurent, Brussels, 1964.
3. Marcel Broodthaers, "Comme du beurre dans un sandwich," *Phantomas*, nos. 51–61 (December 1965), pp. 295–296; quoted in Birgit Pelzer, "Recourse to the Letter," *October*, no. 42 (Fall 1987), p. 163.

the artist working under the conditions of late capitalism. By adopting these attitudes at the outset, however, Broodthaers was able to proceed as if his work as an artist were all part of a fictional ploy. Though it has often been noted that Broodthaers's curious artistic persona began with an acknowledgment of the commodity status of art, it has passed virtually unnoticed that it also entailed the frustration of being unable "to build a collection." This particular admission of "bad faith" may perhaps explain why Broodthaers would become not only a fictive "creator," but also a creator of "museum fictions." For, "with the canny clairvoyance of the materialist,"[4] he would reveal in these fictions the true historical conditions of collecting as they now exist.

———

In a cryptic entry in file "H" of his *Passagen-Werk*, Walter Benjamin jotted down the phrase "Animals (birds, ants), children, and old men as collectors."[5] The suggested biologism of this notation, implying as it does the existence of a *Sammeltrieb* (a primal urge to collect), could hardly be more surprising, especially insofar as Benjamin's assorted notes on the collector, and especially his essay on Eduard Fuchs, link collecting to the task of the historical materialist. This positive dimension of collecting is indicated, albeit negatively, in the following, also from file "H":

> The *positive* countertype of the collector—who at the same time represents his fulfillment, insofar as he realizes the liberation of things from the bondage of utility—should be described according to these words of Marx: "Private property has made us so stupid and passive that an object becomes *ours* only if we own it, that is, if it exists for us as capital, or if it is *used* by us [italics original]."[6]

For Benjamin, the true collector, the countertype of the collector as we know him, resists the demands of capital by rendering "useless" the objects he forms into a collection; the collector's countertype is thus able to unravel the secret historical meaning of the things he accumulates:

> In the act of collecting it is decisive that the object be dissociated from all its original functions in order to enter into the closest possible relationship with its equivalents. This is the diametric opposite of use, and stands under the curious category of completeness. What is this "completeness"? It is a grandiose attempt to transcend the totally irrational quality of a mere being-there through integration into a new, specifically created historical system—the collection. And for the true collector every single thing in this system becomes

4. Benjamin H. D. Buchloh, "Introductory Note," *October*, no. 42 (Fall 1987), p. 5.
5. Walter Benjamin, *Das Passagen-Werk* (Frankfurt am Main: Suhrkamp, 1982), vol. I, p. 280.
6. Ibid., p. 277. Marx's statement is further illuminated by another, which immediately follows it in Benjamin's notes: "The place of all physical and mental senses has been taken by the simple alienation of all these senses by the sense of possession."

an encyclopedia of all knowledge of the age, of the landscape, the industry, the owner from which it derives. The collector's most profound enchantment is to enclose the particular in a magic circle where it petrifies, while the final thrill (the thrill of being acquired) runs through it. Everything remembered and thought, everything conscious, now becomes the socle, the frame, the pedestal, and the seal of his ownership. One should not think that the collector, in particular, would be alienated from the *topos hyper-uranios*, which contains, according to Plato, the eternal Ideas of objects. Admittedly he loses himself. But he has the power to get back on his feet by grasping a straw, and out of the ocean of fog that blurs his mind the object just acquired emerges like an island. Collecting is a form of practical memory and, among the profane manifestations of "proximity," the most convincing one. Therefore, even the minutest act of political commemoration in the commerce in antiques becomes, in a sense, epochal. We are here constructing an alarm clock that awakens the kitsch of the past century into "re-collection."[7]

"Here" refers to the *Passagen-Werk* itself, and thus Benjamin designates his own projected materialist history of nineteenth-century Paris a collection (indeed it survives for us as nothing more than a collection of fragments, quotations, and notes). A portion of the above passage also appears in the autobiographical essay "Unpacking My Library," in which Benjamin had already described himself as a collector. It is also in this earlier essay that he prophesies the demise of this type, his role having been usurped by the *public* collection:

The phenomenon of collecting loses its meaning as it loses its personal owner. Even though public collections may be less objectionable socially and more useful academically than private collections, the objects get their due only in the latter. I do know that time is running out for the type that I am discussing here and have been representing before you a bit *ex officio*. But, as Hegel put it, only when it is dark does the owl of Minerva begin its flight. Only in extinction is the collector comprehended.[8]

If we find this concept of the positive countertype of the collector difficult to grasp, it is not only because the type has become extinct, but also because what has arisen in its stead are two distinct, though related phenomena. The first of these—the contemporary *private* collection, as opposed to Benjamin's *personal* collection—is amassed by that "stupid and passive" collector whose objects exist for him only insofar as he literally possesses and uses them. The second is the public collection, the museum. And it is this latter which gives us greatest difficulty in comprehending Benjamin's ideas, a difficulty that he himself acknowledges when he says that the public collection appears less objectionable socially, more

7. Ibid., p. 271.
8. Walter Benjamin, "Unpacking My Library," 1931, in *Illuminations*, transl. Harry Zohn (New York: Schocken Books, 1969), p. 67.

useful academically. Benjamin here alludes to the conventional, undialectical view of the museum as a progressive historical development, a view that is summed up in the title of a book of documents about the birth of public art institutions in the early nineteenth century, *The Triumph of Art for the Public.*[9] We can begin to understand the true meaning of this "triumph"—that is, who *within* the public benefited from it—by reading Benjamin's critique of the educational program of the Social Democratic Party at the turn of the century, which "raised the whole problem of *the popularization of knowledge.* It was not solved," according to Benjamin.

> And no solution could be approached so long as the object of this educational work was thought of as the *public* rather than as a class. . . . [The Social Democrats] thought the same knowledge that secured the rule of the bourgeoisie over the proletariat would enable the proletariat to free itself from that rule. In reality, knowledge with no outlet in praxis, knowledge that could teach the proletariat nothing about its situation as a class, was no danger to its oppressors. This was especially true of knowledge relating to the humanities. It lagged far behind economics, remaining untouched by the revolution in economic theory. It sought only to *stimulate*, to *offer variety*, to *arouse interest.* History was shaken up, to relieve monotony; the result was *cultural history* [italics original].[10]

This cultural history, to which Benjamin opposes historical materialism,[11] is precisely what the museum offers. It wrests its objects from their original historical contexts not as an act of political commemoration, but in order to create the illusion of universal knowledge. By displaying the products of particular histories in a reified historical continuum, the museum fetishizes them, which, as Benjamin says, "may well increase the burden of the treasures that are piled up on humanity's back. But it does not give mankind the strength to shake them off, so as to get its hands on them."[12] Herein lies the genuine difference between the collection as Benjamin describes it and the collection as we know it in the museum. The museum constructs a cultural history by treating its objects independently both of the material conditions of their own epoch and of those of the present. In Benjamin's collection, objects are also wrested

9. Elizabeth Gilmore Holt, ed., *The Triumph of Art for the Public* (Garden City, New York: Doubleday/ Anchor Books, 1979).

10. Walter Benjamin, "Eduard Fuchs, Collector and Historian," 1937, in *One-Way Street and Other Writings*, transl. Kingsley Shorter (London: New Left Books, 1979), pp. 355–356 .

11. Since Engels's 1892 definition of historical materialism as "that view of the course of history which seeks the ultimate cause and the great moving power of all important historical events in the economical development of society, in the changes in the modes of production and exchange, in the consequent division of society into distinct classes, and in the struggle of those classes against one another," the concept has been the subject of considerable debate within Marxist theory, especially regarding the notion of an "ultimate cause." Walter Benjamin's materialist conception of history— elaborated throughout his writings and the subject of his last completed text, "Theses on the Philosophy of History" (in *Illuminations*, pp. 253–264)—is one of the most subtle and complex in all of Marxist thought.

12. Benjamin, "Edward Fuchs, Collector and Historian," p. 361.

from history, but they are "given their due," re-collected in accordance with the political perception of the moment. Thus the difference:

> Historicism presents an eternal image of the past, historical materialism a specific and unique engagement with it. . . . The task of historical materialism is to set to work an engagement with history original to every new present. It has recourse to a consciousness of the present that shatters the continuum of history.[13]

It is just this consciousness of the present, and the specific and unique engagement with the past determined by such consciousness, that brought about Marcel Broodthaers's museum fictions. Broodthaers himself could no longer perform the task of the historical materialist in the guise of the collector's countertype. Instead, as we shall see, he commemorated the loss of this outmoded figure by assuming another guise—the "countertype" of the museum director. Beginning with the *Section XIXème Siècle*, Broodthaers founded his *Musée d'Art Moderne, Département des Aigles*, "under pressure of the political perception of its time."[14] "This invention, a jumble of nothing, shared a character connected to the events of 1968, that is, to a type of political event experienced by every country."[15] The "museum" was inaugurated only a few months after May 1968, when Broodthaers had participated with fellow artists, students, and political activists in an occupation of the Palais des Beaux-Arts in Brussels. Acting in solidarity with the political manifestations taking place throughout Europe and the United States,[16] the occupiers declared their takeover of the museum to be a contestation of the control over Belgian culture exerted by its official institutions, as well as a condemnation of a system that could conceive of culture only as another form of capitalist consumption.[17]

But in spite of his participation in a political action with these explicit goals, it is not immediately apparent how Broodthaers intended his fictive museum to "share in their character." At the end of the occupation Broodthaers wrote an open letter addressed "A mes amis" and dated "Palais des Beaux-Arts, June 7, 1968." It began:

13. Ibid., p. 352.

14. Marcel Broodthaers, open letter on the occasion of Documenta 5, Kassel, June 1972.

15. Marcel Broodthaers, in a conversation with Jürgen Harten and Katharina Schmidt, circulated as a press release on the occasion of the exhibition *Section des Figures (Der Adler vom Oligozän bis Heute)*, Städtische Kunsthalle, Düsseldorf, 1972; quoted in Rainer Borgemeister, "*Section des Figures:* The Eagle from the Oligocene to the Present," *October*, no. 42 (Fall 1987), p. 135.

16. Broodthaers actually specifies—in an open letter datelined Kassel, 27 June 1968 (reprinted in *Museum in Motion: Museum in Beweging: Het Museum voor Moderne Kunst ter Discussie* [The Hague: 1979], p. 249), and, with some deletions, in the plastic plaque related to it and entitled *Tirage illimité (Le Noir et le Rouge)*, 1968—a number of cities in which the political activities of 1968 took place: "Amsterdam, Prague, Nanterre, Paris, Venice, Brussels, Louvain, Belgrade, Berlin, and Washington"; see Benjamin H. D. Buchloh, "Open Letters, Industrial Poems," *October*, no. 42 (Fall 1987), pp. 85–87.

17. See the documents published in facsimile in *Museum in Motion*, p. 248.

Calm and silence. A fundamental gesture has been made here that throws a vivid light on culture and on the ambitions of certain people who aspire to control it one way or another: what this means is that culture is an obedient material.

What is culture? I write. I have taken the floor. I am a negotiator for an hour or two. I say I. I reassume my personal attitude. I fear anonymity. (I would like to control the *meaning/direction [sens]* of culture.)[italics original].[18]

Recognizing that culture is obedient to those who would exert control over it, Broodthaers also recognizes that he, too, would like to exert such control. Having taken up the profession of the artist, as he had self-consciously done only four years earlier, and now participating in the occupation of the museum, Broodthaers wavers between his role as negotiator and the resumption of a personal attitude, a fundamentally duplicitous position. He ironically restates this duplicity in the letter that announces, exactly three months later, the opening of his museum. While the occupiers of the Palais des Beaux-Arts had specifically contested the power of the ministers of culture, Broodthaers makes his announcement under the ministers' auspices, typing as a heading of his letter: "Cabinet des Ministres de la Culture. Ostende, le 7 sept. 1968,"[19] and signing it "Pour l'un des Ministres, Marcel Broodthaers." The text of the letter reads:

We have the pleasure of announcing to the customers and the curious the opening of the "Département des Aigles" of the Musée d'Art Moderne.

The works are in preparation; their completion will determine the date at which we hope to make poetry and the plastic arts shine hand-in-hand.

We hope that our formula "Disinterestedness plus admiration" will seduce you.[20]

The suggestion that a museum might wish to seduce "customers and the curious" by employing the mock-Kantian formula "disinterestedness plus admiration" is perhaps the most elliptical yet precise critique of institutionalized modernism ever offered. But once again Broodthaers implicates himself in this game of seduction.

One further letter (which, as Benjamin Buchloh has shown, became the basis, with significant alterations, for the "industrial poem" entitled "Museum"), precedes the actual opening of the *Musée d'Art Moderne.* The first open letter to be datelined from one of the museum's various departments—in this case "Département des Aigles"—it provides another instance of Broodthaers's contradictory position:

18. Open letter, datelined Palais des Beaux-Arts, 7 June 1968, addressed "A mes amis," published in *Museum in Motion,* p. 249.

19. The sea resort Ostend is, as Benjamin Buchloh has written, "the least likely place in Belgium for the offices of the ministers of culture to be found"; "Open Letters, Industrial Poems," p. 91.

20. Open letter, Ostend, 7 September 1968; published in *Museum in Motion,* p. 249.

I feel solidarity with all approaches that have the goal of objective communication, which presupposes a revolutionary critique of the dishonesty of those extraordinary means that we have at our disposal: the press, radio, black [*sic*] and color television.

But what can be meant by "objective communication" in a letter that begins:

MUSEUM

. . . A rectangular director. A round servant . . .

. . . A triangular cashier. A square guard . . .

and then ends

. . . no people allowed. One plays here everyday until the end of the world.[21]

A week later the *Musée d'Art Moderne, Département des Aigles, Section XIXème Siècle* "officially" opened in Broodthaers's house/studio at 30, rue de la Pépinière in Brussels. Despite (or perhaps confirming?) the warning "no people allowed,"[22] some sixty invited art-world personalities attended the event, in which an inaugural address was given by Johannes Cladders, director of the Städtisches Museum in Mönchengladbach. What was there for these guests to see were empty picture crates borrowed for the occasion from Menkes Continental Transport and stenciled with such typical warning signs as "keep dry," "handle with care," and "fragile"; together with forty postcards of nineteenth-century French paintings by such "masters" as David, Ingres, Courbet, Meissonnier, and Puvis de Chavannes. A ladder leaned against a wall, numbers on doors appeared to designate rooms as galleries, and the words "musée/museum" were inscribed on the windows, readable from the outside. During the event slides of prints by Grandville were projected.

Broodthaers himself described the *Section XIXème Siècle* in an open letter of two months later:

Poem

I am the director. I don't care. Question? Why do you do it?

Politics

The Département des Aigles of the Musée d'Art Moderne, Section XIXème Siècle, was in fact inaugurated on the 27th of September, 1968, in the presence of leading representatives of the public and the military. The speeches were on the subject of the fate of Art (Grandville). The speeches were on the subject of the fate of Art (Ingres). The speeches

21. Open letter, Düsseldorf, 19 September 1968, published in *Museum in Motion*, p. 250.

22. Because we lack the French Revolutionary tradition, *people* does not carry the political connotations of *peuple*, which could also be translated as "the masses, the multitude, the crowd, the lower classes." Benjamin Buchloh, "Open Letters, Industrial Poems," p. 96, notes the difference between the text of the open letter and that of the plastic plaque entitled *Museum*, 1968: "The statement 'people are not admitted'—ringing with connotations of class and politics—is changed in the plaque version to the more grotesque and authoritarian 'Children are not admitted.'"

Paris, le 29 novembre 1968.

Chers Amis,

 Mes caisses sont vides. Nous sommes au bord du gouffre.
Preuve: Quand je n'y suis pas, il n'y a personne. Alors?
Assumer plus longtemps mes fonctions? Le système des musées
serait-il aussi compromis que celui des galeries? Cependant,
notez que le Département des Aigles est encore indemne bien
que l'on s'efforce à le détruire.
 Chers amis, mes caisses sont superbes; ici un peintre
célèbre, là un sculpteur connu, plus loin une inscription qui
fait prévoir l'avenir de l'Art. Vive l'histoire d'Ingres!
Ce cri résonne au fond de ma conscience. Cri de guerre. Je suis
en péril. Je renonce à vous donner des explications qui
m'exposent à un péril supplémentaire

P o è m e

Je suis le directeur. Je m'en fous. Question ?
Pourquoi le faites-vous ?

P o l i t i q u e

Le département des aigles du musée d'art moderne, section XIXe
siècle, a été effectivement inauguré le 27 septembre 1968 en
présence de personnalités du monde civil et militaire. Les
discours ont eu pour objet le destin de l'Art.(Grandville). Les
discours ont eu pour objet le destin de l'Art.(Ingres). Les
discours ont eu pour objet le rapport entre la violence institu-
tionalisée et la violence poétique.
 Je ne veux, ni ne peux vous exposer les détails, les soupirs,
les étoiles, les calculs de cette discussion inaugurale. Je le
regrette.

I n f o r m a t i o n

Grâce au concours d'une firme de transport et de quelques amis,
nous avons pu composer ce département qui comprend en ordre
principal: 1/ des caisses
 2/ des cartes postales "surévaluées"
 3/ une projection continue d'images (à suivre)
 4/ un personnel dévoué.

Chers amis, je suis désolé du trop long silence dans lequel je
vous ai laissés depuis mes lettres datées de
Je dois, pour l'instant, vous quitter.Vite, un mot d'affection,

 votre Marcel Broodthaers.

P.S.Mon ordre, ici, dans l'une des villes de Duchamp est peuplé
 de poires; on en revient à Grandville.
Correspondance: Musée d'Art Moderne, Département des Aigles,
 30 rue de la Pépinière,Bruxelles 1. Tél.02/12.09.54

were on the subject of the relationship between institutional and poetic violence. I cannot and will not discuss the details, the sighs, the high points, and the repetitions of these introductory discussions. I regret it.

Information
Thanks to the cooperation of a shipping company and of several friends, we have been able to create this department, which includes primarily the following:
1) crates
2) postcards "overvalued"
3) a continuous projection of images (to be continued)
4) a devoted staff [23]

Two fundamental aspects of Broodthaers's initial museum installation, both relating directly to other facets of his work, are crucial: its focus on the artwork's institutional framing conditions and its fascination with the nineteenth century. The first of these is signaled—quite obviously—by the presence of the means of transport and installation; by the pretense of the art opening, including letter of announcement, invitation, *buffet froid*, and inaugural address; by the postcards (the museum's reminder of the "overvaluation" of art that makes it an object of luxury consumption);[24] and by the very designation of the artist's home and studio as a museum. Conflating the site of production with that of reception, Broodthaers reveals their interdependence and calls into question the ideological determination of their separation: the bourgeois liberal categories *private* and *public*.[25]

Broodthaers's return to the past, evidenced by the title of the museum section, by the paintings reproduced on the postcards, and by Grandville—this "altogether dated aura of 19th century bourgeois culture that many of his works seem to bring to mind might easily seduce the viewer into dismissing his works as being obviously obsolete and not at all concerned with the presuppositions of contemporary art."[26] On the contrary, however, it is in this very preoccupation—shared by Walter Benjamin in many of its points of reference (Baudelaire, Offenbach, Grandville; advertising, fashion)—that we can most clearly see Broodthaers's consciousness of the present. For it was precisely in the early nineteenth

23. Open letter, Paris, 29 November 1968, addressed "Chers Amis."
24. "Is a picture post card of a painting by Ingres worth a couple million?"; Broodthaers, quoted in Benjamin H. D. Buchloh, "Formalism and Historicity—Changing Concepts in American and European Art since 1945," in *Europe in the Seventies: Aspects of Recent Art*, exh. cat. (Chicago: The Art Institute of Chicago, 1977), p. 98.
25. See my essay "The End of Art and the Origin of the Museum," *Art Journal*, vol. 46 (Winter 1987), pp. 261–266, in which I discuss the opposition to Alois Hirt's conflation of *studio* and *museum* on the frieze inscription of Berlin's Altes Museum.
26. Buchloh, "Formalism and Historicity," p. 98.

Open letter, Paris, 29 November 1968

century that the "romantic disposition," to which Broodthaers constantly points as the source of contemporary attitudes about culture, took hold of art and provided it with an always-ready alibi for its alienation from social reality. And it was at the same time that the museum arose to institutionalize that alibi. The idealist conception of art, the classificatory systems imposed upon it, the construction of a cultural history to contain it—all of these were secured by the museum as it developed during the past century. And this institutional "overvaluation" of art produced a secondary effect, which Benjamin called "the disintegration of culture into commodities"[27] and Broodthaers referred to as "the transformation of art into merchandise."[28] This, as Benjamin wrote and as Broodthaers presumably recognized, "was the secret theme of Grandville's art."[29]

The dilemma of contemporary art in the late sixties—as it attempted to break this double stranglehold of the museum and the marketplace and become engaged in the political struggles of its time—had its origin in the nineteenth century. Working as an archaeologist of the present, Broodthaers would uncover that point of origin in his four-year-long fiction, whose first episode was the *Section XIXème Siècle.*

––––––––––

Throughout the year that the *Section XIXème Siècle* remained open, and continuing until the "closing" of the *Musée d'Art Moderne* at Documenta 5 in 1972, Broodthaers periodically issued open letters written under his museum's letterhead. (The letterhead varies from the hand-written or rubber-stamped "Département des Aigles" to the typed or typeset "Musée d'Art Moderne, Section Littéraire, Département des Aigles.") The last group of letters

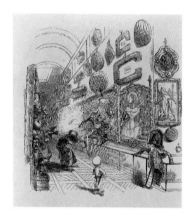

J.J. Grandville
An Exhibition Gallery, illustration
from *Un autre monde* (Paris: 1844)

27. Benjamin, "Eduard Fuchs," p. 360.

28. Marcel Broodthaers, "To be *bien pensant* . . . or not to be. To be blind," transl. Paul Schmidt, *October,* no. 42 (Fall 1987), p. 35.

29. "The correlative to this [enthronement of the commodity] was the ambivalence between its utopian and its cynical element. Its refinements in the representation of dead objects corresponded to what Marx calls the 'theological capers' of the commodity. They took clear shape in the *spécialité:* under Grandville's pencil, a way of designating goods which came into use around this time in the luxury industry transformed the whole of Nature into specialities. He presented the latter in the same spirit in which advertisements—this word too [*réclames*] came into existence at that time—were beginning to present their wares. He ended in madness"; Walter Benjamin, "Paris—the Capital of the Nineteenth Century," in Benjamin, *Charles Baudelaire: A Lyric Poet in the Era of High Capitalism,* transl. Harry Zohn (London: New Left Books, 1973), p. 165. See also file "G," "Ausstellungswesen, Reklame, Grandville," in *Das Passagen-Werk,* pp. 232–268.

comprises the fictive museum's *Section Littéraire*.[30] As if in accord with Walter Benjamin's specification of the task of the historical materialist—"to set to work an engagement with history original to every new present"—a central feature of some of these letters is the reflection upon and revision of previous activities, works, and statements.[31] Their often comic and contradictory tone masks a considerably more serious, consistent (and probably impossible) endeavor: to keep pace with the culture industry's extraordinary capacity to outmaneuver the individual producer. But Broodthaers's running commentary is not limited to his own production; it extends as well to that of his colleagues. "In the visual arts," he said, "my only possible engagement is with my adversaries."[32] Indeed, working at the moment of Conceptual Art, into which category Broodthaers's work was sometimes shoehorned, the *Section Littéraire* can be read as a critique of Conceptualism's often naive claims to have escaped the dominant mechanisms of art's institutionalization, dissemination, and commercialization.[33] Broodthaers counterposes the very designation "literary," again with its "pejorative," archaic ring, to the supposed innovation of "art as idea" or "art as language."

––––––––––

The ceremony to mark the closing of the *Musée d'Art Moderne*'s *Section XIXème Siècle* in 1969 was conducted at Broodthaers's Brussels home. The *Section XVIIème Siècle* opened

30. Because Broodthaers's museum was a fiction, it is sometimes difficult to decide what comprises one of its "real" sections and what exists merely as a matter of Broodthaers's elliptical pronouncements. Thus we can only say that the *Section Littéraire* exists insofar as Broodthaers used this rubric on his letterhead from time to time. On the two occasions that Broodthaers himself specified the sections of his museum—on the announcement of the *Section Cinéma* in 1971 and in the second volume of the catalogue of the *Section des Figures* in 1972—he lists only the following: *Section XIXème Siècle*, Brussels, 1968; *Section XVIIème Siècle*, Antwerp, 1969; *Section XIXème Siècle (Bis)*, Düsseldorf, 1970; *Section Cinéma*, Düsseldorf, 1971; *Section des Figures*, Düsseldorf, 1972. In addition to these, however, there were also the *Section Financière* at the Cologne Art Fair in 1971 and the *Section Publicité*, the *Section d'Art Moderne*, and the *Musée d'Art Ancien, Galerie du XXème Siècle* at Documenta 5, Kassel, in 1972. The announcement for the exhibition of Broodthaers's plastic plaques at the Librarie Saint-Germain des Prés in 1968 identified another section in the following manner: "M.U.SE.E .D'.A.R.T., CAB.INE.T D.ES. E.STA.MP.E.S. Département des Aigles." Broodthaers also mentions a *Section Documentaire* (for which he thanks Herman Daled) in *Marcel Broodthaers: Catalogue/Catalogus*, exh. cat. (Brussels: Palais des Beaux-Arts, 1974), p. 26; and a *Section Folklorique* appears on the list of museum sections in several posthumously published catalogues.

31. For an in-depth analysis of the open letters, see Pelzer, "Recourse to the Letter."

32. Marcel Broodthaers, "Ten Thousand Francs Reward," transl. Paul Schmidt, *October*, no. 42 (Fall 1987), p. 45. Broodthaers reserved his most pointed political criticism for one colleague in particular—Joseph Beuys. For an analysis of Broodthaers's letter to Beuys—written in the form of a "found" letter from Offenbach to Wagner—regarding the cancellation of Hans Haacke's exhibition at the Guggenheim Museum in 1971, see Stefan Germer, "Haacke, Broodthaers, Beuys," *October*, no. 45 (Summer 1988), pp. 63–75. Broodthaers also made his first announcement of his "museum" in a letter to Beuys of July 14, 1968, in which he wrote: "We announce here the creation of the Musée d'Art Moderne in Brussels. No one believes it."

33. This aspect of Broodthaers's open letters has been extensively argued by Benjamin Buchloh in his various writings on Broodthaers; see especially "Formalism and Historicity" and "Open Letters, Industrial Poems."

immediately thereafter at A 37 90 89, an alternative space in Antwerp. An invitation to the event announced that a bus would be provided to take the guests to Antwerp—"From Brussels to Antwerp is fifty kilometers. Not enough time to reflect upon this museum. So I thought in parentheses without words inside."[34] Consisting of similar objects to those of the museum in the rue de la Pépinière in Brussels, this new section substituted postcard reproductions of works by Rubens for those by nineteenth-century painters. It remained open for a week.

Several months later, the nineteenth-century section reappeared in a different guise (and only for two days) as the *Section XIXème Siècle (Bis)* in the exhibition *between 4* at the Städtische Kunsthalle in Düsseldorf. For this "continuation" of the nineteenth-century section Broodthaers selected and installed eight nineteenth-century paintings borrowed from the Kunstmuseum Düsseldorf, thereby briefly lending the temporary exhibition space the appearance of a museum gallery.[35] With the paintings stacked in two rows of four, Broodthaers's installation recalls nineteenth-century hanging methods; but his arrangement of pictures according to size and shape also suggests a prior museological moment in the eighteenth century, when picture galleries constituted a kind of "decor." Like many of Broodthaers's interventions, the *Section XIXème Siècle (Bis)* is a mere gesture, but its resonances are far-reaching. Much of the present-day flurry of museum activity consists of a similar reordering of fetish-objects, whether permanent collections or loans—reconfigurations that only demonstrate that the museum's construction of cultural history can undergo ever new permutations without disrupting the ideology of historicism. One has only to think, as regards the particular century of Broodthaers's interest, of the new Musée d'Orsay in Paris, a "Section XIXème Siècle" of ultimate proportions. Objects transported across the Seine from the Louvre and the Jeu de Paume and appropriated from the French provinces are now regrouped in a setting of such grandiosity as to nullify political recollection all the more fully.[36]

———————

Broodthaers's fictive museum materialized next as the *Section Cinéma* at Haus Burgplatz 12 in Düsseldorf. The announcement card stated that, beginning in January 1971, "didactic films" would be shown every Thursday from two to seven p.m. Around the periphery of the basement room that housed the *Section Cinéma*, Broodthaers displayed a number of disparate objects, labeling each with a stenciled figure number or letter—"fig. 1," "fig. 2," "fig. A"—as

34. Marcel Broodthaers, open letter, Antwerp, 10 May 1969, addressed "Chers amis."

35. Because, outside of Germany, the functions of the art museum (housing a collection) and that of the art exhibition hall (mounting temporary exhibitions) are generally fulfilled by the same institution, Broodthaers's conversion of the one into the other loses much of its meaning in our context. It should also be noted that the Kuns*thalle* is as much a nineteenth-century development as is the Kuns*tmuseum*.

36. See Patricia Mainardi, "Postmodern History at the Musée d'Orsay," *October*, no. 41 (Summer 1987), pp. 31–52.

if they were intended as illustrations in an old encyclopedia. The objects thus "didactically" marked included a light bulb, a chair, the 12 September page of a daily calendar, an accordion case, and a film splicer. A copy of Georges Sadoul's *L'Invention du Cinéma* was placed in a trunk with other objects. A carpentered piano case labeled "Les Aigles" stood against a wall carrying the inscriptions "Musée" and "Museum." Recalling the later reinstallation of certain of these objects in the Mönchengladbach museum, Broodthaers enumerated still others: "a cardboard box, a clock, a mirror, a pipe, also a mask and a smokebomb."[37] In this odd assortment we again see the musty charm of the nineteenth century, the time, indeed, of the "invention of cinema."[38] In addition, we see for the first time among the museum fictions the formation of a *collection*. Because Benjamin's "countertype of the collector" has now become extinct, however, Broodthaers can only conjure up his image with the willful gesture of appending a figure number to each object. "If we are to believe what the inscription says," Broodthaers remarked, "then the object takes on an illustrative character referring to a kind of novel about society."[39] But can we believe it? Or does the *Section Cinéma* only commemorate that type of collection in which "the object is dissociated from its original functions" so that "every single thing becomes an encyclopedia of all knowledge of the age. . ."?

———

Broodthaers's most literal embodiment of the confession that he would become a creator in order to compensate for his inability to be a collector is the work entitled *Ma collection* (1971; p. 84), a "collection" of documents of exhibitions in which the artist had participated, each provided, once again, with a figure number. The work was exhibited at the Wide White Space Gallery in the 1971 Cologne Art Fair. At the same time, "due to bankruptcy," the *Musée d'Art Moderne* was put up for sale under the aegis of its *Section Financière*. The offering was made in the form of a special edition of nineteen copies of the art fair catalogue, each wrapped with a book jacket stating: *Musée d'Art Moderne à vendre, 1970 bis 71, pour cause de faillite.* Evidently, though, the museum didn't find a buyer,[40] because its most ambitious manifestation, the *Section des Figures*, opened the following summer at the Städtische Kunsthalle in Düsseldorf.

———

The *Section des Figures* comprised more than three hundred objects representing eagles, borrowed from forty-three "real" museums as well as from private collections, including

37. Broodthaers, transl. Schmidt, "Ten Thousand Francs Reward," p. 43.
38. As Broodthaers said, "I would never have obtained this kind of complexity with technological objects, whose singleness condemns the mind to monomania: minimal art, robot, computer"; ibid.
39. Ibid.
40. The offering itself, however, did. The nineteen catalogues specially marked by Broodthaers were sold to Michael Werner.

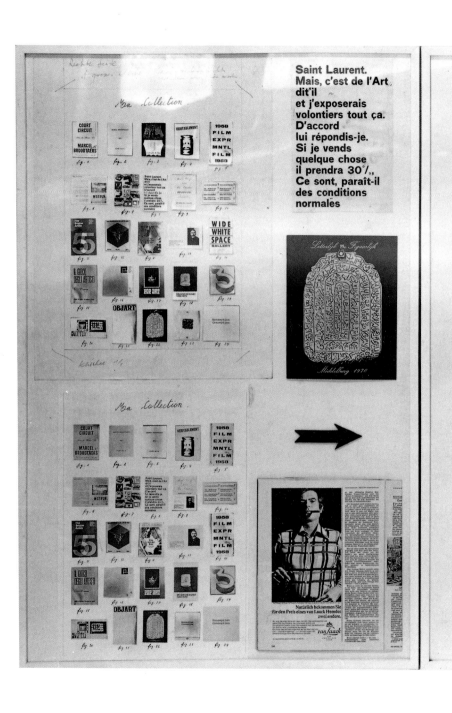

Saint Laurent.
Mais, c'est de l'Art
dit'il
et j'exposerais
volontiers tout ça.
D'accord
lui répondis-je.
Si je vends
quelque chose
il prendra 30%.
Ce sont, paraît-il
des conditions
normales

f i g.0

Broodthaers's own, and ranging in date "from the Oligocene to the present." Shown in glass cases and vitrines, hung on walls, or freestanding, each object was provided with a label stating, in English, French, or German, "This is not a work of art"—"a formula obtained by the contraction of a concept by Duchamp and an antithetical concept by Magritte."[41] Under the heading "Method" in the first of the exhibition's two catalogue volumes, these two concepts—the readymade and what Michel Foucault, in his text "Ceci n'est pas une pipe," called the "broken calligram"—are illustrated with reproductions of Duchamp's *Fountain* and Magritte's *La trahison des images*.[42] Following these, Broodthaers writes:

> The public is confronted here with the following art objects: eagles of all kinds, some of which are fraught with weighty symbolic and historical ideas. The character of this confrontation is determined by the negative inscription: "This is not . . . this is not a work of art." This means nothing other than: Public, how blind you are!
>
> Thus, either-or: either information on so-called modern art has played an effective role, in which case the eagle would inevitably become part of a method; or the inscription appears as mere nonsense—that is, it does not correspond to the level of discussion concerning, for example, the validity of the ideas of Duchamp and Magritte—and then the exhibition simply follows the classical principles: the eagle in art, in history, in ethnology, in folklore. . . . [43]

Two readings are possible, depending on how efficacious modern art has been: either Broodthaers's museum opposes cultural history, or it is simply another instance of it, taking the eagle as its subject.[44]

The *Section des Figures* is Broodthaers's most "complete" collection, "a grandiose attempt," indeed, as Benjamin put it, "to transcend the totally irrational quality of a mere being-there through integration into a new, specifically created historical system. . . ." And this new system has an "epochal" goal: the nullification of another. As Duchamp's readymades made clear, the function of the art museum (as of the artist working within its discursive authority) is to declare, in regard to each of the objects housed there: "This is a work of art." Broodthaers's labels reverse this proposition through the application of

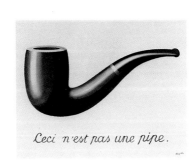

René Magritte
La trahison des images (Ceci n'est pas une pipe) c. 1928–29
oil on canvas
60 x 81.3 cm.
Collection Los Angeles County
Museum of Art
Purchased with funds provided by
the Mr. and Mrs. William Preston
Harrison Collection

(opposite)
Ma collection 1971
photographs and documents
on two cards
each 100 x 65 cm.
Collection Uli Knecht

41. Broodthaers, transl. Schmidt, "Ten Thousand Francs Reward," p. 47.
42. Marcel Broodthaers, "Methode," in *Der Adler vom Oligozän bis Heute*, exh. cat. (Düsseldorf: Städtische Kunsthalle, 1972), vol. I, pp. 11–15; see also *October*, no. 42 (Fall 1987), pp. 152–153. Under Magritte's name in this section on method, Broodthaers simply writes: "Read the text by M. Foucault 'Ceci n'est pas une pipe'"; see Michel Foucault, "Ceci n'est pas une pipe," transl. Richard Howard, *October*, no. 1 (Spring 1976), pp. 7–21.
43. Marcel Broodthaers, "Adler, Ideologie, Publikum," in *Der Adler vom Oligozän bis Heute*, vol. I, p. 16.
44. Broodthaers gives some sense of how well the lessons of modern art have been learned by printing the comments of visitors to the exhibition in the second volume of the catalogue; see "Die Meinung des Publikums," in ibid., vol. II, pp. 8–12.

*Musée d'Art Moderne, Département
des Aigles, Section des Figures*
Installation view.

Magritte's linguistic formula "Ceci n'est pas une pipe." The museum's "this is a work of art"—apparently tautological—is exposed as an arbitrary *designation*, a mere representation.[45]

 "The concept of the exhibition," Broodthaers wrote, "is based on the identity of the eagle as an idea with art as an idea."[46] But the result of "the eagle as an idea" is in this case such a vast diversity of objects—from paintings to comic strips, from fossils to typewriters, from ethnographic objects to product logos—that their juxtaposition can only seem "surreal." When asked, however, if "this sort of claim to embrace artistic forms as far distant from one another as an object can be from a traditional painting" did not remind him of "the encounter of a sewing machine and an umbrella on an operating table," Broodthaers merely remarked upon the museum's system of classification:

45. For a more complete discussion of Broodthaers's "method," see Borgemeister, *"Section des Figures:* The Eagle from the Oligocene to the Present."
46. Marcel Broodthaers, "Section des Figures," in *Der Adler vom Oligozän bis Heute*, vol. II, p. 19. Broodthaers's identification of art and eagle suggests a linguistic substitution to which he never specifically alluded. In French, the phrase "Il n'est pas un aigle" means "he's no genius." We might therefore assume that "Ceci n'est pas un objet d'art," accompanied by the image or object representing an eagle, negates the common association of art with genius. For the most part, Broodthaers's remarks on the eagle link it, however, not with genius, but with power. See, for example, his various pronouncements on the eagle in ibid., pp. 18–19.

> A comb, a traditional painting, a sewing machine, an umbrella, a table may find a place
> in the museum in different sections, depending upon their classification. We see sculpture
> in a separate space, paintings in another, ceramics and porcelains . . . , stuffed
> animals. . . . Each space is in turn compartmentalized, perhaps intended to be a
> section—snakes, insects, fish, birds—susceptible to being divided into departments—
> parrots, gulls, eagles.[47]

The *Section des Figures* demonstrates the oddness of the museum's order of knowledge by presenting us with another, "impossible" order. In this, Broodthaers's fiction recalls Foucault's "archaeology," the initial term for the method he devised to oppose cultural history. *The Order of Things*, Foucault tells us,

> arose out of a passage in Borges, out of the laughter that shattered, as I read the passage,
> all the familiar landmarks of my thought—*our* thought. . . . This passage quotes a "certain
> Chinese encyclopedia" in which it is written that "animals are divided into: (a) belonging
> to the Emperor, (b) embalmed, (c) tame, (d) sucking pigs, (e) sirens, (f) fabulous,
> (g) stray dogs, (h) included in the present classification, (i) frenzied, (j) innumerable,
> (k) drawn with a very fine camelhair brush, (l) et cetera, (m) having just broken the water
> pitcher, (n) that from a long way off look like flies." In the wonderment of this taxonomy,
> the thing we apprehend in one great leap, the thing that, by means of the fable, is
> demonstrated as the exotic charm of another system of thought, is the limitation of our
> own, the stark impossibility of thinking *that*.[48]

It is impossible to think *that*, Foucault explains, because Borges "does away with the *site*, the mute ground upon which it is possible for entities to be juxtaposed. . . . What has been removed, in short, is the famous 'operating table.'"[49] The purpose of Foucault's archaeology is to show that the site that allows us to juxtapose heterogeneous entities is that of discourse, and that discursive formations undergo historical mutations of such magnitude as to render them entirely incompatible with one another. At the same time, Foucault explains that our own historicizing system of thought, which arose in the beginning of the nineteenth century, forces knowledge into a continuous chronological development that effectively conceals the incompatibility.[50] Our cultural history universalizes—and ultimately *psychologizes*—all

47. Broodthaers, transl. Schmidt, "Ten Thousand Francs Reward," p. 46.

48. Michel Foucault, *The Order of Things* (New York: Pantheon Books, 1970), p. xv.

49. Ibid., p. xvii. ". . . like the umbrella and the sewing machine on the operating table; startling though their propinquity may be, it is nevertheless warranted by that *and* . . . by that *on* whose solidity provides proof of the possibility of juxtaposition"; ibid., p. xvi.

50. It is precisely this that the historical materialist opposes: "The historical materialist leaves it to others to be drained by the whore called 'Once upon a time' in historicism's bordello. He remains in control of his powers, man enough to blast open the continuum of history"; Benjamin, "Theses on the Philosophy of History," p. 262.

knowledge by tracing its course in an infinite regress of origins.[51]

The title Broodthaers gave to the *Section des Figures*—*Der Adler vom Oligozän bis Heute* ("The Eagle from the Oligocene to the Present")—can only be a parody of this historicizing enterprise. Under the heading "Figure 0" in the second volume of the catalogue, Broodthaers wrote:

> Such notions are dangerous. Sometimes they precipitate a kind of anesthesia from which there is no awakening. Profoundly terrified . . . knowing nothing . . . finally, admiring, without reservation. The sublime idea of art and the sublime idea of the eagle. From the Oligocene to the present—this is all very sublime. Why Oligocene? The direct relationship between the eagle-fossil, which was found in excavations of the tertiary strata, and the various forms of presentation of the symbol are perhaps weak, if they exist at all. But geology had to enter the sensationalist title so as to imbue it with a false air of scholarship, which accepts the symbol of the eagle without reflection, without even putting it up for discussion.[52]

Within cultural history, categories that arose at particular historical moments—categories such as art—are never questioned; thus art can be seen to have come into existence along with "man himself" and his "creative instinct." Similarly, a fully historical phenomenon such as collecting is also psychologized, understood to be a transhistorical, cross-cultural *impulse*.[53] And the museum, reductively understood only as the institution that houses a collection, was therefore always simply *there* as the "natural" answer to the collector's "needs." In spite of the fact that the museum is an institution that emerged with the development of modern bourgeois society, cultural historians pursue its origins, together with those of the collection, into "time immemorial."

There is no cultural history of the art museum that does not find its own origin in that curious book, understood however as a classic, by Julius von Schlosser, *Die Kunst- und Wunderkammern der Spätrenaissance*, originally published in 1908. The director of the Kunsthistorisches Museum in Vienna—the museum whose very name pays homage to cultural history (and which lent an aquiline suit of armor to the *Section des Figures*)—Schlosser begins his book with a brief reflection on the universality of his subject:

> Whoever endeavors to write a history of collecting from its origins and in all its various ramifications and developments—and this would be an interesting subject both for

Suit of armor
North German, early 16th Century
Collection Kunsthistorisches
Museum, Vienna
Included in Broodthaers's *Section
des Figures*, Städtische Kunsthalle,
Düsseldorf, 1972

51. See Foucault, "The Retreat and Return of the Origin," in *The Order of Things*, pp. 328–335.
52. Broodthaers, "Section des Figures," p. 18.
53. Thus, for example: "Twenty years' experience as curator and director in American museums has convinced me that the phenomenon of art collecting is too instinctive and too common to be dismissed as mere fashion or the desire for fame. It is a complex and irrepressible expression of the inner individual, a sort of devil of which great personalities are frequently possessed"; Francis Henry Taylor, *The Taste of Angels: Art Collecting from Ramses to Napoleon* (Boston: Little, Brown and Co., 1948).

psychology and for cultural history—should perhaps not disdain to descend to the *gazza ladra* and the various and noteworthy observations that can be made regarding the *Sammeltrieb* in the animal kingdom.[54]

From the lower depths of the thieving magpie, Schlosser proceeds up the evolutionary ladder to the collections of children and savages, thence to the fabulous collections of the Incas and Aztecs, of Aladdin and of the *Thousand and One Nights*, and finally to the advent of *history:* the treasuries of the Greek temple and the medieval cathedral as museums, the Renaissance antiquities gallery as museum. Only after this litany does Schlosser turn his attention to his actual subject, the *Wunderkammer.* It is this "cabinet of rarities" that he considers the immediate precursor to the Kunsthistorisches Museum, whose "prehistory" in the *Wunderkammer* at Schloss Ambras he had set out to write.

Anyone who has ever read a description of a *Wunderkammer*, or *cabinet des curiosités*, would recognize the folly of locating the origin of the museum there, the utter incompatibility of the *Wunderkammer*'s selection of objects, its system of classification, with our own.[55] This late Renaissance collection did not *evolve* into the modern museum. Rather it was *dispersed;* its sole relation to present-day collections is that certain of its "rarities" eventually found their way into our museums (or museum departments) of natural history, of ethnography, of decorative arts, of arms and armor, of history . . . even in some cases our museums of art.

The *Section des Figures* does not, of course, return to the *Wunderkammer.* But it does recollect the heterogeneous profusion of its objects and the museum's reclassification of them during the nineteenth century. On the front and back covers of both volumes of the *Section des Figures* catalogue Broodthaers listed the museums from which he borrowed his eagles:

> Kunstmuseum Basel Kupferstichkabinett / Staatliche Museen Stiftung Preussischer Kulturbesitz Berlin (West) . . . Museum für Islamische Kunst / Nationalgalerie, Skulpturenabteilung . . . Musée Royal d'Armes et d'Armures Brüssel / Musée Wiertz Brüssel . . . The Ethnography Department of the British Museum London / Imperial War Museum London / Victoria & Albert Museum London . . . Museum of the American Indian Heye Foundation New York / Musée de l'Armée, Hôtel des Invalides, Paris / Musée des Arts Décoratifs Paris . . . Musée d'Art Moderne Département des Aigles Brüssel Düsseldorf.

Interior of the Museum
Wormianum, Copenhagen.

54. Julius von Schlosser, *Die Kunst- und Wunderkammern der Spätrenaissance: Ein Beitrag zur Geschichte des Sammelwesens* (Braunschweig: Klinkhardt & Biermann, 1978), p. 1.

55. For descriptions of various cabinets of curiosities, see Oliver Impey and Arthur MacGregor, eds., *The Origins of Museums: The Cabinet of Curiosities in Sixteenth- and Seventeenth-Century Europe* (Oxford: Clarendon Press, 1985). The title of this publication—stemming from a symposium held to celebrate the tercentenary of the Ashmolean Museum—is an example of the obliviousness of traditional art historians to questions posed to cultural history by either Benjamin's materialist historiography or Foucault's archaeology.

This is a list that points, in the conjunction of place names and museological classifications, to the *truly* historical dimension of modern "public" collections: their link with power—not only the imperial power that the eagle so consistently signifies, but also the power that is constituted through their systems of knowledge. More importantly, it points to the *relationship* of imperial power to knowledge-power.[56] As recent radical scholarship has consistently shown, ethnocentric, patriarchal "knowledge" has been as essential to imperialist regimes as have all the invading armies from Napoleon's to those of the present.

———————

While the *Section des Figures* remained in place, a *Section Publicité* showing photographs of the Düsseldorf exhibition opened at Documenta 5, the major international art exhibition held periodically in Kassel. This final appearance of Broodthaers's museum comprised two additional parts as well: the first of these, the *Musée d'Art Moderne, Département des Aigles, Section d'Art Moderne*, was in place from the opening of Documenta at the end of June until the end of August. In the so-called Abteilung Individuelle Mythologien ("Personal Mythologies Section"),[57] organized by Harald Szeemann, Broodthaers painted a black square on the floor of the Neue Galerie and inscribed within it, in white script and in three languages, "Private Property." The square was protected by stanchions supporting chains on all four sides. The words "musée/museum" were written on the window, readable from outside, just as they had appeared four years earlier in the rue de la Pépinière, but this time they were accompanied by "Fig. 0," legible from inside. There were also the usual directional signs of the museum: "entrée, sortie, caisse, vestiaire," and so forth, together with "Fig. 1, Fig. 2, Fig. 0. . . ."

The fiction changed its name and character at the beginning of September. Now called the *Musée d'Art Ancien, Département des Aigles, Galerie du XXème Siècle*, the black square was repainted, and inscribed in the following manner:

Ecrire Peindre Copier

figurer

Parler former Rêver

Echanger

faire Informer Pouvoir[58]

Taken together, these three final gestures point pessimistically to a new phase in the museum's history, the one we are now experiencing: the conjuncture of exhibitions as a form of public relations, of the ultimate reduction of art to private property, and of the evolution of artistic strategies into those of a pure alignment with power. Broodthaers did not live to see the fulfillment of his darkest predictions in the present takeover of the culture industry by corporate interests and, at the same time, the final eclipse of the commemorative role of the collector as historical materialist. But he did foresee what had become of his own *Musée d'Art Moderne*:

This museum, founded in 1968 under pressure of the political perception of its time, will now close its doors on the occasion of Documenta. It will therefore have exchanged its heroic and solitary form for one that borders on consecration, thanks to the Kunsthalle in Düsseldorf and to Documenta.

It is only logical that it will now model itself on boredom. Of course, this is a romantic point of view, but what can I do about it? Whether we look at St. John the Evangelist or Walt Disney, the symbol of the eagle is always particularly weighty when it concerns the written word. Nevertheless I am writing these lines because I conceive of the romantic disposition as a nostalgia for God.[59]

56. The explicit analysis of power/knowledge is, of course, the direction Foucault's work would take in its "genealogical" phase after *The Archaeology of Knowledge.* Broodthaers's *Section des Figures* anticipates this direction even though he himself could not have known it, as its first manifestation, *Discipline and Punish,* was published in 1975, three years after the "close" of Broodthaers's museum.

57. We almost have to wonder whether this absurd category was invented specifically in order that Broodthaers could mock it.

58. Write Paint Copy
 figure
 Speak form Dream
 Exchange
 make Inform Power

Pouvoir is also, of course, a verb, meaning "to be able, to have power," but it is the only word in the list that can, in French, also be used as a noun—hence the ambiguity of the inscription.

59. Marcel Broodthaers, open letter, Kassel, June 1972.

Author's Note

Virtually everything I know about the work of Marcel Broodthaers I have learned, in one way or another, from my friend Benjamin Buchloh. My introduction to the work came from his essays "Marcel Broodthaers: Allegories of the Avant-Garde," *Artforum,* vol. 18 (May 1980), pp. 52–59; and "The Museum Fictions of Marcel Broodthaers," in *Museums by Artists* (Toronto: Art Metropole, 1983), pp. 45–56. I also had the opportunity of working closely with him on the special issue of *October* on Broodthaers (no. 42, Fall 1987), for which he was guest editor. In addition, he lent me his personal copies of many of the documents I consulted in the preparation of this essay, helped with translations from French and German, and read and commented on the manuscript at various stages.

Among source materials, apart from Broodthaers's own writings, the masters theses by Dirk Snauwaert, "Marcel Broodthaers. Musée d'Art Moderne, Département des Aigles, Section des Figures. Der Adler vom Oligozän bis heute: Een Analyse" (Ghent: Rijksuniversiteit, 1985) and Etienne Tilman, "Musée d'Art Moderne, Département des Aigles, de Marcel Broodthaers" (Brussels: Université Libre de Bruxelles, Faculté de Philosophie et Lettres, 1983–1984) were especially useful in reconstructing various aspects of Broodthaers's museum fictions, none of which I saw firsthand.

This essay makes no pretense to be a complete presentation of Broodthaers's *Musée d'Art Moderne* in its many elliptical guises (see note 30); rather I have attempted simply to sketch out its central manifestations within a particular analytical framework.

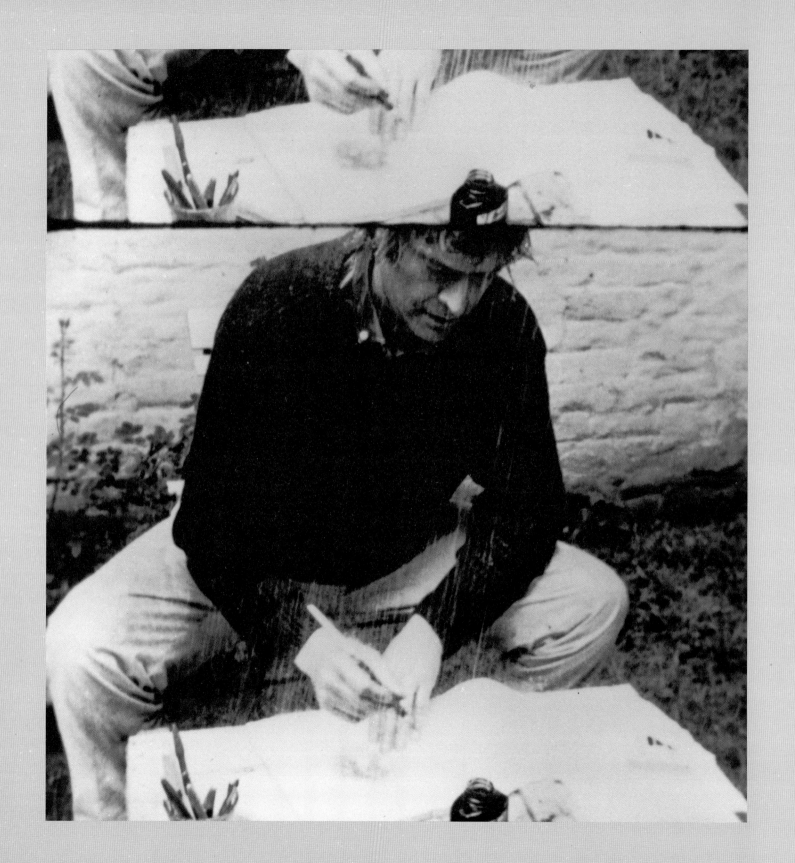

CB: Cinema Broodthaers

Bruce Jenkins

When the cruel sun strikes blow upon blow on the city and the meadows, the roofs and the cornfields, I go practicing my fantastic fencing, all alone, scenting a chance rhyme in every corner, stumbling against words as against cobblestones, sometimes striking on verses I had long dreamt of.—Charles Baudelaire, *Les fleurs du mal*

Seated before a small writing table located in a courtyard version of his *Musée d'Art Moderne*—instantiated here for the hour as a sort of museum without walls—Marcel Broodthaers is writing with pen and ink (p.92). As his work proceeds, rain begins to pour down upon the author and his text. Broodthaers, stonefaced, continues his jottings despite the fact that the water has begun to transform his efforts into something approaching the work of a painter. The writing is completed with a signature that manages to survive the storm, the screen fades to black, and a title appears: "Projet pour un texte."

As with his debut artwork *Pense-Bête* (1964; p.26), a sculptural assemblage of bundled copies of Broodthaers's final volume of poetry inserted into plaster, *La pluie (Projet pour un texte)* (1969) serves as a metaphor for Broodthaers's aesthetic-material transition from literary to visual artist. In *Pense-Bête* he obstructs the act of reading; in *La pluie*, the act of writing. And in each instance the denial of one work serves as the grounds for the creation of another: books stuck in plaster become a sculpture, a text drenched in rain becomes a movie.

No less allegory than biography, these transgressive acts situate Broodthaers within a history, both real and imagined, of radical artistic practice. The Dadaists exemplified this aspiration to sweep aside the discrete boundaries between artistic disciplines. Although engaged by their ideas, Broodthaers preferred the company of others. He acknowledged two such compatriots with a pair of prints produced in 1972 that celebrate the (apocryphal) careers of Charles Baudelaire, painter, and René Magritte, author. *La pluie* inscribes on film another seemingly counterfactual biography in its wry portrayal of "Marcel Broodthaers, cinéaste." One winces ("ceci n'est pas une pipe") and then, serenely, the logic of the associations overtakes their initial incongruity.

La pluie (Projet pour un texte)
1969
Production still

Marcel Broodthaers had initiated his work in film more than a decade before the production of *La pluie* and a half-dozen years before *Pense-Bête* signaled his emergence as a visual artist. As a filmmaker, his career spanned nearly twenty years and involved some fifty projects. He worked in 16mm and 35mm (and occasionally in Super-8), produced documentaries, animation, and short fiction pieces, and screened his films in a variety of venues. A lifelong cinephile, Broodthaers invested even his most modest productions with citations drawn from classic narrative cinema; he made particular allusions to the films of Charlie Chaplin and Buster Keaton, Jean Vigo and Jean Renoir, as well as Orson Welles. This fascination with film is well evidenced in *La pluie*, with its multiple references to Keystone sight gags, the "Great Stoneface" Keaton, and the open-air primitiveness of the Lumières. Yet even at their most cinematically referential, Broodthaers's films still focus primarily upon his own artistic enterprises and frequently incorporate material taken from his books and multiples, objects and exhibitions. Not only did films result from his gallery exhibitions, but film installations and special screenings were frequently staged during the course of his shows.

Despite their predominance within Broodthaers's artistic output, the films remain the least recognized and documented component of his work. This relative obscurity has resulted in part from their content (he confounded the cinematic subject to a degree that was extreme even for the European art cinema of the time); in part from the unique screening contexts he created (site-specific installations, single-event screenings or, on occasion, presentation before the feature in a commercial movie theater); and, perhaps most significantly, from his rejection of the label "experimental film." These factors conspired to limit the recognition of Broodthaers's work within any specific film-going public. The films rarely circulated through the network of avant-garde showcases, cine-clubs, and co-ops, but rather tended to be exhibited and acquired by museums and galleries that possessed neither the space nor the equipment to screen them. One was far more likely to encounter these elusive films displayed in their cans inside a vitrine than projected on a screen.

For his part, Broodthaers seems to have contested not only the experimental epithet, but also any characterization of the films as derivative of his visual art.

> In the publicity for this programme [of films at Brussels, December 1972] there have appeared the words "essential complement to his visual art" and elsewhere "experimental films." These do not seem to me appropriate to describe the films which I wish to show. It is not cinematographic art . . . it is no more and no less than something to talk about like a picture by Meissonier or Mondrian. . . . these are [just] films.[1]

1. Quoted in Michael G. Compton, "Marcel Broodthaers 1924–1976," *A Programme of Films by Marcel Broodthaers*, exh. cat. (London: The Tate Gallery, 1977).

Although "[just] films," Broodthaers actually employed the cinema throughout his work as a primary aesthetic receptacle for the cultural materials that formed the terms of his artistic interventions; film thereby predated and anticipated his appropriation of other nineteenth-century modes of spectacle and enchantment: the museum, the bestiary, the botanical garden.[2] To the extent that these recontextualizing devices themselves become, in turn, material for films, the cinema might, in fact, be seen as Broodthaers's preeminent medium, reversing the implicit marginality of the cinema in art and, in particular, in his artistic program. We can ask (after Walter Benjamin's celebrated formulation) not whether his films were art, but to what extent Broodthaers's films irrevocably transformed the very form of his other art.[3]

Of all the arts, for us the cinema is the most important.—V.I. Lenin

Described by Broodthaers as "an exercise of a sentimental lecturer,"[4] *La Clef de l'Horloge (Un poème cinématographique en l'honneur de Kurt Schwitters)* (1957–1958) is a kinetic study of a group of assemblages from the first major exhibition of Schwitters's work, the Kestner-Gesellschaft show, which traveled to Brussels in the fall of 1956. For his first film, Broodthaers employed borrowed equipment, outdated black-and-white film stock, and the assistance of guards and an electrician (Guy Hekkers) from the Palais des Beaux-Arts, where he was able to film the exhibition after-hours. The result is a complex art documentary which focuses not only upon the Schwitters work, but equally upon the perceptual and interpretive shifts that transpire in the act of filmmaking.

In *La Clef de l'Horloge*, Broodthaers transforms Schwitters's assemblages into moving pictures by relying upon what Walter Benjamin described as the resources of the camera's intervention: "its lowerings and liftings, its interruptions and isolations, its extensions and accelerations, its enlargements and reductions."[5] Through montage, camera movement and even subject movement (as Broodthaers turns the spokes of the broken wheel attached to Schwitters's *Bild mit Drehrad [Picture with Flywheel]*), the film animates the pictorial and sculptural elements of the collages, redoubling the effects of Schwitters's original juxtapositions.

Kurt Schwitters
Das Arbeiterbild 1919
mixed media
125 x 91 cm.
Collection Moderna Museet,
Stockholm

2. This discussion of Broodthaers's use of film in relation to his appropriation of nineteenth-century cultural forms is indebted to ideas presented in Bill Nichols's "The Work of Culture in the Age of Cybernetic Systems," *Screen*, vol. 29 (Winter 1988), pp. 22–46.

3. Walter Benjamin, "The Work of Art in the Age of Mechanical Reproduction," transl. Harry Zohn, in *Illuminations* (New York: Schocken Books, 1969), pp. 217–251.

4. Marcel Broodthaers, unpublished notes on *La Clef de l'Horloge*, in the Marcel Broodthaers archive, collection of Maria Gilissen, Brussels; English translation by Maria Gilissen.

5. Benjamin, "The Work of Art in the Age of Mechanical Reproduction," p. 237.

Broodthaers's camera initially traces the individual trajectories of elements within each assemblage, clarifying the formal relationships among the heterogeneous materials. In his portrayal of the *Neues Merzbild*, for example, he engages both camera and editing strategies to highlight the compositional dualities that govern this celebrated work ("Dada and Constructivist, anecdotal and abstract, environmentally allusive and self-contained").[6] Broodthaers varies camera distances, direction and speed, alternates positive and negative images, and counters upright compositions with inverted versions. At other points he isolates and magnifies compositional details to capture symbolic relationships, as in his use of giant close-ups of details in *Das Sternenbild (The Stars Picture)* to elucidate the work's opaque reference to stellar configurations. Finally, at its most kinetic, *La Clef de l'Horloge* thrusts together material from multiple assemblages, transforming the film screen into moving mega-Merz compositions.

Broodthaers constructs *La Clef de l'Horloge* not only as a dialogue between camera and canvas, but also between sound and image and, in particular, between a male narrator and his female companion. As Broodthaers noted,

> I was able to accomplish the film thanks to a love poem which plays the role of the traditional counterpoint in my efforts here. . . . I wanted to make a fiction film whose elements are furnished by fragments of the Merz work of Schwitters and which would rejoin the documentary film by the spirit of the era with which it deals.[7]

Broodthaers's "love poem" is presented as a voice-over conversation between a man and a woman who share our visual perspective on the Schwitters assemblages. The man (the voice of Broodthaers) introduces the artist and his work after the fashion of the documentary: "He is the creator of Merz art. Merz is the second syllable of the German word *Kommerz*."[8] His voice is accompanied by a tinny recording of carousel music that is reprised throughout much of the film, occasionally punctuated by comically iconic sounds of banging, clanging, and electronic buzzes. As the film proceeds, the dialogue becomes less objective, with descriptive responses to formal aspects of the assemblages ("Look, there are even squares") giving way to more lyrical interpretations:

> Oh, in the end he got sick of all these stars. You know, when it comes to stars, I know mostly the green ones. . . . People say we don't recognize our own happiness. Maybe it's true. . . . Come on, sweetheart, it's getting late. Give me your hand.

6. John Elderfield, *Kurt Schwitters* (London: Thames and Hudson, 1985), p. 196.

7. Marcel Broodthaers, "La Clef de l'Horloge," in *1958 FILM EXPRMNTL FILM 1958*, exh. cat. (Knokke le Zoute, Belgium: The International Festival of Independent Film, 1958), p. 34.

8. All quotations from the film are from a transcript of the voice-over dialogue for *La Clef de l'Horloge*, in the Broodthaers archive; English translation by Janet C. Jenkins.

The associative relationship of dialogue and imagery becomes increasingly figurative ("Look, the moon is trembling," as Broodthaers cuts to a large close-up of a tin lid in negative) until, by the end, the fiction has displaced the documentary as Broodthaers's lovers address nature and the romantic, emotive sentiments it engenders. The industrial and cultural detritus assembled by Schwitters is now appropriated as an ironic setting for this ashcan romance.

While predating his official emergence as an artist, *La Clef de l'Horloge* effectively sets the terms for Broodthaers's subsequent filmmaking, as well as for much of his other work. The mixed form of the film—documentary and fiction, celebratory and ironic—reveals the artist as both a masterful assembler and shrewd dissembler. In the terms of Baudelaire's sociological characterization of the modern artist, Broodthaers, like Schwitters, comes to resemble not so much the *flâneur* (the voyeur personified in the fashionable stroller of Parisian boulevards) as the ragpicker:

> Everything that the big city threw away, everything it lost, everything it despised, everything it crushed underfoot, he catalogues and collects. . . . He sorts out things and makes a wise choice; he collects, like a miser guarding a treasure, the refuse which will assume the shape of useful or gratifying objects between the jaws of the goddess of industry.[9]

It is such cultural refuse, wisely chosen, that forms the raw materials for the cinema of Broodthaers.

———

Broodthaers incorporated film into many of his activities in the late 1950s and early 1960s, organizing and presenting programs of classic and contemporary films, and of appropriated documentary and mainstream movie footage. In *Le chant de ma génération* (1959), for example, he interspersed newsreel footage from the Second World War with postwar footage, apparently taken from travelogues. For "Poésie Cinéma," a program he hosted at the Palais des Beaux-Arts in 1959, he assembled recent films by the celebrated French director Roger Leenhardt, young Belgian documentary maker Edmond Bernhard, and the master Czech animator Karel Zeman, together with his own appropriated work *Actualités reconsidérées* "avec Sophia Loren, Samuel Goldwyn, Georges Simenon, Renoir. . . ."[10]

Aside from provocative program notes, no footage from these screenings seems to have survived. However, for a 1971 exhibition in Düsseldorf, Broodthaers reprised this earlier format under the aegis of his *Section Cinéma* and presented a program of six short films shown on special projection screens on which were printed such titles as "fig. 1," "fig. a,"

9. Quoted in Elderfield, *Kurt Schwitters*, p. 168.
10. Marcel Broodthaers, "Poésie Cinéma," Palais des Beaux-Arts, Brussels, April 1959, mimeographed program note, in the Broodthaers archive.

"fig. 2." The films included *Charlie as Filmstar* (a purchased print of a Chaplin short), *Brussels* (a purchased travelogue), *Belga Vox* (a montage of newsreels assembled by Broodthaers, now lost), and *20th Century Mode*. The last, the only extant Broodthaers film assemblage, is a silent array of poorly duped nonfiction pieces (newsreels, science films, advertisements) organized after the fashion of the movie newsreel. The subjects range from curling matches and yacht races to military maneuvers, air battles, rescues at sea, and a volcanic eruption. Broodthaers divides the segments by inserting the studio logo for 20th Century-Fox.

————

It was a fox of a different order, however, that served to clarify the role of cinema in Broodthaers's enterprise. Nearly a decade after *La Clef de l'Horloge*, Broodthaers created a trio of works loosely based on a classic fable by La Fontaine. *Le Corbeau et le Renard* (1967) was published by Broodthaers as a book, produced as a film with printed projection screens, and mounted as a gallery exhibition—these three forms recapitulating the progression of Broodthaers's artistic development.

> I began with poetry, moved on to three-dimensional works, finally to film, which combines several artistic elements. That is, it is writing (poetry), object (something three-dimensional), and image (film). The great difficulty lies, of course, in finding a harmony among these three elements.[11]

This characterization of cinema as *Gesamtkunstwerk* strongly suggests that rather than relegating film to the role of "visual complement," Broodthaers may have envisioned his texts and objects as set pieces and props, scenario and subtitles for the primary work—the film. But whatever the original priorities in the creation of the three aspects of *Le Corbeau et le Renard*, it is the film that has endured.

Le Corbeau et le Renard, like the earlier *La Clef de l'Horloge*, mixes a sort of celebratory documentation with a contravening discourse. In the Schwitters film, the fiction of the "love poem" provided counterpoint; in the La Fontaine/Broodthaers, complexity arises from the rebuslike interpenetration of the poet's texts with the artist's objects. As Broodthaers noted,

> I went back to La Fontaine's text and transformed it into what I call personal writing (poetry). I had my text printed and placed before it various everyday objects (boots, a telephone, a bottle of milk) which were meant to form a direct relationship with the printed letters. It was an attempt to deny, as far as possible, meaning to the word as well as to the image.[12]

This pattern of semantic interference engendered by Broodthaers's installation recasts the original moral of the fable ("The tardy learner, smarting under ridicule, / Swore he'd learned

11. "An Interview with Marcel Broodthaers by the Film Journal *Trépied*," *October*, no. 42 (Fall 1987), p. 36.
12. Ibid.

his last lesson as somebody's fool")[13] into what Broodthaers termed "a reading exercise."[14]

Again like *La Clef de l'Horloge*, *Le Corbeau et le Renard* is a kinetic, highly edited portrait of details from individual works seen in close-up. The spatial shifts of the earlier film, however, have given way here to trick-film manipulations of the art objects. In Broodthaers's comic choreography for the camera, high-heeled mannequin legs are crossed, egg cups leap over pitchers, pickaxes and milk bottles bear offspring, and black boots displace white telephones. Between the printed texts and the three-dimensional objects, Broodthaers has affixed a series of photographic cutouts that function as a third discourse—a sort of photo-novel that relocates both the original didacticism of the fable and the lesson on signification into the artist's own biography. In these static, decontextualized images, Broodthaers enacts the fable in comic silent pantomime, casting himself as the fox, his friend René Magritte as the crow, and Magritte's black bowler as the cheese.

A Voyage on the North Sea
1973–1974
Film can, designed by Broodthaers

13. Marianne Moore, transl., "The Fox and the Crow," in *The Fables of La Fontaine* (New York: The Viking Press, 1954), p. 14.

14. "An Interview with Marcel Broodthaers by the Film Journal *Trépied*," p. 36.

The playfulness of *Le Corbeau et le Renard* seems motivated in part by the style and wit of its literary source and in part by Broodthaers's filmic response to it in the form of such cinematic "juvenilia" as primitive trick-film techniques and silent comedy gags. A more profound level of play, however, derives from Broodthaers's dispersal of the didacticism of the original text (a succinct nexus of narrative and moral) into the free play of signifiers, of mute objects, blank texts, and dumb show.

Le Corbeau et le Renard represented Broodthaers's first integration of filmmaking into his own visual artworks. Throughout the rest of his life, he would continue to conjoin the two media in an aesthetic and semantic dialogue. While some of the films can be seen as conveying an authorized reading of Broodthaers's objects and installations, they function equally to disturb the contemplative mood of art viewing, to contest the reification of the art objects, and to deny the aura of the original. And while the films form a permanent record of much of Broodthaers's art, the views they provide are fleeting, unstable, reversible.

—

The cinematic turn taken by Broodthaers after *Le Corbeau et le Renard* is most evident in pieces like *A Voyage on the North Sea* (1973–1974; p.99) which were also realized on film. This work, issued simultaneously as a thirty-eight page book (with seventy-eight illustrations) and as a silent film of slightly more than four minutes, focuses on a set of "black-and-white photographic images of a pleasure boat on the North Sea and colour reproductions from an oil painting of a small fleet of fishing vessels by an amateur around the year 1900."[15] Working against the grain of each medium, Broodthaers dynamically structures the book's layout through montage—alternating details from the painting based on shifts (often manipulated) in framing, texture, and color—while the film is statically organized by page numbers. In both film and book, the photograph works in counterpoint to the painting (twentieth century *versus* nineteenth century, leisure *versus* labor, "real" *versus* "imagined"), while the details of the painting are juxtaposed into a visual dialogue on illusionism and abstraction.

In "making use of the same elements as the book,"[16] the film would seem to offer a sort of performance version of the work in which the artist intricately structures our reading and interpretation—turning the pages of the text for us, as it were. Yet the co-presence of film and book subtly begins to challenge any ascription of primacy: is the book merely a shooting script for the film; the film, a simple recording of the book? Broodthaers further complicates the chicken-and-egg question of antecedence by offering two other complete, but divergent film versions based on the same material. The first, *Analyse d'une peinture* (1973; p.101),

15. Advertising circular for the publication of *A Voyage on the North Sea* (London: Petersburg Press, 1974), in the Broodthaers archive.
16. Ibid.

Analyse d'une peinture 1973
Still

features the painting mounted in an elaborate gilt frame and utilizes images of the gallery wall (rather than the photograph of the sailboat) as counterpoint to create "a review of the history of art through one picture."[17] The second version, *Une peinture d'amateur découverte dans une boutique de curiosités* (1973), closely resembles *Analyse d'une peinture* and contains within itself an alternate abridged version (*Le même film, revu après critiques*) that appears after a long pause in the main film.

Through this cluster of works (three films and a book), itself based upon the juxta-position of two prior pieces (the amateur painting and an incidental photograph), Broodthaers raises complex questions of reference and of origins. On the one hand, there is the issue of

17. "Interview with Marcel Broodthaers on his film 'Analysis of a Painting' by B.H.D. Buchloh and Michael Oppitz," press release for the exhibition *Peintures Littéraires* (Gallery Zwirner, Cologne, September 1973), in the Broodthaers archive.

how mechanical reproduction and appropriation have altered the nature of the work of art, its relationship to the world and, so to speak, its semantic destination. There is as well the correlative problem of the source, the site from which the artwork emanates. Although much of Broodthaers's art opens onto these questions, they receive extensive elaboration in his film work and, in particular, in a cycle of films that, like *La Clef de l'Horloge*, takes its subject from the oeuvre of another artist, fellow Belgian René Magritte.

———

Between 1968 and 1972, Broodthaers created no less than eight filmic variations on the theme of Magritte's *Ceci n'est pas une pipe*, a seminal work that he credited as a personal influence:

> Magritte denies the aesthetic nature of painting (which does not prevent him, almost in
> spite of himself, from creating some beautiful paintings). *Ceci n'est pas une pipe* is the title
> of a painting as enigmatic as the smile of the Mona Lisa. . . . Still faithful to his initial
> purpose, he continues to elaborate a poetic language aimed at undermining that upon
> which we depend.[18]

As Broodthaers suggests in this brief homage, the enigma of the Magritte painting stems from the artist's resolute efforts to undermine "that upon which we depend"—namely, language and meaning. Broodthaers adapts Magritte's emblem of this loss—the contradictory image of the pipe and its self-negating caption—into a series of comic misadventures in the quest for meaning.

In the preliminary versions, *La pipe (René Magritte)* (1968–1970) and *Ceci ne serait pas une pipe* (1970), Broodthaers utilizes animation techniques to suspend the pipe, placing it in mid-air before the garden wall of *La pluie*. The pipe is levitated, less for art historical reasons (the Surrealism of the source) than for semantic ones. As Michel Foucault noted in his provocative analysis of the Magritte painting: "The form reascends to its heaven from which the complicity of letters with space had momentarily brought it down: free from any discursive bond, it can go back to floating in its native silence."[19] While replicating the shallow space of Magritte's illustration, Broodthaers jettisons the original transgressive inscription in favor of ones that recontextualize the image and begin to expose the cinema to the corrosive forces that Magritte had unleashed on painting. In *La pipe (Figure Noire)* (1968–1970), for example, Broodthaers subtitles the entire sequence with the single word "Figure," thereby reducing filmic representation to the level of illustration. In *Ceci ne serait pas une pipe*, he employs the transgressive device of marking objects with contradictory

Ceci ne serait pas une pipe 1970
Frame enlargements

(opposite, top)
La pipe satire 1969
Frame enlargements

(opposite, bottom)
Jean Vigo
L'Atalante 1934
Still

18. Marcel Broodthaers, "Gare au défi! Pop Art, Jim Dine, and the Influence of René Magritte," transl. Paul Schmidt, *October*, no. 42 (Fall 1987), p. 34.
19. Michel Foucault, "Ceci n'est pas une pipe," transl. Richard Howard, *October*, no. 1 (Spring 1976), p. 10. Broodthaers was apparently well acquainted with the Foucault essay and, according to a postscript to the publication circular for *A Voyage on the North Sea*, planned to publish his own edition of Foucault's text.

designations—the wall subtitled "Figure I" and then "Figure II," the smoking pipe labeled successively "Figure III," "Figure I," and "Figure II," the final image of the extinguished pipe subtitled "Figure I et II." As in *Le Corbeau et le Renard*, Broodthaers interpenetrates word and image, denying meaning to both. The result is a rebuslike form emptied of reality and significance. Foucault best described it: "Magritte allows the old space of representation to prevail, but only on the surface, for it is no more than a smooth stone, bearing figures and words: underneath, there is nothing."[20]

That which fills the void at the center of representation forms the subject for Broodthaers's most elaborate appropriation of Magritte. He comically portrays attempts to find a source of meaning in the work of art by recourse either to the figure of the artist or, alternatively, to the processes of the unconscious. In *La pipe satire* (1969), Broodthaers inserts himself in the role of artist—masked, shirtless, wearing a sailor's cap, mysteriously exhaling smoke, and eventually playing an accordion. The artist portrayed in *La pipe satire* is neither Magritte nor Broodthaers, but another fiction, a phantom, a citation: he is "Père Jules," the old junk-collecting sailor of Vigo's *L'Atalante*, the maritime version of Baudelaire's ragpicker. In a like recourse to fiction, the meaning of the pipe is recuperated in the film, through the machinations of psychoanalysis, as a phallus, displayed by Broodthaers in close-up as a smoking briar held between the thighs of a nude woman. By unfettering film from its referential bonds, Broodthaers allows cinema to float, like Magritte's pipe, in a sea of citation, of other voices and other forms.

—————

Shakespeare, Rembrandt, Beethoven will make films. . . . —Abel Gance

In 1970 Marcel Broodthaers presented a film "realized" by the poet, translator, and critic Charles Baudelaire. By way of explication, he subtitled Baudelaire's film *Carte politique du monde* and provided this disclaimer:

> *Un film de Charles Baudelaire* is not a film for cinephiles. Why not? Because it was shot in the nineteenth century. And because the cinephiles have never seen reels dating from a time when Muybridge, the Lumière brothers and Edison were still unborn or were taking their first steps under the watchful eyes of their industrialist mamas and papas.[21]

A piece of pre-cinematic cinema, *Un film de Charles Baudelaire* consists of an array of static materials—words (printed and spoken), dates, details of a map, a museum sign—that Broodthaers animates into an imaginary voyage. According to the first in the series of dates

20. Ibid., p. 16.
21. Marcel Broodthaers, unpublished notes on *Un film de Charles Baudelaire*, in the Broodthaers archive; English translation by Maria Gilissen.

that circulate throughout the course of the film, it is "January 3rd 1850," the virtual beginning of the second half of the nineteenth century and day one of the voyage. The dates come in brief succession amid single-word texts ("Shark," "Knife," "Cook," "Silence," "Death") as the voyage moves from winter into spring and early summer; the maps illustrate a spatial trajectory from Western Europe to the Celebes Islands (adjacent to the famed Spice Islands, a trading mecca for Europe from the sixteenth century on).

For much of the voyage, the shifting images of the map depict mainly oceanic details, which perhaps serve to motivate the continuing malignancy of the textual captions: "Famine," "Scurvy," "Death." Although the year is deleted from the date, the journey continues to unwind chronologically until mid-December, when the dates shift into reverse order and the voyage begins to double back upon itself. It is on this return leg that Broodthaers incorporates several new elements. A "Musée-Museum" sign glimpsed early in the film is shown in greater detail, including now its subtitle "enfants non admis" ("children not allowed"), and a child's voice is heard twice repeating the text. The sound of a clock chiming twelve o'clock ("Midnight"/"Noon") and its subsequent ticking are heard precisely at the point where the chronology of dates concludes. On the final tick, the author's initials ("C. B.") appear and the film ends.

Un film de Charles Baudelaire reprises an actual voyage taken by Baudelaire in 1841 to India, a difficult passage that was to provide a major source of images and experiences for his subsequent poetry. Yet, given the textual descriptions and the cartographic details, the film evokes as well the classic voyages of "discovery" that led to the colonization of much of the world by the powers of Western Europe. The lexicon of suffering and deprivation that unfolds in the film emerges as readily in the poetry of Baudelaire as in the sixteenth-century journals of Pigafetta, chronicler of Magellan's historic voyage around the world.[22]

The museum that is signaled throughout the film—a museum for adults, not children— would necessarily broach the domains of history and art, of conquest and poetry, and of the pain and torment that subtend both areas of human activity. While serving itself as a sort of temporal museum (memorializing in time the past), *Un film de Charles Baudelaire* suggests a new poetics for the cinema, originating not in light, but in the word—a radical form that would wed the writings of Baudelaire with the machine of the Lumières.

The treasures of the world abound there, as in the house of a laborious man who deserves
well of the entire world. A strange country, superior to others, as Art is to Nature, where

22. See Antonio Pigafetta, *Magellan's Voyage*, vol. 1, transl. R.A. Skelton (New Haven and London: Yale University Press, 1969), especially pp. 57–65, which deal with the emergence of the expedition out of the Straits of Magellan and into the Pacific.

the latter is reshaped by dream, where it is corrected, embellished, recast. Let them seek, let them seek again, let them push back unceasingly the limits of their happiness, those alchemists of horticulture!—Charles Baudelaire, *Le Spleen de Paris*

In 1974 Broodthaers produced a film and concurrent gallery exhibition in which another nineteenth-century form collides with contemporary artistic practice. Like the classic European botanical and zoological gardens of the mid-nineteenth century, Broodthaers's "garden" in *Un jardin d'hiver* (p.107) placed elements of the phenomenal world at a safe, spectatorial distance from the public.[23] Mediated by lithography, horticulture, video, and theater, nature is displayed as spectacle for an audience doubly removed from any direct encounter by factors of time (the mid-winter hibernation of the natural world) and of space (the limits of Baudelaire's "Pauvre Belgique").

The exhibition featured a dozen or so nineteenth-century prints of animals and insects in their native habitats framed and hung on the gallery walls and displayed in a vitrine, as well as a group of potted palms arranged with chairs in a central circle and adjoining the prints on both sides of the gallery. For the only time in his career, Broodthaers incorporated video into the exhibition. A closed-circuit monitor and camera were installed in the far corner of the gallery to allow spectators to participate directly in the reductive process of representation—each viewer emerging as an image on the tiny television screen.

Film enters the garden as another form of mediation, creating a new level of representation and a further reduction of the exhibition's primary content—the natural world. Broodthaers actively implicates film in this process by constructing what might be termed a comedy of diminution.[24] As in *La Clef de l'Horloge*, the camera radically alters the scale of the objects and images. Here Broodthaers alternates close-ups of the prints on the gallery walls (often composing the shot to include a palm frond across one edge) with full shots that reveal the actual dimensions and positions of the works. In the series of close-ups, a fantastic world is glimpsed in which bees are the size of camels and a goshawk looms larger than an elephant. The long shots serve as a corrective in displaying the global reduction of nature, the leveling of the world to a uniform size that can be framed, encased, and potted.

———————

A year after *Un jardin d'hiver*, Broodthaers extended this critique of representation into the arena of history when he mounted *The Battle of Waterloo* (p.205), his final and most

23. For an historical analysis, see Nichols, "The Work of Culture in the Age of Cybernetic Systems," p. 34.
24. This form of visual humor was a favored technique of the first master of the trick film, Georges Méliès; see Paul Hammond, *Marvelous Méliès* (London: Gordon Fraser Gallery, 1974), especially pp. 49–50. For comparison within Broodthaers's own oeuvre, see his Tom Thumb-sized atlas, *La conquête de l'espace. Atlas à l'usage des artistes et des militaires* (Brussels: Lebeer Hossmann, 1975).

ambitious film, in conjunction with an exhibition at the Institute of Contemporary Arts in London. According to Broodthaers, the exhibition was "entirely conceived as a 'Décor' and assembled from rented objects."[25] The objects were displayed in two galleries: one representing the nineteenth century and the other the twentieth. In the first, Broodthaers assembled a pair of cannons on astroturf carpeting, a lifelike figure of a coiled snake, a pair of ornate silver candelabras set on small tables, a pair of wooden whiskey barrels, an antique revolver, two thronelike red velvet chairs, a group of six potted palms, and red plastic lobsters and crabs. In the second gallery, a white lawn table with umbrella and four padded chairs was centrally placed, and against the wall on either side of the doorway adjoining the first gallery, twenty or so automatic rifles were mounted on shelves. On the table lay a partially assembled jigsaw puzzle of a painting of the Battle of Waterloo.

The two galleries of *Décor*, as the exhibition was titled, become the principal settings in Broodthaers's proto-narrative *The Battle of Waterloo* (1975). The production takes place on 14 June 1975, the date in Great Britain of the Trooping of the Colour and nearly 160 years to the day after Napoleon's defeat at Waterloo. Outside the museum, the annual military procession is in progress. Broodthaers juxtaposes footage of the passing troops (taken from the roof of the ICA) with events within the galleries. As in *Le Corbeau et le Renard*, he resorts to trick-film techniques within the nineteenth-century room (wisps of smoke issue from a cannon, a lobster and crab cavort), while in the other gallery he stages a fragment of fiction film. In the scene, a young woman is seated at the table completing the jigsaw puzzle. In close-up (accompanied by music from the military procession and from Wagner's *Tristan und Isolde*) she examines the final pieces, attempting to gain a better view of the actual battle. As the procession continues outside, the woman begins to deconstruct the puzzle, removing pieces from its dramatic center, examining each one, and then tossing it back on the table. The formal maneuvers of the troops are shown as the young woman tears whole sections of the puzzle apart. In the final movement of the film, Broodthaers's camera zooms in on the top of the puzzle box for a close-up of Napoleon, a cut is made to the emperor's iconic silhouette gracing the label of a cognac bottle, and the crabs assemble at the throne seats.

The Battle of Waterloo is at once Broodthaers's most explicitly political film and his most conventionally cinematic. Political content enters the exhibition much as obsolete munitions and monuments to military heroes invade public parks and city plazas. The garden of *Un jardin d'hiver* has been displaced by relics of warfare and aggression which serve to divide the two galleries both temporally and spatially: the nineteenth-century room portraying the imperial hegemony of Western Europe, the twentieth-century room belonging to that superpower of lawn furnishings and weapons systems, the United States.

25. Marcel Broodthaers, note on *Décor* exhibition, *October*, no. 42 (Fall 1987), p. 197.

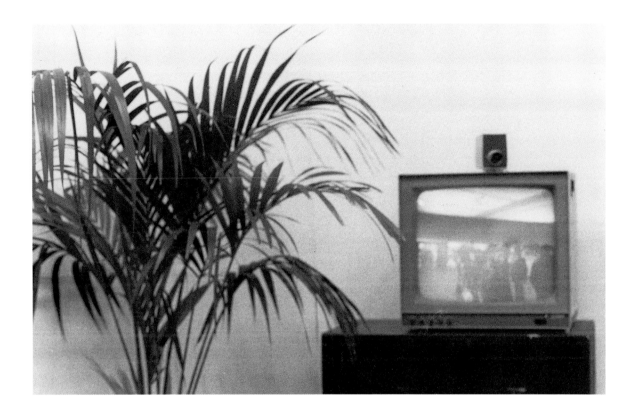

Un jardin d'hiver 1974
Still

Un jardin d'hiver 1974
Production still

Cinematically, Broodthaers contrasts the picturesque scene of the Napoleonic decor with a spare, studiolike space that suggests not only the period of American imperialism (the Vietnam era), but also the twentieth century as the film age. He incorporates filmic citations into each gallery—the one approximating the props room for Gance's *Napoleon*, the other directly quoting a scene from Welles's *Citizen Kane*. Broodthaers has reworked the celebrated sequence, in which the tedium of life at Kane's Xanadu is encapsulated in Susan Alexander's assembling of jigsaw puzzles, in order to connect the two chambers of the exhibition and to direct us back to the central figure of his investigations.

The journalists who assembled the heterogeneous portrait of Kane in the Welles film seem to have set the terms of Broodthaers's project: "It isn't enough to tell us what a man did, you've got to tell us who he was."[26] And like the journalists, Broodthaers ultimately seeks that knowledge in objects and artifacts, assembling a storeroom of relics whose silence, however, conspires to limit access to the past. As Thompson, the chief journalist, observes near the end of *Kane*: "I don't think any word can explain a man's life. No, I guess Rosebud is just a piece in a jigsaw puzzle, a missing piece."[27] In *The Battle of Waterloo*, Broodthaers too seems unable to piece together a coherent portrait of "who he [Napoleon] was," opting in the end to display an image of what he has become—an imperial figure enlisted into the empire of signs, the figurehead on the cognac bottle.

> In my naïvëté, I actually believed that I could put off choosing a profession until my demise.
> —Marcel Broodthaers

Dressed in a pinstripe suit and smoking like a detective in an American *film noir*, Marcel Broodthaers is seated before a large display case interrogating the wax figure inside (p.109):

> If you have a statement to make, please do so. If you have a secret, tell me. . . . Give me an
> indication. If you wish to protest, I promise to keep it. . . . [Do] you prefer to dream?

While his questions go unanswered, a documentary narration commences with a biographical sketch of British philosopher Jeremy Bentham (whose waxed remains reside at London's University College), replete with facts about his life, descriptions of his theories, and an account of his dreams. Broodthaers abandons the interrogation for his newspaper and finally exits onto the street; to the music of Chopin, he paces the sidewalk, only to encounter the frozen faces of shop window mannequins. Other "figures" begin to appear: currency symbols for pounds sterling, dollars, and deutsche marks, postmarks from University College, and stamps. A passage by Beethoven is heard on the soundtrack, and more mannequins are seen,

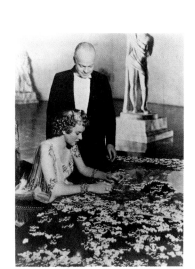

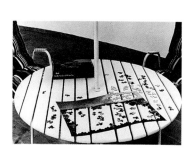

Orson Welles
Citizen Kane 1941
Still

The Battle of Waterloo 1975
Still

26. "RKO Cutting Continuity of the Orson Welles Production, Citizen Kane," *The Citizen Kane Book* (Boston: Atlantic Monthly Press Book—Little, Brown and Company, 1971), p. 322.
27. Ibid., p. 420.

until a final image of the street viewed back through the shop windows simulates the object of their fixed gaze.

Figures of Wax (1974) represents a late allegorical reflection on Broodthaers's work in film. As in *La pluie*, Broodthaers casts himself as protagonist, exhibiting much the same Keatonesque persistence in the face of failure. Like the Keaton of *Sherlock Junior*, Broodthaers is thrust into an incongruous fiction that requires him in a poignant sight gag to converse with a dead man. And like the rain that obstructed the writing in *La pluie*, the wax halts the cinematic discourse here. Wax, the substance that can assume any shape, retain and transfer visual impressions and sound, simulate the human visage—wax, the plastic of the nineteenth century, proves unresponsive to Broodthaers's invocations, remaining fixed and silent in the face of a medium predicated on movement and sound.

While spatially present, Bentham is frozen in a different temporality, one that Broodthaers's camera can only encase in yet another reified, temporal layer. As if fearing his own reification in conferring with the dead, Broodthaers takes flight from the figure of Bentham and the film. As he takes to the street he is seen again only in fleeting detail—his brown shoes pacing the sidewalk, his hawklike eyes countering the mannequins' stares. Abandoning cinema, Broodthaers emerges as a peripatetic figure unfettered by the material constraints of writing, painting, filmmaking, at play forever within a realm of pure discourse. He constructs a cinema no longer grounded in illusionism; his is a cinema that begins with the word, a cinema focused upon the discursive nature of actuality—a cinema of the sentimental lecturer, a cinema Broodthaers.

Figures of Wax 1974
Production still

Plates

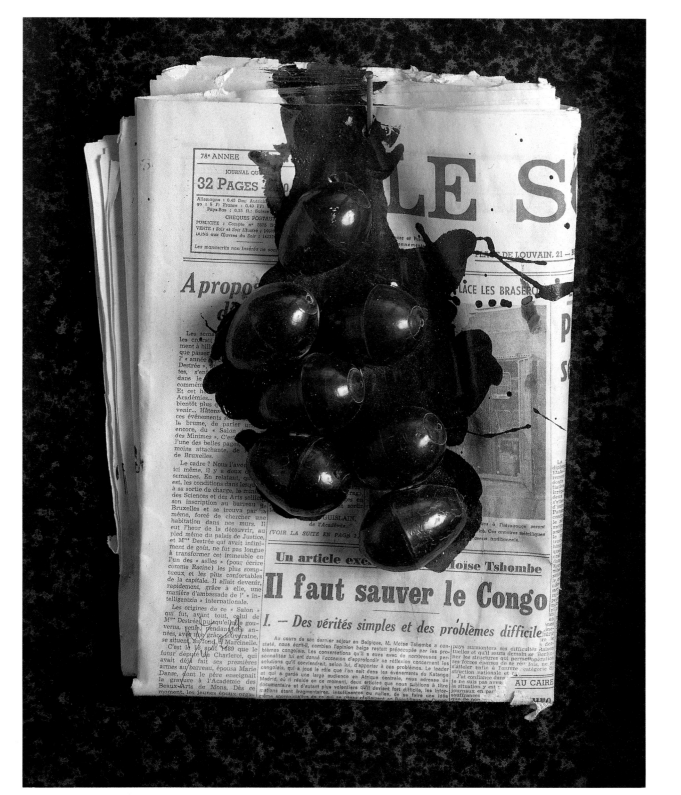

Cymbalium 1964
brass cymbals, plaster, paint
7 x 39 x 37 cm.
Private collection

Bombardon 1964
brass horn, paint
85 x 42 x 6.5 cm.
Private collection

Pupitre à musique 1964
wood, mussel shells, plaster, paint
136 x 96 cm.
Courtesy Galerie Willy D'Huysser,
Brussels

(opposite)
Le problème noir en Belgique 1963
newspaper, enameled eggs, paint
50 x 42 cm.
Courtesy Galerie Willy D'Huysser,
Brussels

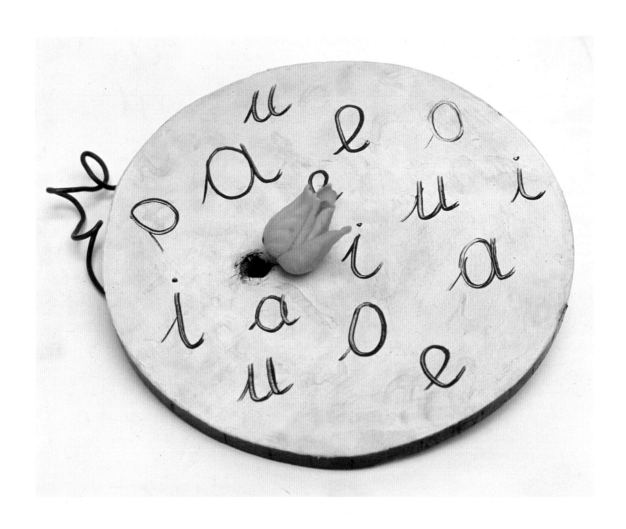

Langage de fleurs 1965
wood, paint, plastic
30 cm. diameter
Private collection

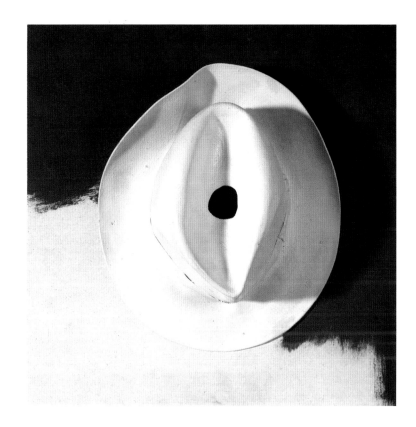

Chapeau blanc 1965
felt hat, paint, panel
45 x 45 x 16.5 cm.
Collection M. Van Gijsegem

Chapeau buse avec trou c. 1965
silk and leather top hat
14 x 31 x 25.5 cm.
Private collection

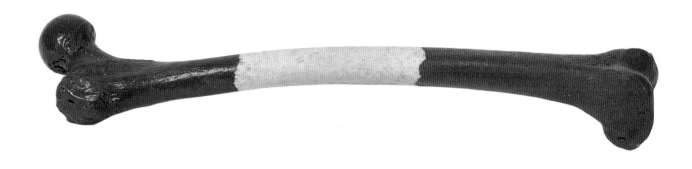

Fémur de la femme française 1965
bone, paint
9 x 43 cm.
The Sonnabend Collection

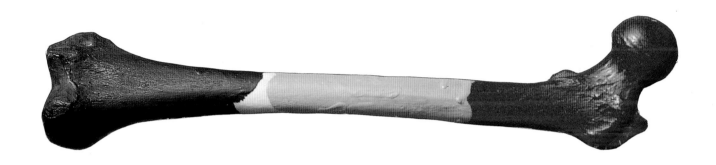

Fémur d'homme belge 1965
bone, paint
8 x 47 x 10 cm.
Private collection

Tabouret 1968
footstool, paint
24 x 20 x 30 cm.
Collection Marie-Puck Broodthaers

Fauteuil d'enfant c. 1968
wicker chair, paint, ink
52 x 41 x 35 cm.
Collection Marie-Puck Broodthaers

(front and back views)
Tableau noir (Les Aigle) 1970
child's blackboard, chalk
148 x 70 x 36 cm.
Collection De Decker-Lohaus

Petite armoire, pots, et ventouses
1965
glass, wood, paint, magazine
reproductions
59 x 34 x 12.5 cm.
Collection Milantia and Charles
Berkovic

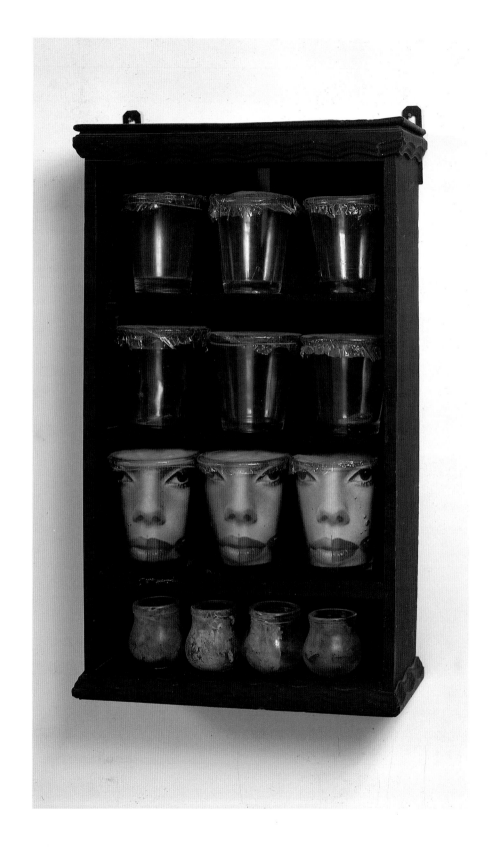

La tour visuelle 1966
glass, wood, magazine
reproductions
88 x 50 cm.
Collection National Gallery
of Scotland, Edinburgh

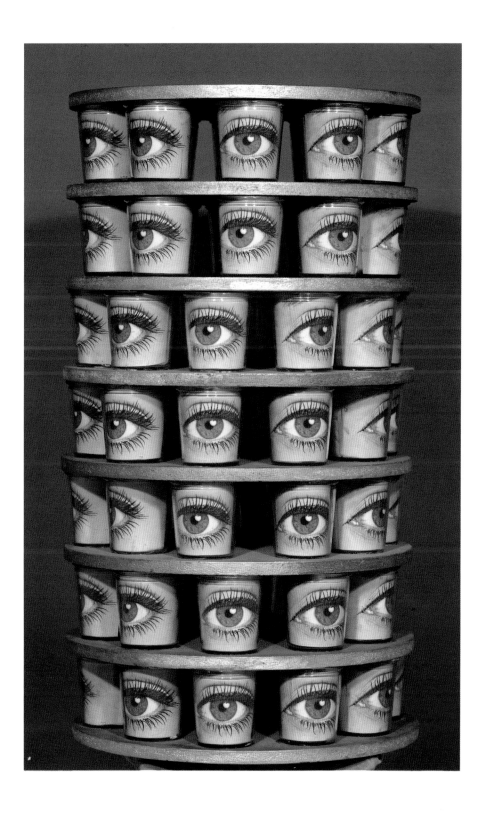

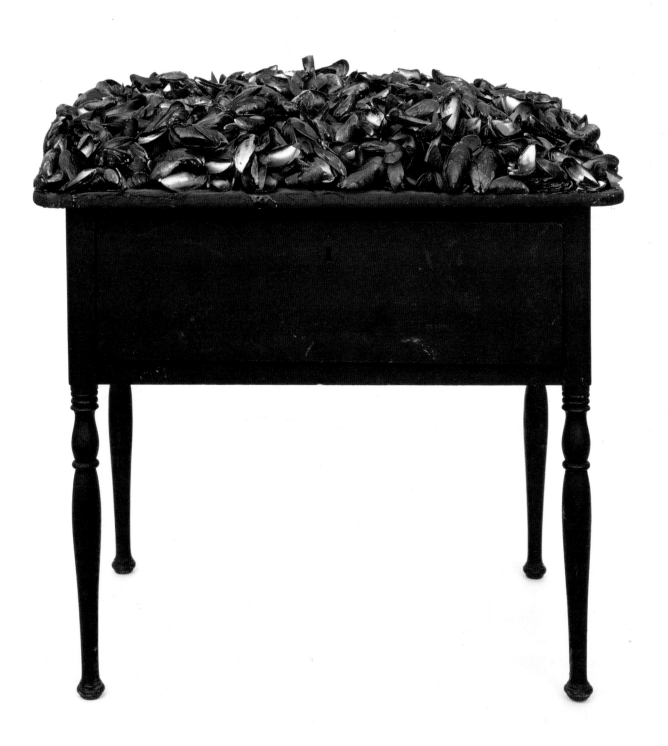

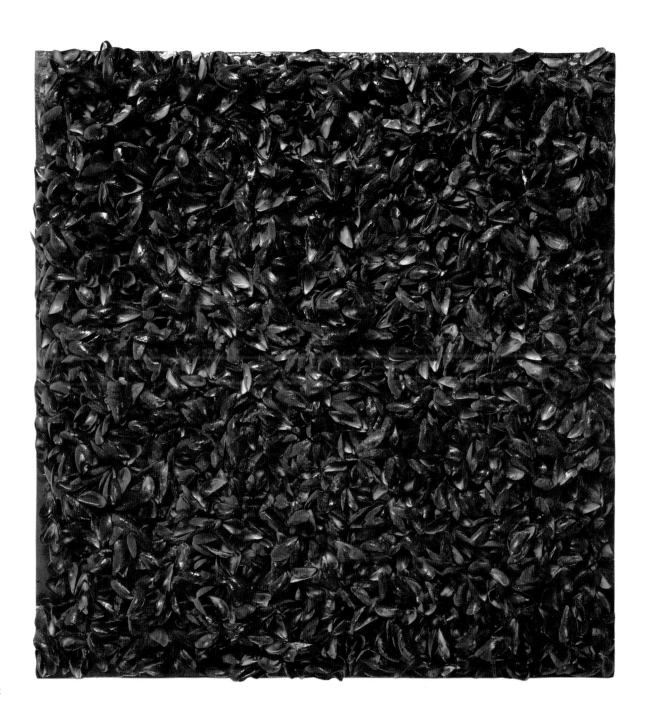

Panneau de moules 1966
mussel shells, resin on panel
116 x 122 x 14 cm.
Collection Mr. and Mrs. Toussaint
Gilissen

(opposite)
Bureau de moules 1966
bureau, mussel shells, paint, resin
85 x 88 x 65 cm.
Courtesy Galerie Michael Werner,
Cologne

Chaise lilas avec oeufs 1966
chair, eggshells, paint
90 x 43 x 45 cm.
Private collection

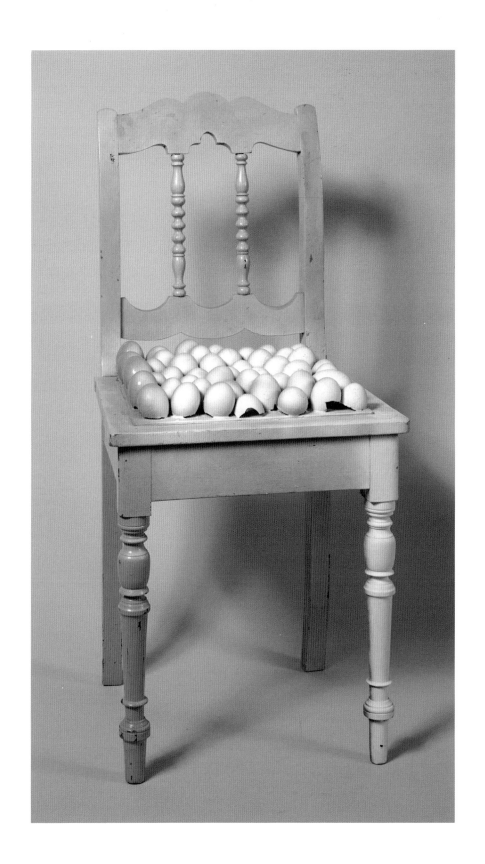

(top)
Armoire d'oeufs 1965
cupboard, eggshells, paint
86 x 82 x 62 cm.
Private collection

(bottom)
Une table d'oeufs 1965
table, eggshells, paint
104 x 100 x 40 cm.
Private collection

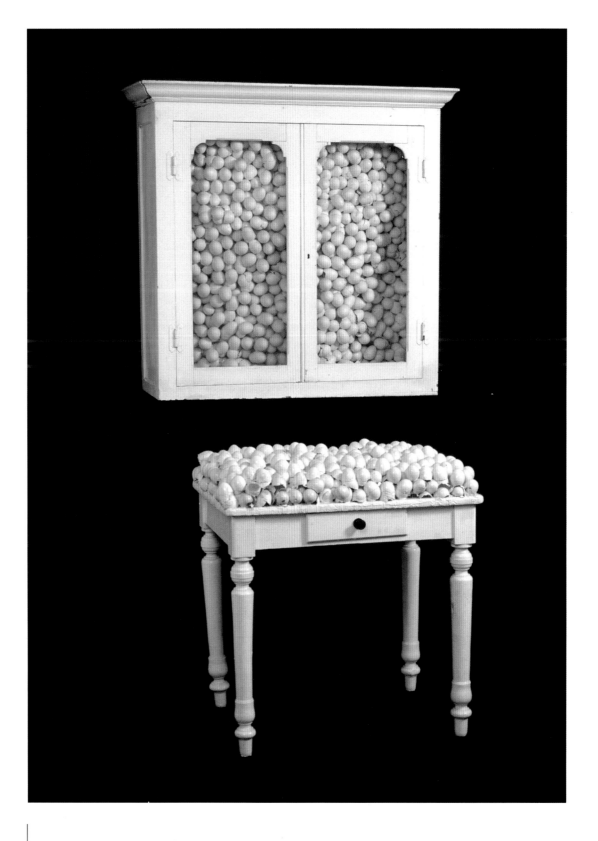

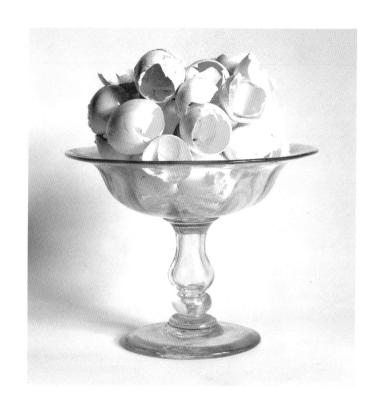

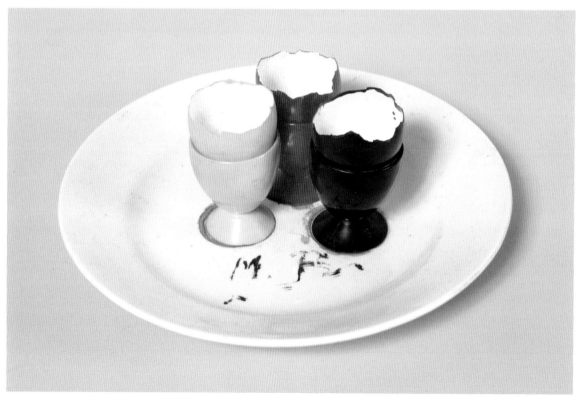

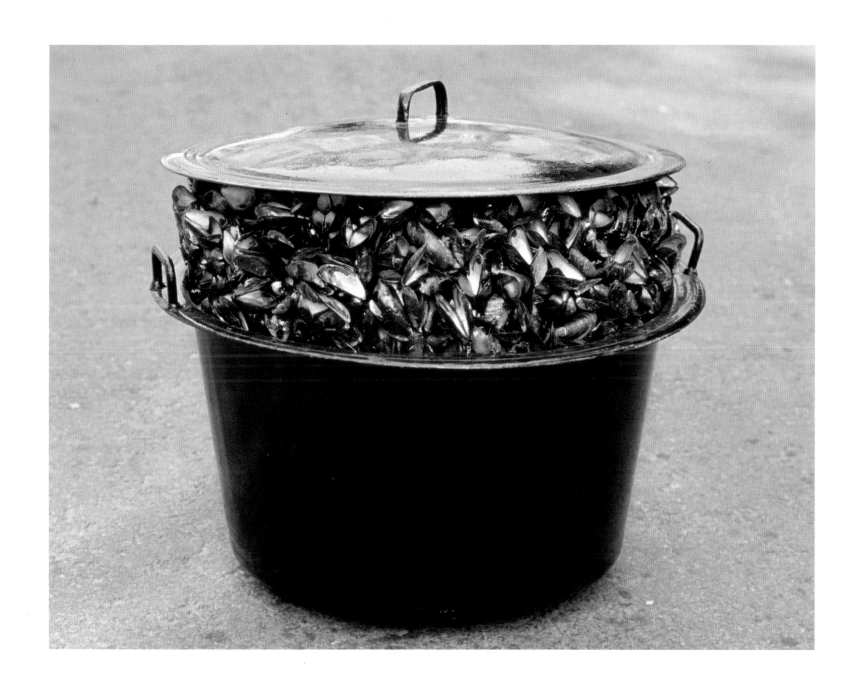

Grande casserole de moules 1966
casserole, mussel shells, paint
65 x 75 x 70 cm.
Collection De Decker-Lohaus

(opposite, top)
Coupe avec coquilles d'oeufs 1967
glass, eggshells
27 x 22 cm.
Collection Mr. and Mrs.
Kok-Broodthaers

(opposite, bottom)
*Trois coquetiers rouge jaune noir
sur assiette* 1966
plate, egg cups, eggshells, paint
9 x 23 cm.
Collection Milantia and Charles
Berkovic

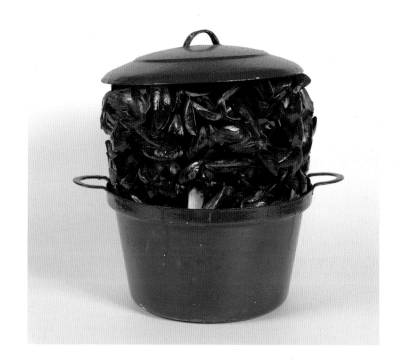

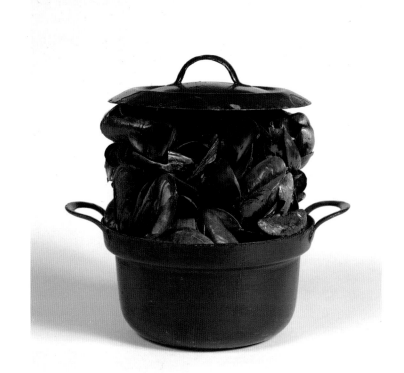

Casserole de moules verte 1965
casserole, mussel shells, paint
40 x 39 x 32 cm.
Collection Sylvio Perlstein

Casserole de moules noire 1968
casserole, mussel shells, paint
25 x 25 x 18.5 cm.
Collection Mr. and Mrs.
Kok-Broodthaers

Panneau de charbon 1966
charcoal on panel
93.5 x 98 cm.
Courtesy Galerie Ronny Van De
Velde & Co., Antwerp

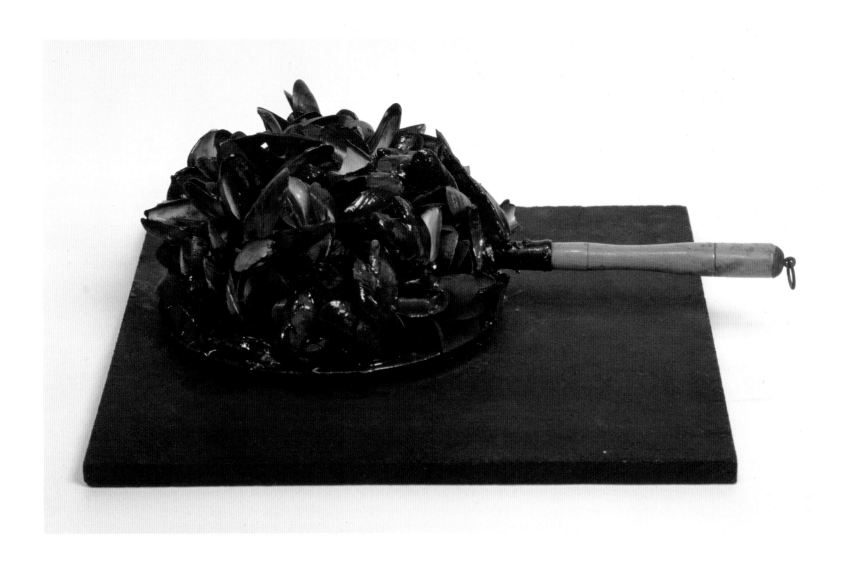

Poêle de moules 1965
mussel shells, frying pan
20 x 45 cm.
Courtesy Marian Goodman Gallery,
New York

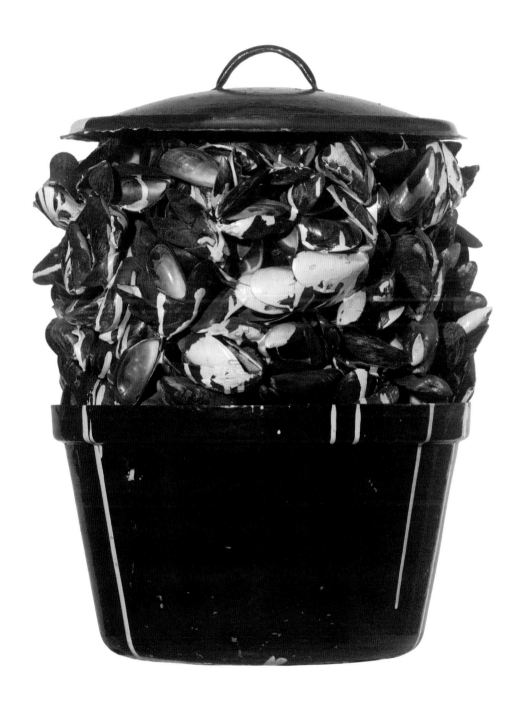

Moules sauce blanche 1967
casserole, mussel shells, paint
50 x 36 x 36 cm.
Collection Mr. and Mrs. Isy Brachot

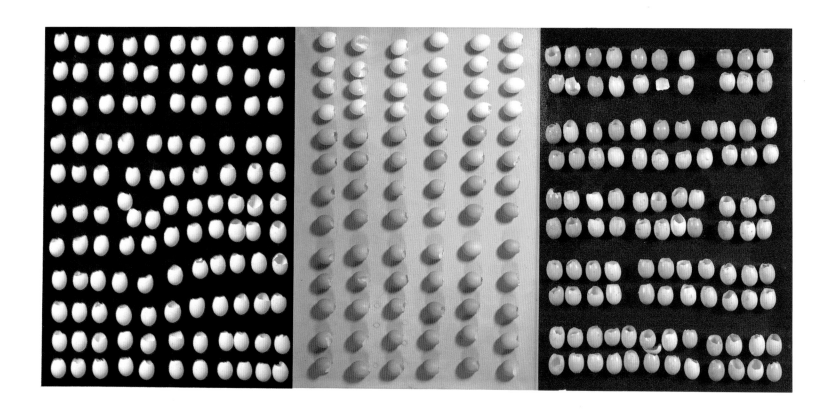

Triptyque 1966
three canvases with paint and
eggshells
each 100 x 70 cm.
Private collection (left), Private
collection (center), Collection
Sylvio Perlstein (right)

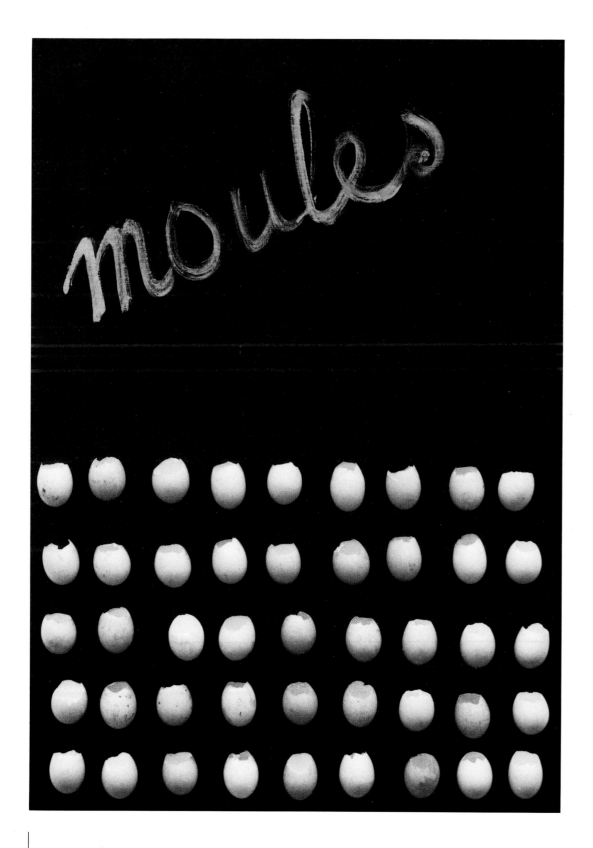

L'Erreur 1966
canvas, eggshells, paint
100 x 70 x 8 cm.
Private collection, on loan to
Museum van Hedendaagse Kunst,
Ghent

Un tableau Magritte 1967
photographic image on canvas
176 x 120 cm.
Collection H. Tob

*Portrait de Maria avec
statif* 1967
photographic image on canvas,
tripod
canvas: 101.5 x 83.5 cm.
tripod: 120 x 15 x 15 cm.
Courtesy Liliane and Michel
Durand-Dessert, Paris

Livre tableau 1969–1970
paint on vacuum-formed plastic
85 x 120 cm.
Courtesy Galerie Michael Werner,
Cologne

Cinéma modèle 1970
paint on vacuum-formed plastic
85 x 120 cm.
Courtesy Galerie Michael Werner,
Cologne

Porte A 1969
paint on vacuum-formed plastic
85 x 120 cm.
Courtesy Galerie Michael Werner,
Cologne

Service publicité 1971
paint on vacuum-formed plastic
85 x 120 cm.
Courtesy Galerie Michael Werner,
Cologne

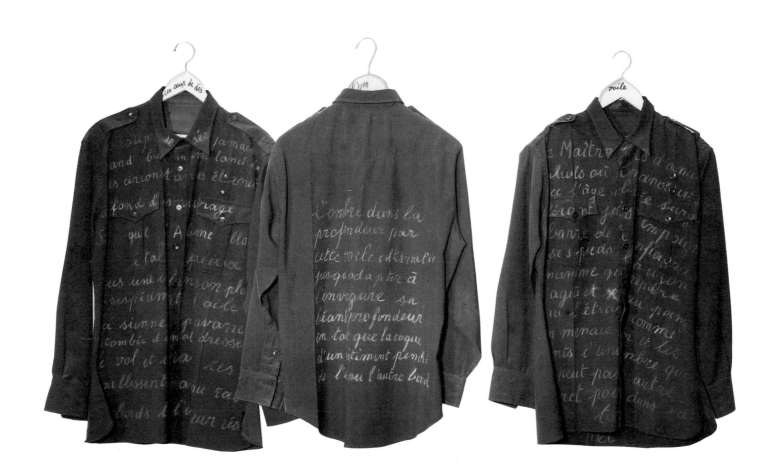

Un coup de dés 1969
three shirts, chalk
100 x 180 cm.
Collection Städtisches Museum
Abteiberg Mönchengladbach

Un coup de dés 1969
oil, felt markers on canvas
165 x 122 cm.
Collection Dr. Speck

Carte du monde utopique
1968–1973
map on canvas, marker
115.5 x 181 cm.
Private collection

*L'Ombre enfouie dans la
profondeur par cette
voile alternative* 1968
markers on canvas
146 x 114 cm.
Private collection

*Etagère avec portrait de
Mallarmé* 1969
wood, paint, photograph
80 x 80 x 25 cm.
Courtesy Galerie Konrad Fischer,
Düsseldorf

Echelle avec alphabet 1965–1971
wood, paint
200 x 60 cm.
Private collection

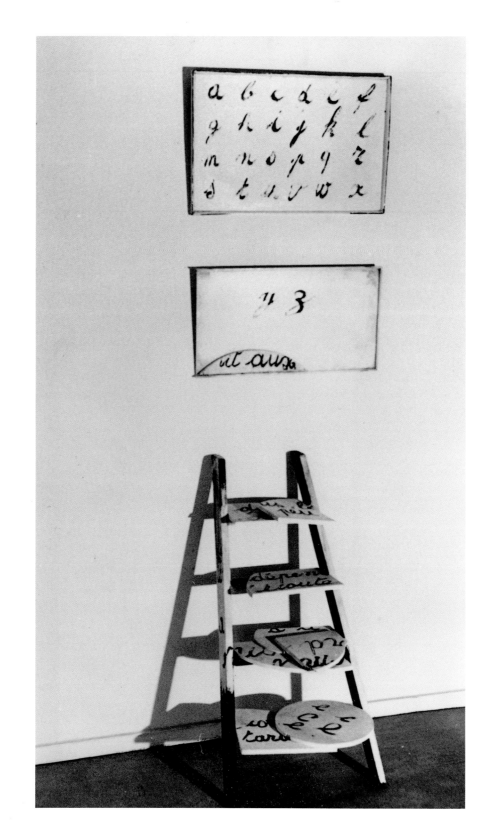

Chaise avec briques et pelle
1969–1973
chair, spade, bricks, paper, paint
chair: 88 x 43 x 36 cm.
spade: 114.5 x 19.5 cm.
Collection Gerald S. Elliott

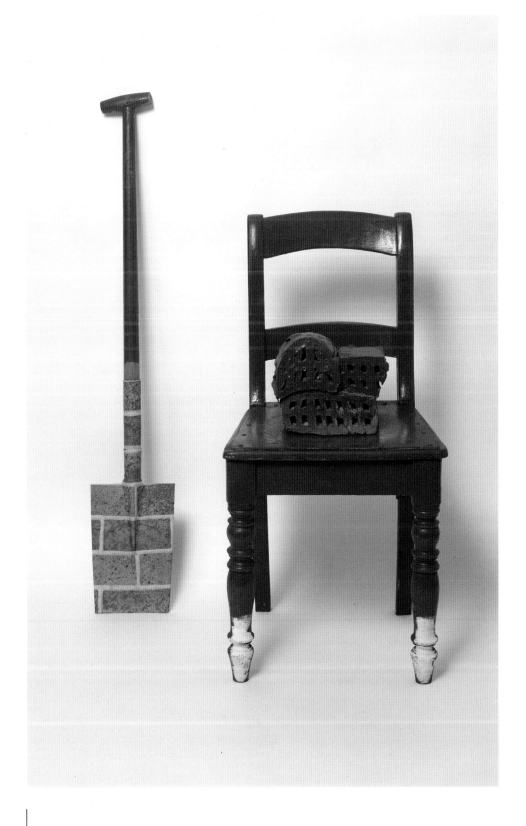

aaa Art 1967
pedestal, paint
100 x 30 x 30 cm.
Courtesy Marian Goodman Gallery,
New York

Casier avec alphabet 1967–1973
wood, paint
63 x 38 x 11 cm.
Private collection

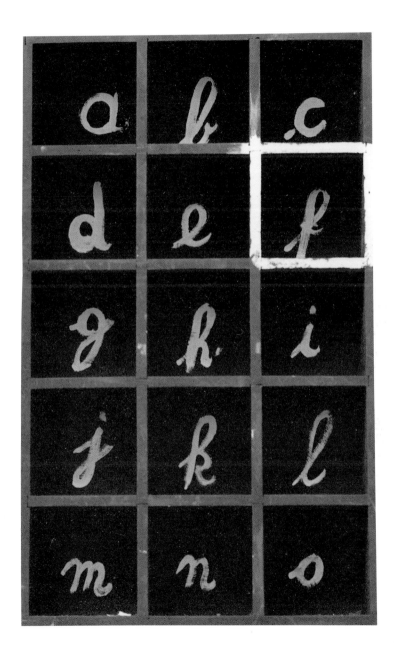

Dix-neuf petits tableaux en pile 1973
stretched canvases, paint
36 x 41 x 33 cm.
Private collection

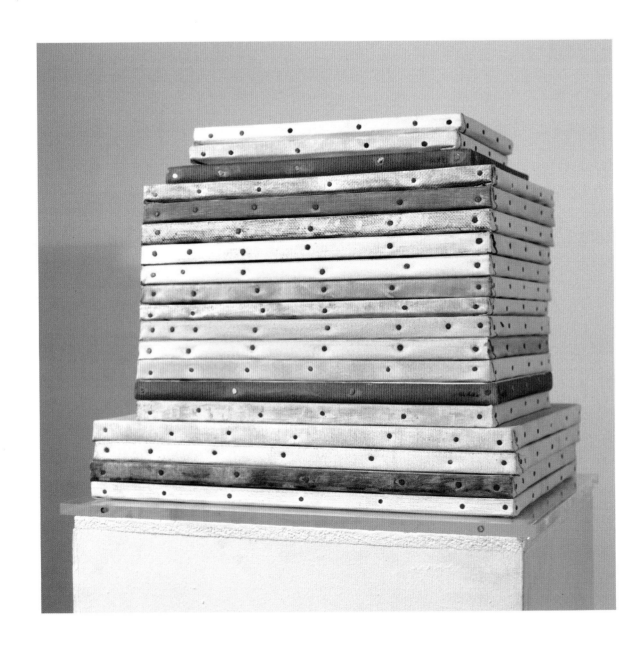

Pyramide de toiles 1973
stretched canvases, paint,
printed card
40 x 65 x 60 cm.
Courtesy Galerie Jule Kewenig,
Cologne

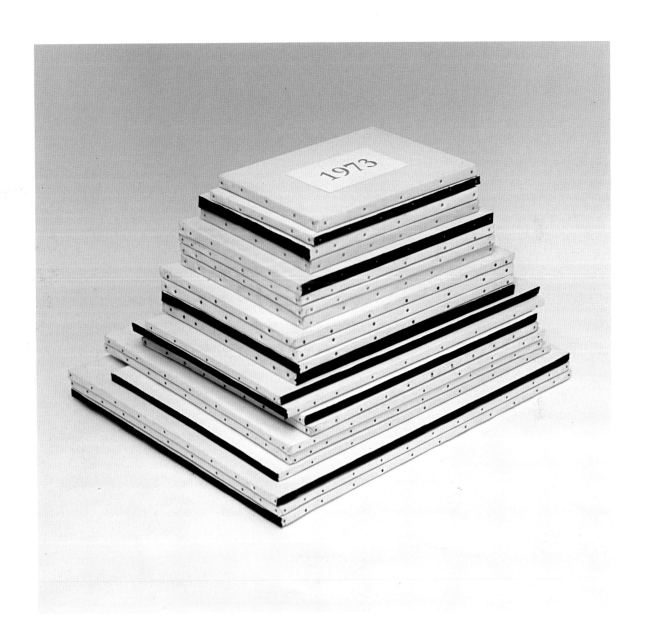

Palette P 1974
gouache and crayon on canvas
board
41.2 x 34.8 cm.
Courtesy Galerie Michael Werner,
Cologne

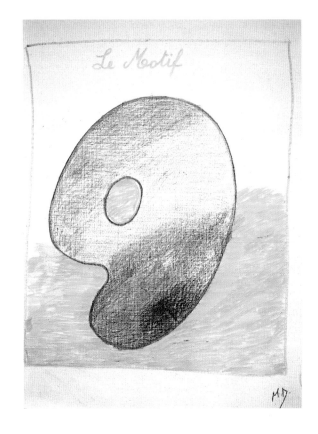

Le sujet 1973
paint and printing ink on canvas
17 x 19.2 cm.
Private collection

Le motif 1973
pencil and pastel on canvas
32.8 x 25.5 cm.
Private collection

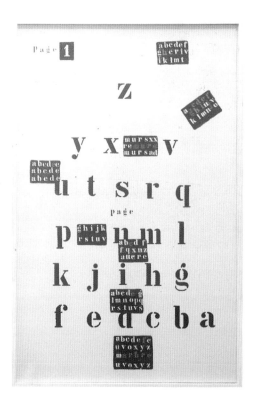

*The Ballad of a Star over Reading
Gaol* 1974
paint on three canvases
each 160 x 100 cm.
Visser Collection

Il est défendu 1975
paint on primed canvas
220 x 138 cm.
Private collection

Il est défendu
d'entrer dans le jardin
avec des fleurs à la main

Il est défendu
d'entrer dans le jardin
avec des fleurs

Un coup de dés jamais n'abolira le hasard. Image.
Antwerp, Wide White Space
Gallery; Cologne, Galerie Michael
Werner, 1969
32.5 x 25 cm., 32 pp.

(opposite, top)
La conquête de l'espace. Atlas à l'usage des artistes et des militaires
Brussels, Lebeer Hossmann, 1975
38 x 25 mm., 38 pp.
offset, boxed

(opposite, bottom)
Plan vert. La porte est ouverte.
Cologne, Galerie Michael Werner,
1972
21 x 14.5 cm., 12 pp.

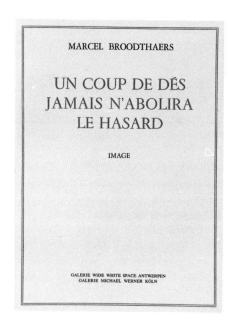

MARCEL BROODTHAERS

UN COUP DE DÉS
JAMAIS N'ABOLIRA
LE HASARD

IMAGE

GALERIE WIDE WHITE SPACE ANTWERPEN
GALERIE MICHAEL WERNER KÖLN

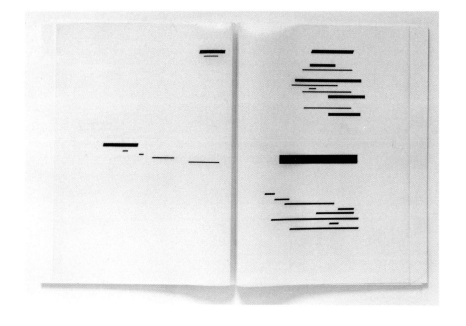

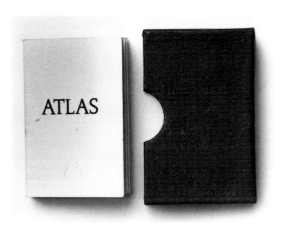

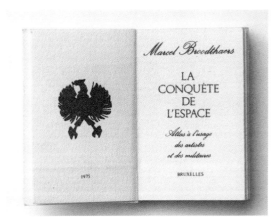

Musée-Museum 1972
lithograph
two sheets, each 50 x 75 cm.
Courtesy Galerie Isy Brachot,
Brussels

Les animaux de la ferme 1972
lithograph
two sheets, each 82 x 61 cm.
Courtesy Galerie Isy Brachot,
Brussels

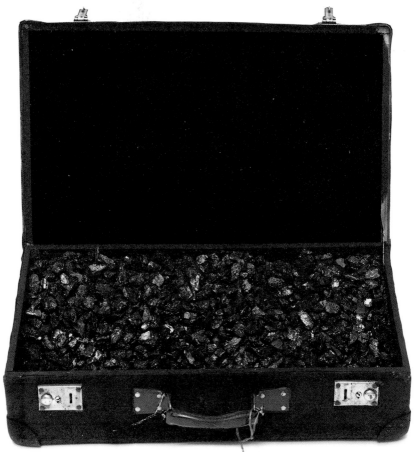

(open and closed views)
Valise charbon 1966
suitcase, coal, paint
23 x 63 x 37 cm.
Courtesy Galerie Konrad Fischer,
Düsseldorf

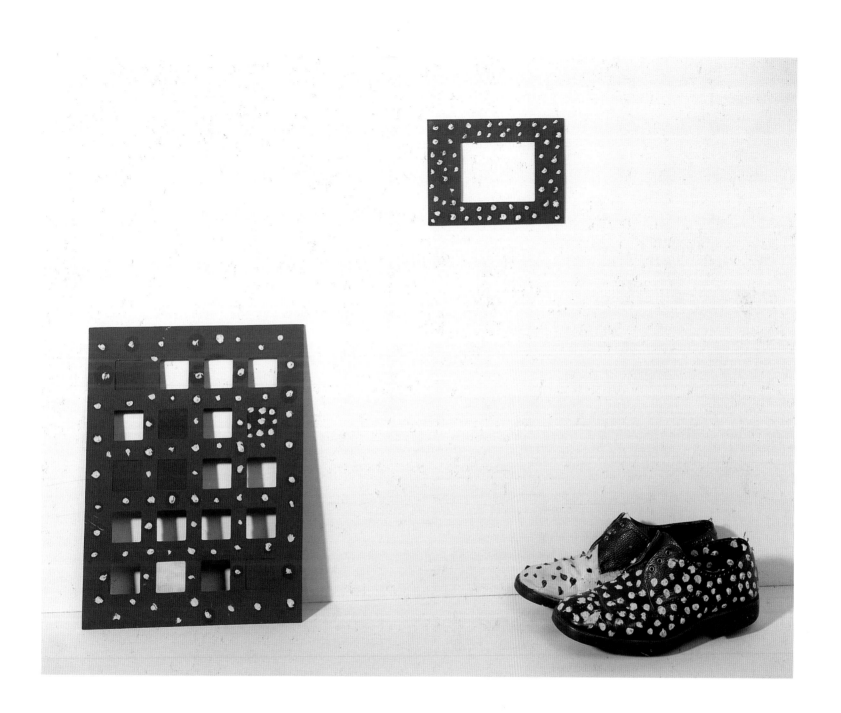

La paire de chaussures 1974
cardboard, shoes, paint
shoes: each 14 x 32.3 x 11.5 cm.
large cardboard: 41.5 x 31 cm.
small cardboard: 16.7 x 21 cm.
Collection Anna and Otto Block

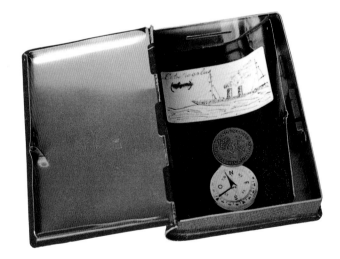

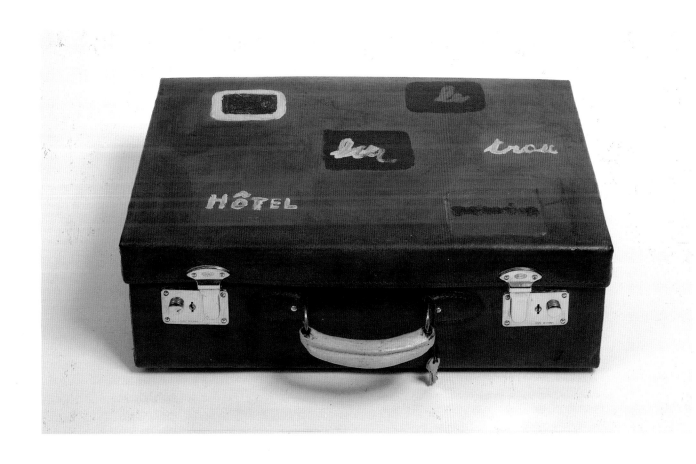

Hôtel 1974
leather valise, paint
35 x 48 x 16.5 cm.
Private collection

(opposite, top)
Un mètre pliable c. 1974
ruler, paint
24 x 3 x 1.6 cm.
Private collection

(opposite, bottom)
Treasure Island (L'Astragalus)
1974
tin box with objects
14.6 x 10 x 3 cm.
Collection David Lamelas

Cheminée d'usine 1974
paint on photographic canvas
dimensions variable
Collection Sylvie Van Hiel

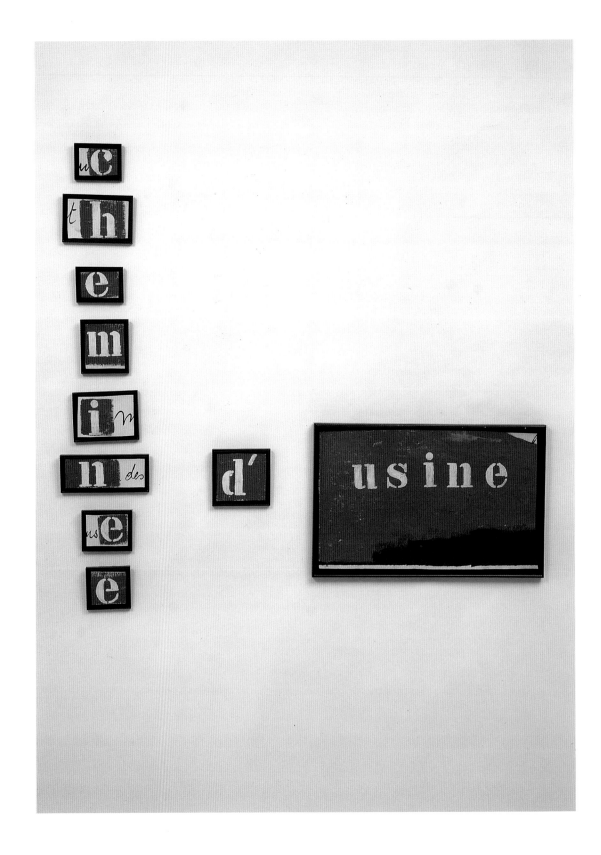

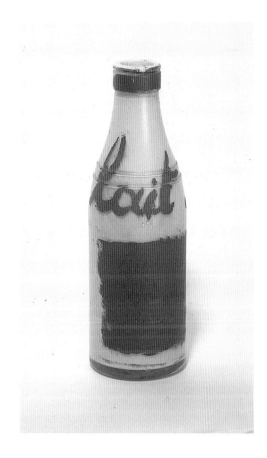
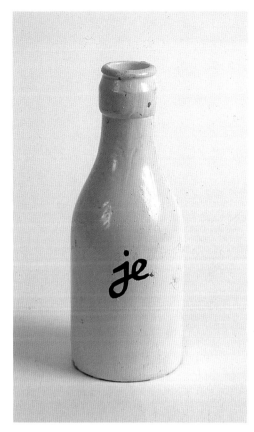

Lait 1973
bottle, paint
28 x 9 x 9 cm.
Collection Pénélope Fiszman

Je 1974
glass bottle, paint
21 x 7.5 x 7.5 cm.
Private collection

Une/un c. 1974
skull, plastic watering can,
paint, cards
skull: 15 x 15 x 21 cm.
watering can: 22 x 16 x 8 cm.
Private collection

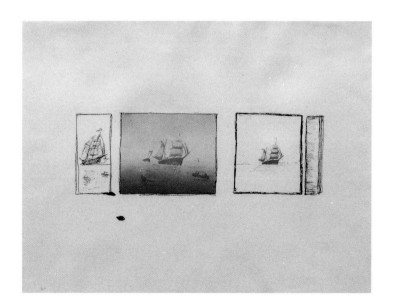

Journal d'un voyage utopique 1973
lithograph and colored ink
95 x 120.4 cm.
Collection The Museum of Modern
Art, New York
Gift of Samuel I. Rosenman

Die crise? . . . Ein Traum
(chien souffrant de la solitude)
1975
drawing and collage on paper
22.7 x 30.2 cm.
Collection Sylvio Perlstein

Baltimore. 1852? 1974
ink on primed canvas
29.5 x 47.5 cm.
Private collection

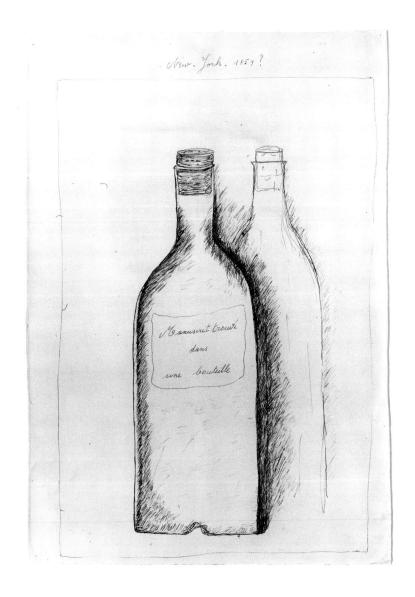

New York. 1854? 1974
ink on primed canvas
47.5 x 29.9 cm.
Private collection

Le Corbeau 1974
ink on primed canvas
47 x 33 cm.
Private collection

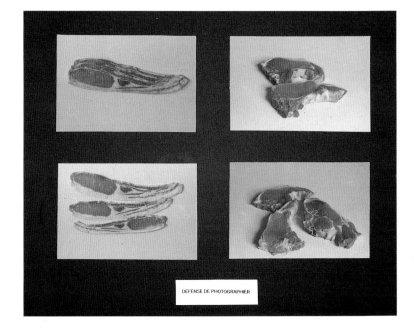

No photographs allowed/Défense
de photographier 1974
framed and labeled photographs
each 28 x 31.5 cm.
Private collection

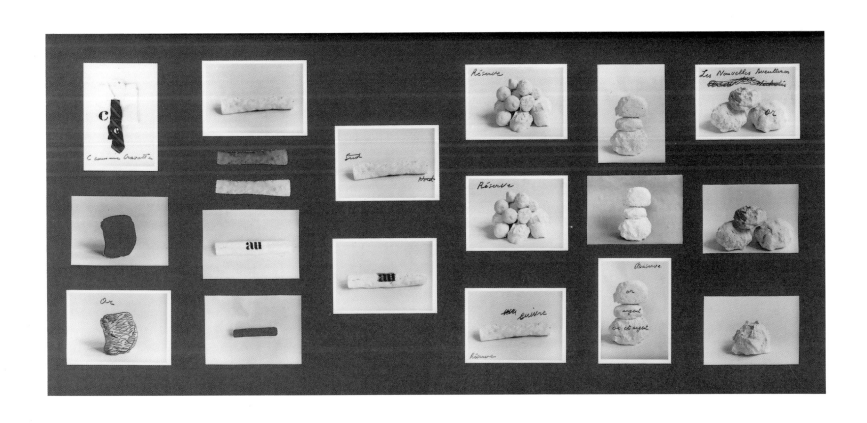

Untitled c. 1974
nineteen black and white
photographs with ink and cutouts
41 x 86 cm.
Mounted by Maria Gilissen, 1988
Private collection

VIPERA AD VIVUM DELINEATA.

Portraict du Sycomore.

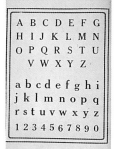

A B C D E F G
H I J K L M N
O P Q R S T U
V W X Y Z
a b c d e f g h i
j k l m n o p q
r s t u v w x y z
1 2 3 4 5 6 7 8 9 0

of Mercury is represented in the accompa
phenomenon took place in 1845, but ther

Fig. 577.—Transit of Mercury.
The first recorded took place in Novembe

PRAISE TO GOD.

HUMILITY.

THE DYING CHRISTIAN.

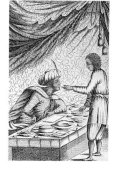
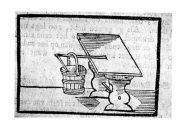

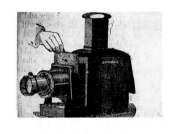

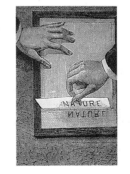

Extracts from *Un jardin d'hiver*
(unfinished work)
Slide projection using
two carousels
Courtesy Galerie Michael
Werner, Cologne

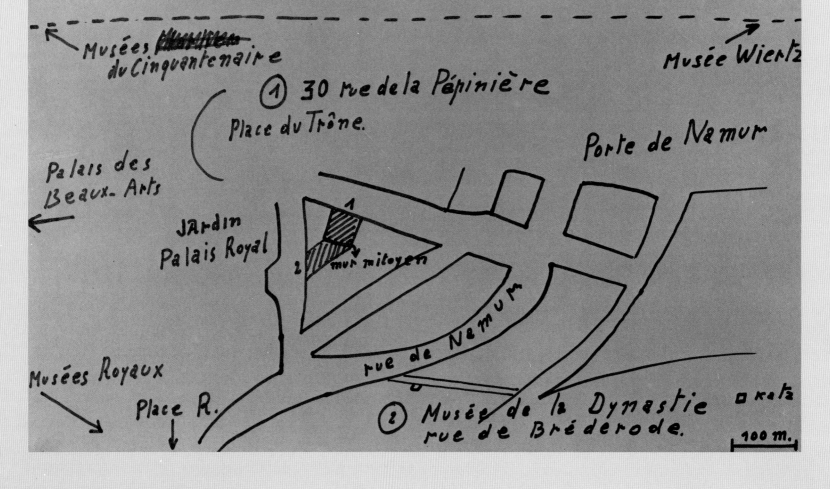

Plan du musée d'art moderne de Bruxelles.

I. Departement
des Aigles

Musées du Cinquantenaire

Musée Wiertz

① 30 rue de la Pépinière
Place du Trône.

Porte de Namur

Palais des
Beaux-Arts

Jardin
Palais Royal

2 mur mitoyen

rue de Namur

Musées Royaux

Place R.

② Musée de la Dynastie
rue de Bréderode.

100 m.

The Castle, the Eagle, and the Secret of the Pictures

Martin Mosebach

In 1968, Marcel Broodthaers occupied a house in Brussels's rue de la Pépinière in the vicinity of the Palais Royal. The small garden of the house lay only a street away from the palace gardens, and on days when royal garden parties were held, the usher's voice announcing the guests would carry into Broodthaers's house. His dwelling was typical of hundreds in Brussels. Even today there are few qualms about pulling such buildings down. Indeed, this is what happened to Broodthaers's house about the time of his death.

Such houses are tall and relatively narrow; on the main floor, three connecting parlors lead in from the facade, with its view onto the road, to the garden behind with its high walls. Despite their shoulder-to-shoulder construction, the houses are discrete; once inside, one is no longer aware of a neighbor. These once middle-class houses tell of the wealth this country must have enjoyed in the nineteenth century; but they also intimate how heavily the burden of the past must rest upon Belgium today, marked as it has been by economic crises and national strife. In a house of this kind, Marcel Broodthaers was surrounded by the aesthetic atmosphere of the nineteenth century—not, however, in its original opulent, triumphant guise, but rather in a state of exhaustion to which the ceremonial calls of the royal usher beyond the garden wall lent an amusing flavor.

In the immediate vicinity there was one of those forgotten, dusty little museums that live out their twilight without a public and are known only to the fiscal administrators who pay the warders. This was the Musée de la Dynastie, accommodated in a building not very much larger than Broodthaers's own and replete with memorabilia of the House of Saxe-Coburg-Gotha, which has been the Belgian royal family since 1830. In this museum the solemn custodian with tarnished gold braid sells admission tickets and then, with great dignity, opens the passage through the little galleries with their display cases in which rest the sepia photographs, pallid documents and disintegrating bits of uniform. The absurdity of this museum, touching in its futile ceremoniousness, wrapped it in a magic cloak of invisibility against the eyes of the impassioned reformers. And it became, as it were, the opposite pole to the Palais des Beaux-Arts, which in 1968 was embroiled in the politics of the day and occupied by artists and students. While the Palais des Beaux-Arts was shaken by the dispute

Plan du musée d'art moderne de Bruxelles 1969
marker on cardboard
59.5 x 85 cm.
Collection Benjamin Katz

about its purpose and its exhibition policy, the *idea* of a museum such as the little Musée de la Dynastie emerged with particular clarity—precisely because it lacked categorically "serious" exhibits. Not very long after Broodthaers himself had left the occupation of the Palais des Beaux-Arts, the rue de la Pépinière boasted another museum—his *Musée d'Art Moderne, Département des Aigles, Section XIXème Siècle*. Although Broodthaers naturally figured as the curator or director of the institute he had established, he wryly bestowed the honor of inaugurating it with a "real" museum director, Dr. Johannes Cladders of the Städtisches Museum, Mönchengladbach. No sooner was it open, however, than the new establishment proved to be only the germ of a developing edifice of giant proportions. Until 1972, one new section of Broodthaers's museum followed another, each giving only a hint of an overall system that would never actually materialize.

The riddles began with the very name of the institution; anyone who accepts the consensus that the essential feature of modern art is its break with the traditions of the nineteenth century must wonder what a museum of modern art was doing with a department dedicated to the "anathema" of a superseded artistic era. And what was the *Département des Aigles?* At first it might seem as if the new museum were divided not only into *Sections* but *Départements* as well—but closer inspection would soon reveal that the *Musée* and *Département des Aigles* were identical, the museum as a whole thus constituting but one department of a colossal organization lodged in obscurity, able with its *Sections* to touch every sphere of life. No doubt the general affront to traditional institutions had aroused in Broodthaers an almost wanton urge to take up what was so sorely beset and create it anew according to his own ideas. In view of how his *Museum* project developed, it would not be unthinkable to suppose that he imagined himself countering chaos with an ephemeral, delicate, yet comprehensive system of order. But Broodthaers did not aspire to be a philosopher articulating the mysteries of the universe; the poet's grace preserved him from that. "A mes amis," writes Broodthaers as a museum curator, praising the facilities in his establishment, the tills, the devoted staff, etc., without so much as a mention of the exhibits: "peuple non admis. On joue ici tous les jours, jusqu'à la fin du monde" ("people not allowed. Here there is play everyday, until the end of the world"). One senses that Broodthaers meant to deny access to a particular group of people—to those whom the German poet Christian Morgenstern had in mind when he wrote, "who asks, is judged. There shall be no defining here! Here what's done is poetry in itself." Marcel Broodthaers, too, was creating poetry "in itself" in creating the *Museum*, even though his starting point was a set of extraordinarily crude political facts and he kept reality strictly within his sights, like any master of the absurd.

Broodthaers's procedure was systematic. He developed his *Musée d'Art Moderne* single-mindedly from the barest fundamental notions to an almost threateningly encyclopedic

visualization, and then made the accumulated array vanish again with little warning.

On 27 September 1968, the first section of Broodthaers's *Musée d'Art Moderne* opened its doors in the rue de la Pépinière. On the two windows looking out onto the road was written "Musée," "Museum." The three main rooms were furnished with large crates of the kind museums use to ship works of art. Inscriptions in typical stenciled lettering—"Picture," "Keep dry," "With care fragile"—betrayed their purpose. What had happened? Had the pictures which might have explained the riddle of a nineteenth-century department in a museum of modern art never even been removed from their cases? Or were they already packed and waiting to be shipped away again?

Some forty postcards were stuck on the wall, with reproductions of paintings by David, Ingres, Courbet, Corot, Winterhalter, etc., recalling the practice of museums of putting a photograph and a brief explanatory note in the place of a painting undergoing restoration or sent away on loan. Had the reproductions already become worthy of the museum, while paintings slumbered in the dark of their crates? Ultimately the reproduction was the very proof of the work of art's existence, proof which the painting itself could no longer supply. The relationship between photograph and painting was now possibly akin to that between the gold ingot and the banknote—it becomes irrelevant whether or not the paper currency is backed by gold, so long as there are no troublemakers to destroy the fiction of such backing.

Almost in passing and barely perceptible for the superficial beholder, Broodthaers also demolished the illusion that such questions applied only to the paintings of the nineteenth century: among the postcards were two which crossed the boundary of that era into the past and the future. One was Jean Fouquet's *Madonna and Child* in Antwerp, regarded as one of the earliest paintings in a distinctly French tradition. The other was by Magritte, showing a painting of a landscape in front of the real landscape. The latter was turned face to the wall and bore an inscription "Musée des Aigles" and only turned face up later. All art is synchronous, Broodthaers seems to have been proclaiming just as he had begun to erect his complicated, categorizing system of reference. It is precisely paradoxes of this kind that vitalize Broodthaers's oeuvre and contradict any suspicion that it is no more than charades or decipherable metaphors.

The sum and climax of all these elements that defy dissection—and, thus, removal—by explanation simple or strenuous, is the eagle or, rather, the eagles that soared like guardian spirits over the inventions of Broodthaers's *Museum* and who lent the *Département des Aigles* its name. It is worth casting a glance at these eagles before we look in more detail at the series of *Museum* sections themselves, for the bird represents the signature under which each project was realized. The meanings of the eagle symbol are legion; mythology, gnosis and heraldry teem with eagles and yield weighty interpretations to which one can only object that they totally contradict the artistic style of Broodthaers. He was not a man to work with "educated"

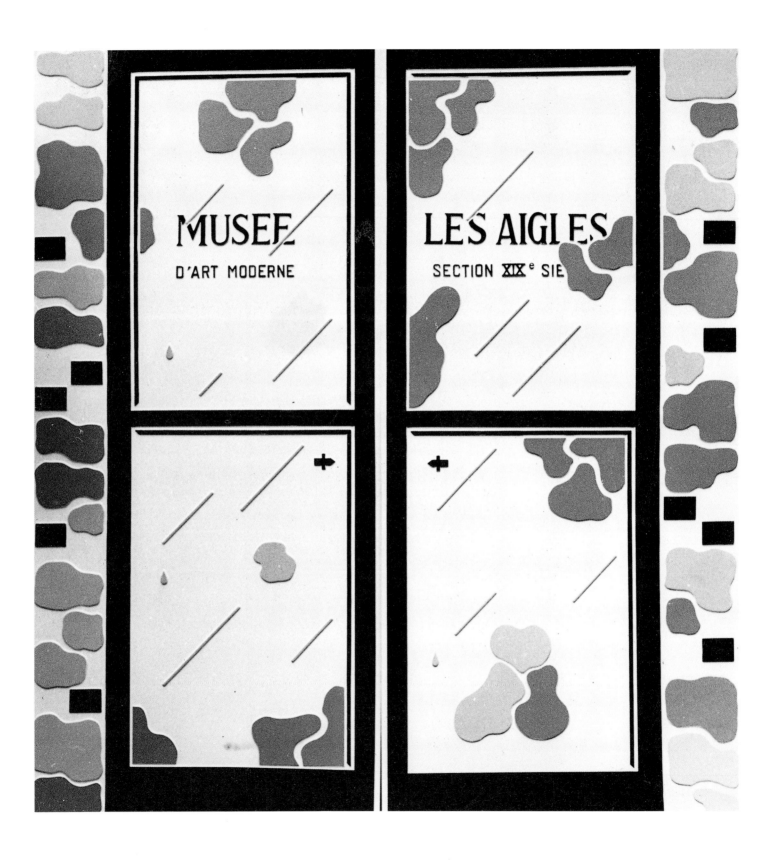

allusions. It would have gone against his grain to supply his skillfully concealed inventions with a key that any scholar would recognize. As always, the way to understanding is through poetry. His eagles soar in the most spiritual and ethereal sphere attainable by the human soul—the sphere of words. The eagles first appear in a play of sound and alphabet. In 1935 the hermetic poet Raymond Roussel described, in his programmatic essay "Comment j'ai écrit certain de mes livres," an age-old procedure that has been frequently applied in popular verse as well as in the nonsense verse that developed from it. This is the development of meaning out of like-sounding words: "I chose two almost identical words. . .for instance, *billard* and *pillard*. To these I would then add words that sounded the same but were to be understood in two different senses, and thus obtained two almost identical sentences. . . . Once the two sentences had been found, the point was to write a narrative that could begin with the first sentence and end with the second." Marcel Broodthaers was still a poet who had no thought of letting his ideas become object or drawing when he first composed his now famous poem of six words, amounting to no more than an evocation: "O mélancholie, aigre château des aigles" ("O melancholy, bitter castle of eagles"). Whether these *aigles* sprang from the unexpected adjective "aigre" ("bitter"), or whether "aigre" is a match for the precedent "aigles" ("eagles"), remains the poet's secret; what seems certain is that Broodthaers heard the sound of the two words and found them closely related, and that he therefore set about bestowing upon them a sense that would also link them across the surface of connected meaning, of context. In this way the stern Castle of Eagles as an aerie of Melancholy became a resonant image—but far be it from Broodthaers to let it rest there. "Aigre" strongly suggested "vinaigre" ("vinegar"), which is how there arose before his mind's eye in 1971 an enormous vinegar factory to be installed in one of the ruined castles (*Château des Aigles*) on the romantic Rhine, whose trademark should be, of course, the eagle. In this playful manner the pure sound, having evoked the high tone of contemplative lyricism, flowed into the grotesque; but it would be misleading to think Broodthaers had now found his goal, for he was not so far committed to the laws of pure sound as to make do with puns and nothing more.

Many years after the line of poetry had appeared in print, the eagles reappeared: in the *Département des Aigles* they lent to the individual stages of his *Museum* that soaring magic which made it quite impossible to understand these installations as merely the illustrations of a topical critique. Of course, Broodthaers did not miss the opportunity of disseminating in an array of different catalogue texts the most contradictory, confusing interpretations of his eagles, and the public eagerly took him at his word, even though, knowing his method, every one of his "scientific" or "scholarly" explanations should have been recognized as a fiction. Yet even these statements conceal hints that direct one's eyes in the right direction. For instance, when Broodthaers declares that for him there is "an identity of the eagle as idea, with art as idea," he is creating a genuine allegory; not, of course, in any sense that the

Untitled (Les portes du musée)
1968–1969
paint on vacuum-formed plastic
190 x 180 cm.
Collection Diego Cortez

eagle possesses traits which predestine that fowl to be an emblem for art, but in a sense resting upon his own artistic experience.

The fact is that Broodthaers's *Musée d'Art Moderne* has as many faces as he created versions of it. For the artist himself, who saw the whole, vast network before him, the individual projects cannot have seemed paradoxical, whereas his audience was confronted with new enigmas every time. An almost total absence of image alternated with an overwhelming flood of pictures. The public of the first section of the *Musée d'Art Moderne* in Brussels, having been faced with the large picture crates and having come into contact with paintings only in the shape of postcard reproductions, stood in Düsseldorf two years later before a wall of genuine nineteenth-century paintings borrowed from the reserves of the Düsseldorf Kunstmuseum and hung in the symmetrical manner of old galleries. Broodthaers had seen to it that the various genres, the mythological and the history painting, the portrait, the landscape, the still life and the preparatory sketch, were each represented by one or two examples. The pictures had returned, but as mere examples, standing for their kind rather than for themselves. The most gigantic enterprise of all was the *Section des Figures*, completed in 1972, in which the eagles appeared for the first time not only in the title and name of a *Département*, but also as a physical subject of the exhibition, in the shape of numerous loans from some of the greatest and remotest museums of Europe and abroad. *Der Adler vom Oligozän bis Heute* (*The Eagle from the Oligocene to the Present*) was the seemingly tame subtitle of an exhibition in which images of the eagle—in wood, stone, sheet metal, cloth or paper, as the object of an excavation, as work of art, as craft object and as consumer goods, in immense variety and from all epochs—lay in showcases, hung on walls and stood on pedestals. Every object, no matter whether a drawing by Ingres or an Adler typewriter, was provided with the note, "This is not a work of art!" To reverse Duchamp's procedure seemed nothing if not apt, for Duchamp had once attributed the character of a work of art to objects of daily life and then transported them as such into the museums; now Broodthaers was categorically denying works of art of the highest order and objects of daily use alike any character of artworks and exhibiting them for just that reason. The *Museum* became the location of the "non-artwork," perhaps even the place that robbed an object of its characteristic of being a work of art. Every one of the exhibits could be seen as just a "figure," an exemplum of something great that stood behind it and from which alone it drew its vital force and significance. And this greater eagle experienced its hundredfold reproduction in the exhibits without once being rendered quite as it was. Broodthaers's allegory of art—the eagle—remained invisible, but was simultaneously the only *real* work of art, the creative second in which a human spirit can make a living entity out of the dead material tumbling around it.

Within the framework of a brief description, it is impossible to illuminate the numerous

aspects of this *Section*. Particularly deserving of detailed consideration would have been Broodthaers's attitude toward realism and his comprehensive conception of the museum. It is a concept that rejected every deadening categorization and simultaneously wanted the museum sealed off for certain forms of "wild creativity." Accordingly, despite such abundance of images and thought, the museum remained of fleeting corporeal reality and fragile attractiveness.

Among the eleven *Sections* of the *Musée d'Art Moderne* that Broodthaers realized (together with the concluding *Musée d'Art Ancien*), the *Section Documentaire* deserves particular mention. In order to give his museum a domicile, Broodthaers and a friend marked out a site on a patch of wet beach at Le Coq on the Belgian Channel coast, drew out the ground plan with a spade and put up three placards designating the area as the site for the *Museum voor moderne Kunst*. The returning tide washed over the beach, dislodged the placard from the ground and obliterated every trace of the grand scheme. Broodthaers had once again demonstrated that his museum was not of this world, and in so doing joined the ranks of poets such as Keats, upon whose Roman grave only this line stands—"Whose name is written in water." This conspicuous submerging of the *Musée d'Art Moderne* predated its real liquidation, but foretold that event in its necessity. What remained were photographs and documents and a host of works of art which Broodthaers had made in relation to the *Museum* project.

The most beautiful of these works today emerges as the essential monument to the fictitious, inner museum which Broodthaers had placed under the aegis of the eagle. This is a reconstruction in full scale of one and a half rooms in the rue de la Pépinière, the house that has now vanished from the site. In these rooms, where the first manifestation of the *Museum* came to be, words denoting concepts from the world of art and of painting are written in an elegant hand across the walls. That world itself remains concealed. It is as if *La salle blanche*, where no picture appears, was intended to become a magic space where, by conjuring up the properties and fundamentals of art and of painting, the artist literally paints the first truly new picture before the incredulous eyes of the beholder. *La salle blanche* was Marcel Broodthaers's last work, the work of an artist who, as far as his real intentions are concerned, remains intangible. He never gave away what the picture he was hoping for might look like. His message is concealed beneath the grace of the poet at play. It was his own will that the eagles should only become visible for a short time. Upon their disappearance, their power once again resides in the influence of their legend.

Translated by Stephen Reader

The Museum and The Décors

Musée d'Art Moderne, Département des Aigles, Section XIXème Siècle

rue de la Pépinière, Brussels,
27 September 1968–27 September 1969

This first manifestation of the *Musée d'Art Moderne* was installed at the artist's home, which also served as his studio, and remained in place for one year. The museum consisted of crates which had been used to ship artworks, postcards of nineteenth-century French paintings by artists such as Courbet, Meissonier and David, a slide projection, and, for the occasions of the opening and closing, an empty transport truck parked outside the building. During the year of its existence, various events and performances took place.

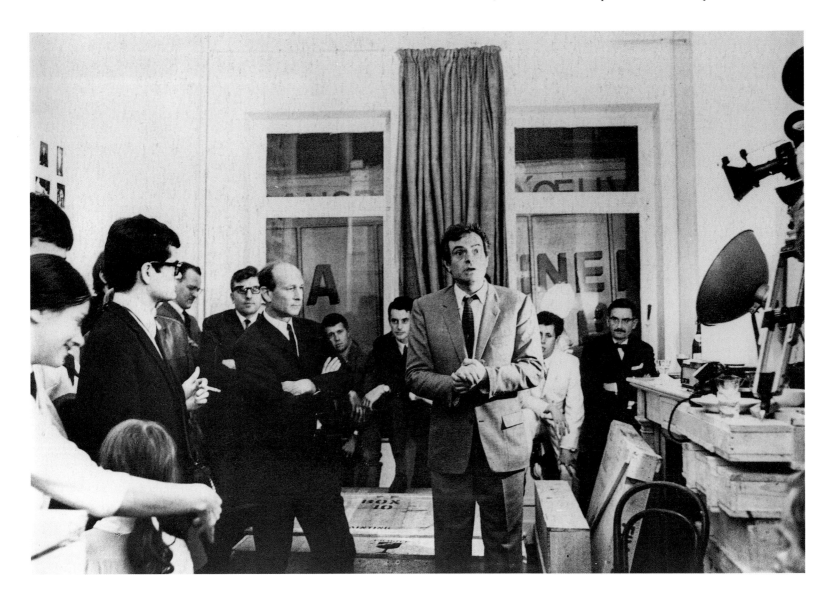

MUSEE D'ART MODERNE
Département des Aigles

Marcel Broodthaers prie

de bien vouloir assister à l'inauguration de la section XIXᵉ S.
du Département des Aigles par
Monsieur J. CLADDERS Dr. Phil.
Directeur du Musée de Mönchen-Gladbach
qui aura lieue vendredi, le 27 septembre à 19 h. 30.

R.S.V.P. avant le 25-9-68
30, rue de la Pépinière
Bruxelles 1 - Tél. 02/12 09 54

Buffet froid.

(opposite)
Broodthaers speaking at the
opening. At his right is Dr.
Johannes Cladders, then director
of the Städtisches Museum
Mönchengladbach. The empty
transport truck is visible through
the window.

(top, left)
Invitation to the opening.

(top, right)
Interior of the museum.

Musée d'Art Moderne, Département des Aigles, Section XVIIème Siècle

A 37 90 89, Antwerp,
27 September–4 October 1969

The seventeenth-century section of Broodthaers's *Musée d'Art Moderne* opened in Antwerp on the same day that the nineteenth-century section closed in Brussels. The Antwerp installation, like that in Brussels, included inscriptions, packing cases, a ladder, and postcards of artworks. The opening ceremony was conducted by P.K. van Daalen, director of the Zeeuws Museum, Middelburg, The Netherlands.

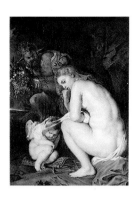

Guests travelled by bus from the
closing of the *Section XIXème Siècle*
in Brussels to the opening of the
Section XVIIème Siècle in
Antwerp. (top) Broodthaers is at
right, Dr. Johannes Cladders at left.

(opposite)
Ten postcards of paintings by Peter
Paul Rubens, from the group of
twenty installed in this *Section*.

Announcement showing the
exterior of A 37 90 89 in Antwerp,
an alternative exhibition space
whose name was borrowed from
the telephone number of the gallery.

Musée d'Art Moderne, Département des Aigles, Section XIXème Siècle (Bis)

Städtische Kunsthalle Düsseldorf,
14–15 February 1970

Broodthaers's contribution to the group exhibition *between 4*, this installation was a continuation of the nineteenth-century section of his museum. The artist borrowed eight nineteenth-century paintings from the collection of the Düsseldorf Kunstmuseum and hung them in two rows according to size, shape, and genre. On the other walls he hung postcards, photographs of the Brussels installation, and posters from both the Brussels and Antwerp *Sections*. Opening speeches were made by Broodthaers and the assistant director of the Kunsthalle, Jürgen Harten.

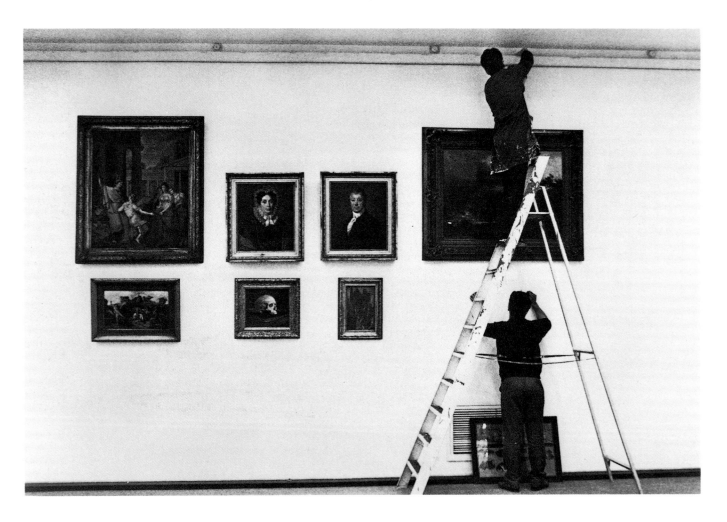

Installation view.

Musée d'Art Moderne, Département des Aigles, Section Documentaire

beach at Le Coq, Belgium, 1970

A less formal manifestation of the museum took place on the beach at Le Coq, on the North Sea coast of Belgium, in the summer of 1970. Broodthaers, working with Herman Daled, marked out and then dug into the sand forms that suggested the plan of a museum. While working, they wore caps inscribed "museum." They set up posts with lettered placards whose translation from the French and Flemish reads, "Touching the objects is absolutely forbidden."

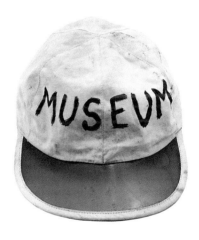

The hat worn by Broodthaers, now in the collection of Harry Ruhé.

View of the ground plan of the *Section Documentaire*.

Musée d'Art Moderne, Département des Aigles, Section Cinéma

Burgplatz 12, Düsseldorf,
Winter 1971-Fall 1972.

The *Section Cinéma* took place in a subdivided basement room at the Haus Burgplatz. In the larger portion several films, including one by Chaplin and a travelogue of Brussels, were projected; in the smaller space was an arrangement of various objects, including a trunk containing items ranging from Georges Sadoul's book *L'Invention du Cinéma* to a framed photograph of an eagle's head.

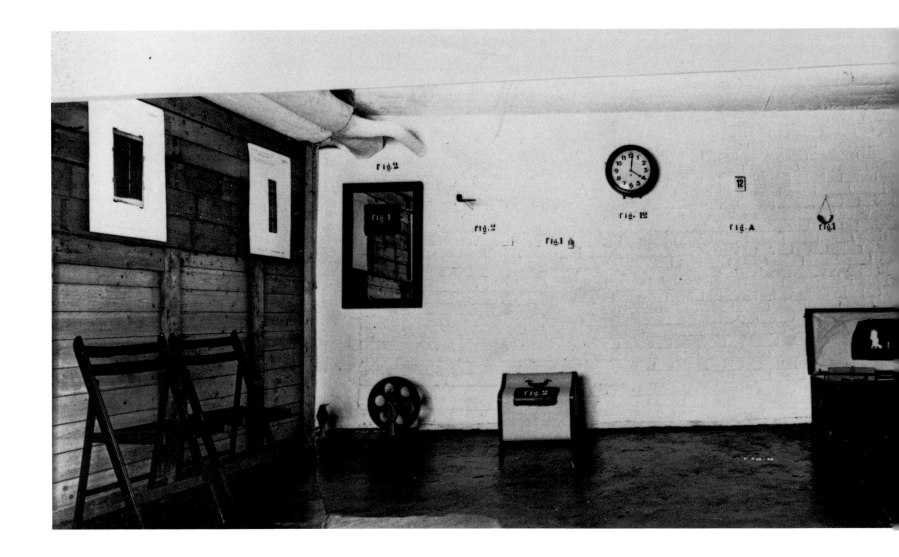

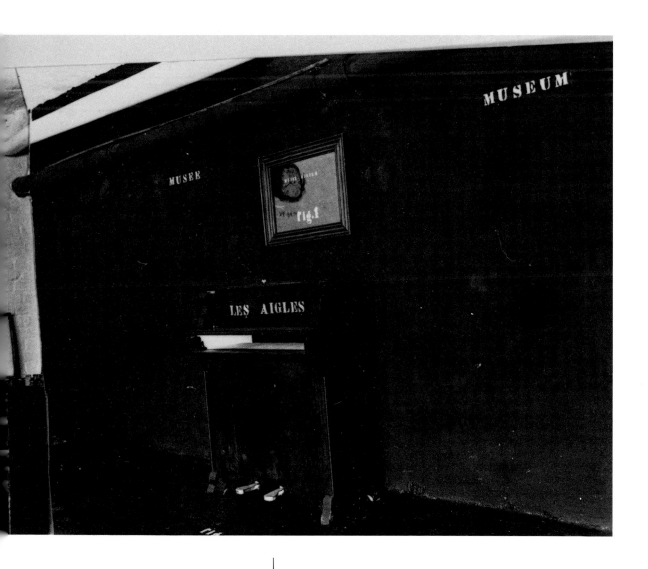

Copy of *L'Invention du Cinéma* by Georges Sadoul, with stenciling by Broodthaers.

The smaller room.
A photographic work about this installation was given the title *Théorie des figures*, which has also been applied to the ensemble of objects along the rear wall, now in the collection of the Städtisches Museum Abteiberg Mönchengladbach.

Musée d'Art Moderne, Département des Aigles, Section Financière

Cologne Kunstmarkt,
5-10 October, 1971

During the Cologne Art Fair, Broodthaers put the *Musée d'Art Moderne* up for sale, "due to bankruptcy."

[The first page of the manuscript is missing.]

1. ...

2. .. by means of an intermediary.

3. In the event that the publisher K or the intermediaries refuse to accept this percentage, it will be returned to the account of the Museum of Modern Art.

4. The Kilogram of gold, in bar or lingot, from a source at the discretion of the purchaser—cost of transit at his expense—is proposed as an unlimited edition.

5. The price is fixed at double the current rate. Payment in cash.

6. Each kilo of gold is stamped by means of a punch with the eagle, the mark of the Museum of Modern Art, and accompanied by a manuscript letter from the curator in order to prevent the production of fakes.

7. The purchaser is free to have his lingot or bar melted, so as to obliterate the mark, or to burn the letter of identification in order to enjoy fully the purity of the substance and the freshness of the originial intention.

8. An example of the edition will be deposited in a bank, in a strong-box in the name of the Museum of Modern Art, Department of Eagles (see photograph).

9. For all information, write to: The Curator
 Musée d'Art Moderne
 Department of Eagles
 12 Burgplatz - 4 Düsseldorf

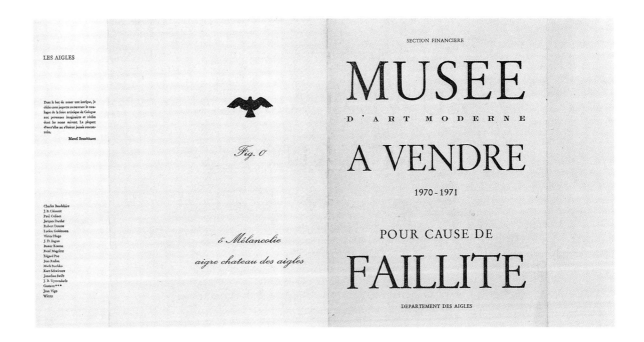

Announcement of the sale of the museum, which was made in the form of a wrapper for the Cologne Art Fair catalogue. Below is the announcement for a special edition of nineteen of these wrappers. The back inside flap contained a dedication to nineteen individuals and each copy had a different citation in manuscript celebrating one of these names.

(opposite)
Gold bar, stamped with an eagle, which Broodthaers intended to offer for sale at double the current market price of gold. Half this price may represent its value as gold and half, its value as art. The profits realized from the sale of this edition were intended for the benefit of the *Musée d'Art Moderne*. The text is a contract of sale to accompany the gold bar, of which an edition was published posthumously in 1987.

19 KATALOGE DES KUNSTMARKTES KÖLN 1971

ZU VERKAUFEN
WEGEN
KONKURS

Section Financiere. Musée d' Art Moderne. Dt des Aigles.

PREIS DM 300,-

AUSSTELLUNG VOM 8. - 13. NOVEMBER 1971
GALERIE MICHAEL WERNER, 5 KÖLN 1, ST. APERNSTRASSE 14

Musée d'Art Moderne, Département des Aigles, Section des Figures *(Der Adler vom Oligozän bis Heute)*

Städtische Kunsthalle Düsseldorf,
16 May-9 July 1972

Broodthaers's most ambitious museum installation, this exhibition was created at the invitation of Jürgen Harten, who had become director of the Kunsthalle Düsseldorf. It comprised over 300 objects representing eagles, borrowed from numerous museums and private collections in Europe and abroad. The exhibition surveyed the period "from the Oligocene to the present," and each object was provided with a label which stated, "This is not a work of art!" Two slide projectors provided additional images taken largely from advertising and comics. Broodthaers published a two-volume catalogue to accompany the exhibition.

MUSEUM

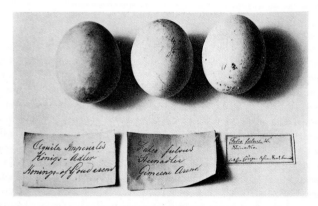

Kunstmuseum Basel Kupferstichkabinett
Staatliche Museen Stiftung Preußischer Kulturbesitz Berlin (West)
Antikenabteilung, Kunstbibliothek, Kunstgewerbemuseum
Kupferstichkabinett, Museum für Islamische Kunst
Nationalgalerie, Skulpturenabteilung, Museum für Völkerkunde
Abt. Amerikanische Archäologie
Staatliche Museen zu Berlin (Ost) Vorderasiatisches Museum
Akademisches Kunstmuseum der Universität Bonn
Musées Royaux d'Art et d'Histoire Brüssel
Département d'Antiquités Précolombiennes, Département de
Céramique, Département de Folklore, Département de Tapisserie
Musée Royal d'Armes et d'Armures Brüssel
Musée Wiertz Brüssel
Hetjensmuseum Düsseldorf

MUSEUM

ow and elongated, differing from the heavier, broader form of living

FIG. 1.—Skull of *Palaeoplancus sternbergi*, natural size. The cranial portion, shown by dotted lines, is crushed and distorted in the specimen.

Kunstmuseum Basel Kupferstichkabinett
Staatliche Museen Stiftung Preußischer Kulturbesitz Berlin (West)
Antikenabteilung, Kunstbibliothek, Kunstgewerbemuseum
Kupferstichkabinett, Museum für Islamische Kunst
Nationalgalerie, Skulpturenabteilung, Museum für Völkerkunde
Abt. Amerikanische Archäologie
Staatliche Museen zu Berlin (Ost) Vorderasiatisches Museum
Akademisches Kunstmuseum der Universität Bonn
Musées Royaux d'Art et d'Histoire Brüssel
Département d'Antiquités Précolombiennes, Département de
Céramique, Département de Folklore, Département de Tapisserie
Musée Royal d'Armes et d'Armures Brüssel
Musée Wiertz Brüssel
Hetjensmuseum Düsseldorf

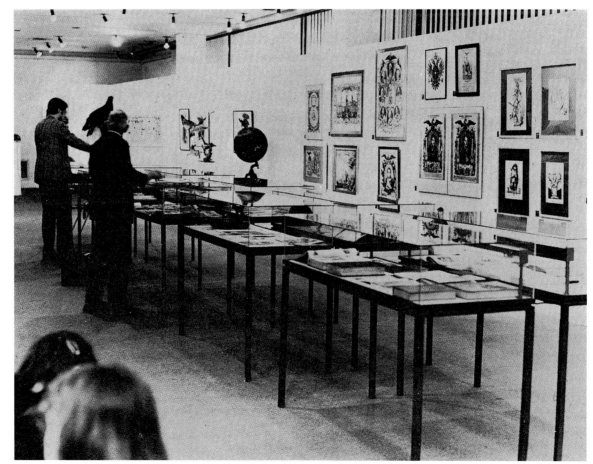

(top)
Details of the installation.

(bottom)
Installation view. This photograph
appeared in the two-volume
catalogue (opposite) which Broodthaers
prepared to accompany the
exhibition.

Musée d'Art Moderne, Département des Aigles, Section Publicité and *Section d'Art Moderne*

Neue Galerie, Documenta 5, Kassel,
30 June–8 October 1972

The official closing of the *Musée d'Art Moderne* took place in two parts at Documenta 5, organized by Harald Szeemann. The *Section Publicité* was located on the ground floor of the Neue Galerie in Kassel, and consisted of photographs, documents, catalogues, empty frames, and a selection of *plaques en plastique*. The *Section d'Art Moderne* was Broodthaers's contribution to a special Documenta exhibition, *Personal Mythologies*, and was located on an upper floor of the Galerie. It occupied an entire room, and included a painted square on the floor that was surrounded by stanchions, stenciling on the window, and directional labels on the walls. In late August, Broodthaers replaced the *Section d'Art Moderne* with the *Museé d'Art Ancien, Galerie du XXème Siècle* by making changes in the text which appeared on both floor and walls. The *Galerie du XXème Siècle* was the final manifestation of the *Musée d'Art Moderne*.

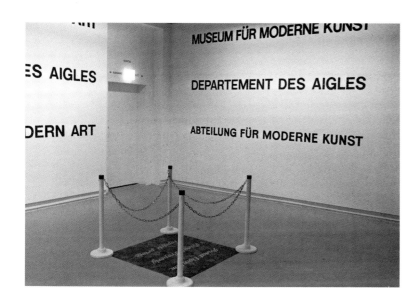

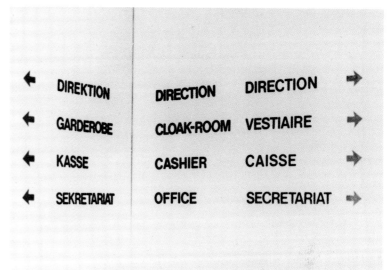

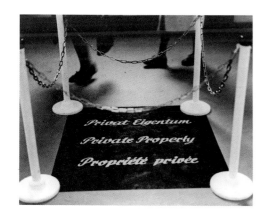

" 'Private property'—the presentation of this inscription can be understood as a satyre on the identification of Art with Private property. One can also see here the expression of my artistic power as it is destined to replace that of the organizer—Szeemann from *documenta 5*— (Personal Mythology Section).

The second aim, finally seemed to me not to have been attained, and on the contrary, the inscription reinforces the structure put in place.

Whence the change,—for one of the roles of the artist is to attempt, at least, to carry out a subversion of the organizational scheme of an exhibition.

Is it any better this time?"

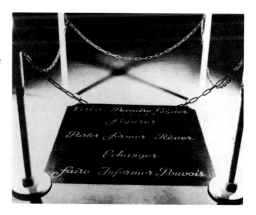

(top, left)
Installation view,
Section d'Art Moderne.

(top, right)
Directional labels on walls,
Section d'Art Moderne.

(bottom, left)
The painted floor, as it appeared until the end of August 1972, as part of the *Section d'Art Moderne.*

(bottom, right)
The painted floor as it appeared after the beginning of September 1972, as part of the *Musée d'Art Ancien, Département des Aigles, Galerie du XXème Siècle.*

(center)
Text by Broodthaers, which appeared in the journal *Interfunktionen,* explaining why he transformed the *Section d'Art Moderne* into the *Galerie du XXème Siècle.*

(opposite, top left)
Exterior of the Neue Galerie, showing lettering on the window in the *Section d'Art Moderne.*

(opposite, bottom left)
The *Section Publicité.* In the background is a small booth which contained a slide projection of eagles; on the outside was a display of empty frames and photographs of the *Section des Figures.*

(opposite, right)
Window seen from the inside.

Catalogue-Catalogus

Palais des Beaux-Arts, Brussels,
27 September–3 November 1974

After the "closing" of his *Musée d'Art Moderne*, Broodthaers began creating retrospective exhibitions of his own works, which he called *Décors*. The *Décors*, because they included many early works that Broodthaers had reconfigured into new ones, commented on the way context can affect a work's meaning. This first *Décor* had an elaborate catalogue containing an essay in which Broodthaers "interviewed" himself on the subject of artistic production.

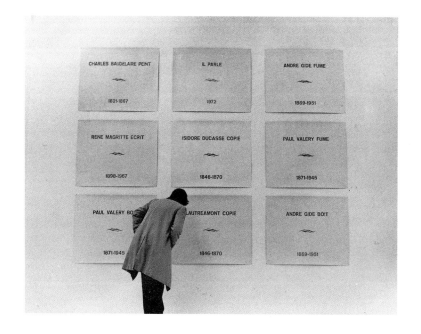

(top)
Installation views.

(bottom, left)
Miroir d'époque Régence, 1973, now
in the collection of the Museum van
Hedendaagse Kunst, Ghent.

(bottom, right)
Installation view.

(opposite)
The galleries at the Palais reflected
in the *Miroir d'époque Régence*.

Eloge du sujet

Kunstmuseum Basel,
5 October–3 November 1974

This large *Décor* was installed within a series of small interconnected rooms, each devoted to a single "subject." The visitor entered into an installation titled *L'Entrée de l'exposition*; other rooms had names such as Room of the Parrot, Room of Painting, and the Lumière Room. A Pedagogical Room presented slide projections of the objects exhibited in neighboring rooms.

CHANGE EXCHANGE WECHSEL

B

1650 F. F.

125 D. M.

98£ 50$

C Teil II Exemplar Nr.

GEDICHT POEM POEME

28

10

12

75

5

6

25

45

19

8

3

258

A Teil I Exemplar Nr.

Poème-Change-Exchange-Wechsel,
1972, lithograph, exhibited in
L'Entrée de l'exposition.

(opposite)
L'Entrée de l'exposition, now in the
collection of the
Bonnefantenmuseum, Maastricht,
The Netherlands.

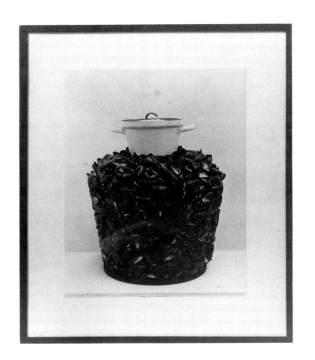

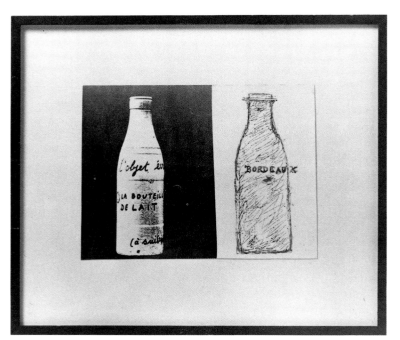

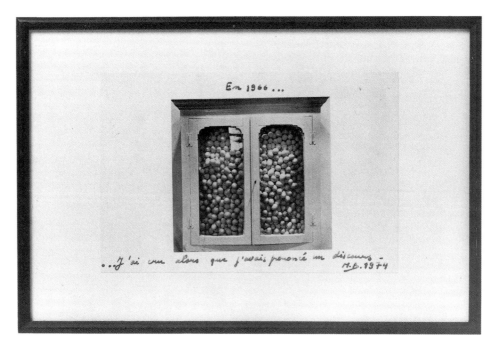

(this page, and opposite)
Five photographs of previous works
by Broodthaers, framed and hung
along with one lithograph, as part
of *L'Entrée de l'exposition*.

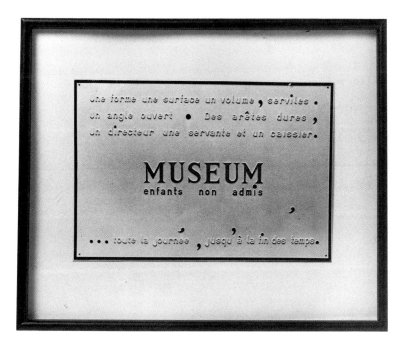

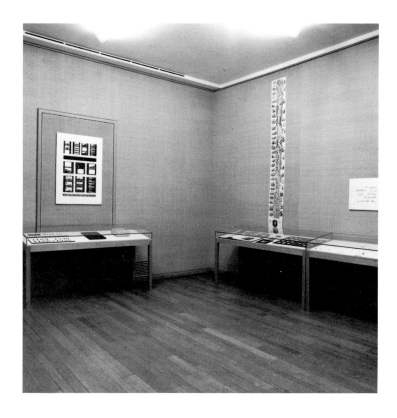
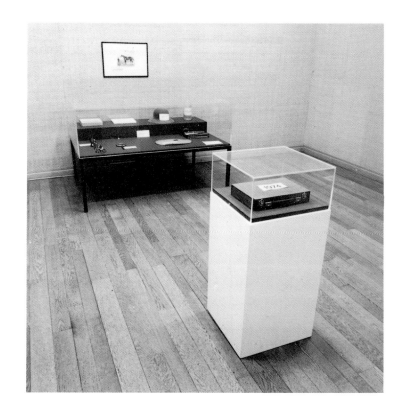
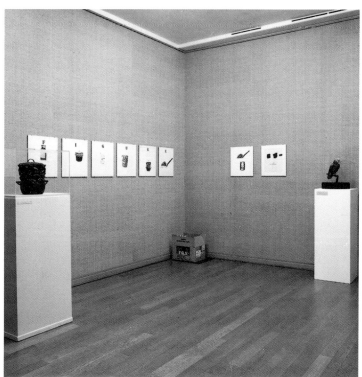
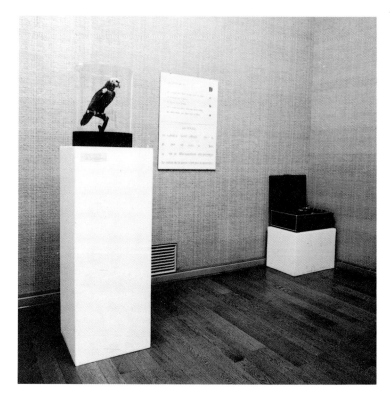

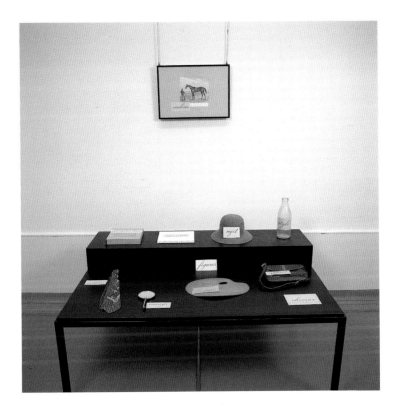

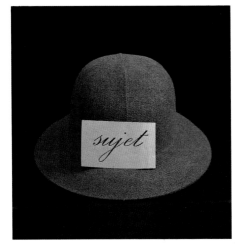

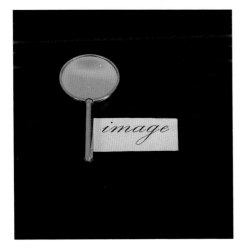

Details of the work *Eloge du sujet*, which was exhibited in the Room of the Eulogy.

(opposite, top left)
Installation view, Figures room.

(opposite, top right)
Installation view, Room of the Eulogy.

(opposite, bottom)
Installation views, Room of the Parrot.

Invitation pour une exposition bourgeoise

Nationalgalerie, Berlin,
25 February–6 April 1975

Broodthaers created this exhibition while living in Berlin on a DAAD Fellowship. Another retrospective of his work, the installation and catalogue also commented on the artist's feeling that he had been "invited to take part in official life" through the DAAD Fellowship. The exhibition was accompanied by Broodthaers's film *Berlin oder ein Traum mit Sahne (Berlin or a Dream with Cream)*.

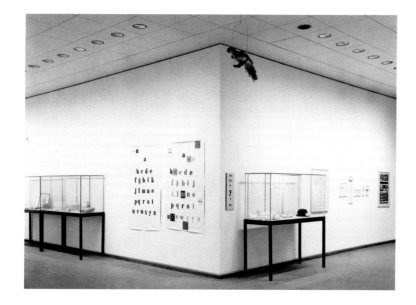
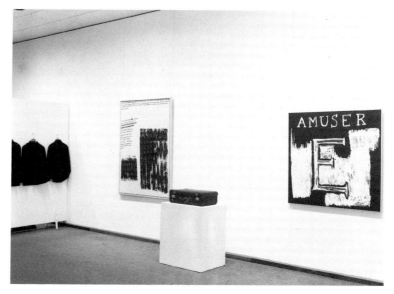

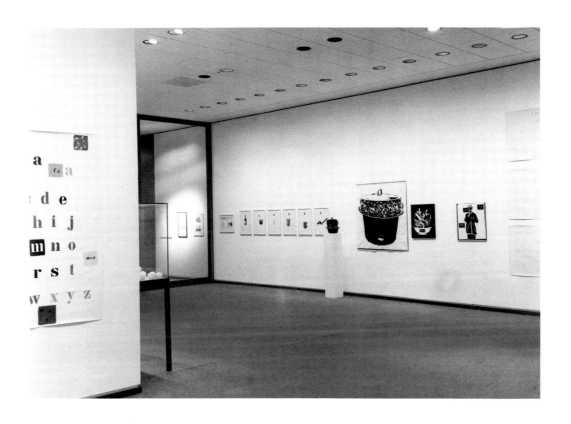

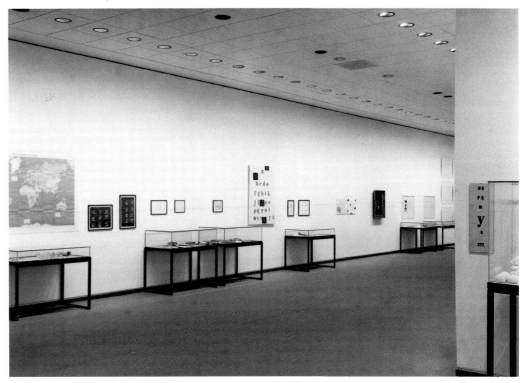

(this page, and opposite)
Installation views.

Le privilège de l'art

Museum of Modern Art, Oxford,
26 April-1 June 1975

This *Décor*, which opened barely three weeks after the Berlin exhibition closed, shared a catalogue with it and included several slide projections.

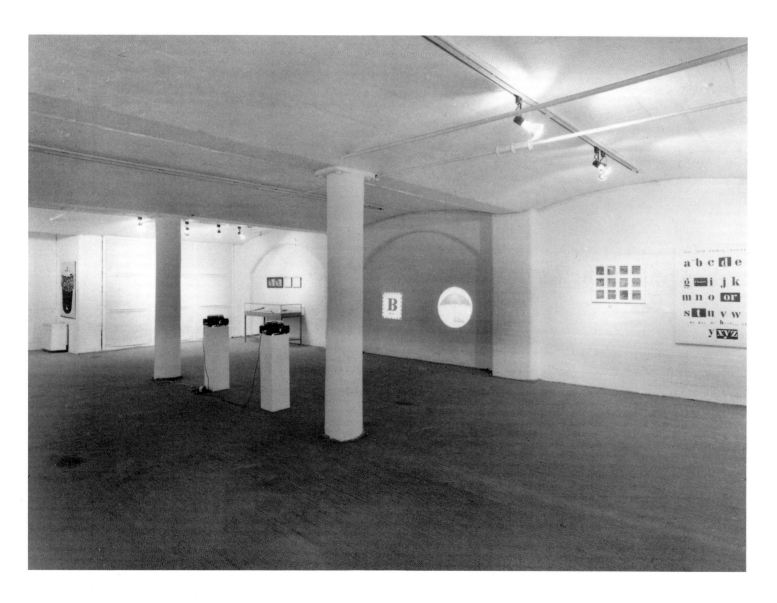

Installation view

Décor: A Conquest by Marcel Broodthaers

Institute of Contemporary Arts, London,
11 June–6 July 1975

Broodthaers described the theme of this exhibition as "the relationship of war to comfort." Furniture and objects—mostly rented from a supplier of theater and film props—were arranged in two rooms of the museum, one representing the nineteenth century, the other the twentieth. The installation served as the "decor" for Broodthaers's film *The Battle of Waterloo*.

Installation in the "nineteenth-century room," showing Napoleonic cannons and huge stuffed snake.

Installation in the "twentieth-century room," showing lawn furniture and rifles.

L'Angélus de Daumier

Centre National d'Art Contemporain, Paris,
2 October-10 November 1975

The last of Broodthaers's *Décors*, this exhibition in the galleries of the Centre National d'Art Contemporain was an installation of works from different periods of his career put together to form a new totality. It included the reconstitution in wood of part of the rooms in the rue de la Pépinière—in which the *Musée* had first been shown—and the remaining period room of the Rothschild family, former owners of the building.

 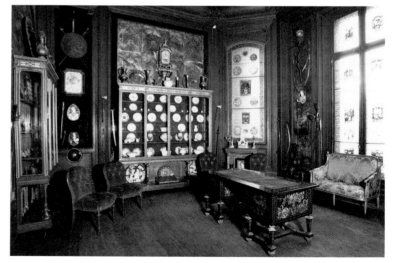

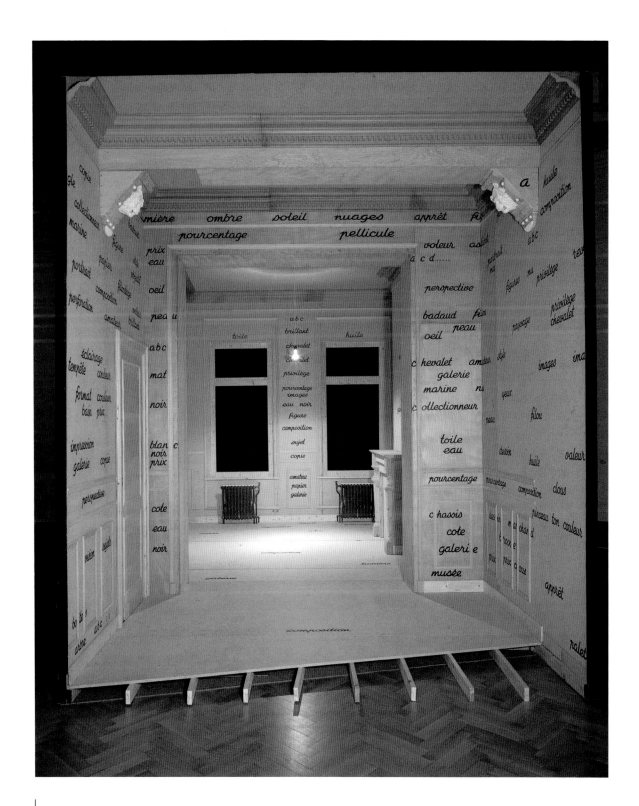

La salle blanche, Broodthaers's re-creation of his rue de la Pépinière dwelling.

(opposite, left)
Ceremonial staircase in the Hôtel Rothschild.

(opposite, right)
The Salon Rothschild, a period room in the CNAC which, in Broodthaers's installation, was viewed through an open, roped-off doorway.

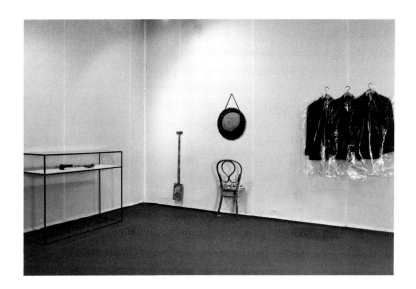

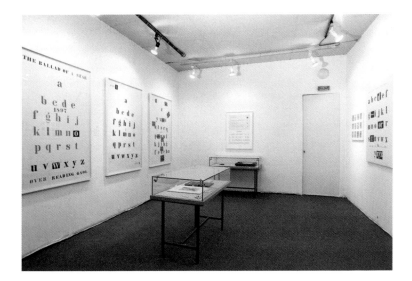

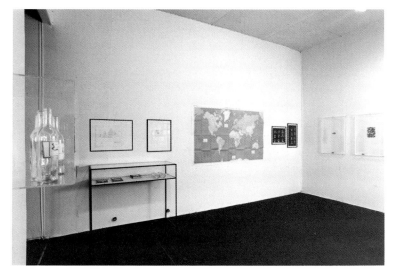

Installation views.

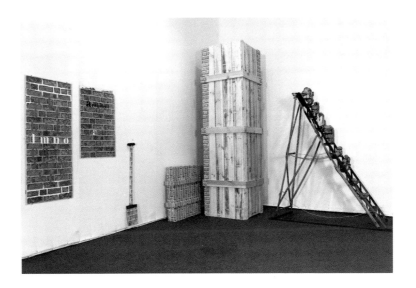

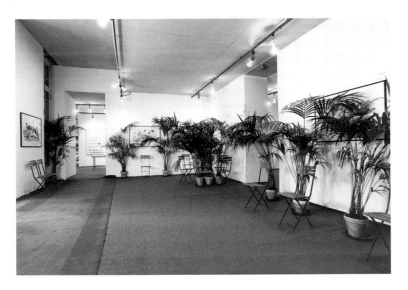

(top)
Installation view of related objects,
including *Une echelle de briques*
(1969), *Une pelle* (c. 1970),
a architect (c. 1973), and *Deux
caisses* (1975).

(bottom)
La salle verte, partial views of
installation.

One-artist exhibitions

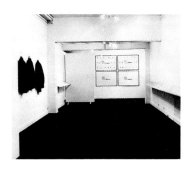

Exposition littéraire autour de Mallarmé: Marcel Broodthaers à la Debliou-debliou/S Wide White Space Gallery, Antwerp, 2–20 December, 1969. Installation view.

1964
Moi aussi, je me suis demandé si je ne pouvais pas vendre quelque chose . . . , Galerie Saint-Laurent, Brussels, 10–25 April.

Sophisticated Happening, Galerie Smith, Brussels, 23 July.

Exposition surprise, Parc du Mont des Arts, Brussels, September.

1965
Objets de Broodthaers/ Voorwerpen van Broodthaers, Galerie Aujourd'hui, Brussels, 2–24 April.

1966
Marcel Broodthaers, Galerie J, Paris, 8–21 March.

Moules Oeufs Frites Pots Charbon, Wide White Space Gallery, Antwerp, 26 May–26 June.

Peinture à l'oeuf—Peinture à l'oeuf, Galerie Cogeime, Brussels, 27 September–9 October.

Galerie Smith, Brussels.

1967
Le Court-Circuit/Marcel Broodthaers, Palais des Beaux-Arts, Brussels, 13–25 April.

Marcel Broodthaers, 't Kasteelke, Mullem, Belgium, 18 November–9 December.

1968
Le Corbeau et le Renard, Wide White Space Gallery, Antwerp, 7–24 March.

Marcel Broodthaers, Galerie Rudolf Zwirner, Cologne, September.

La collection privée de Marcel Broodthaers, Galerie 44, Brussels.

1969
Broodthaers, Galerie Gerda Bassenge und Benjamin Katz, Berlin, March–April.

Galerie Fitzroy, Brussels, 23 April–7 May.

Naar een onbeduidende Kunst?/ Vers un art sans importance?, Galerie Richard Foncke, Ghent, 19 August–10 September.

Exposition littéraire autour de Mallarmé: Marcel Broodthaers à la Debliou-debliou/S, Wide White Space Gallery, Antwerp, 2–20 December.

1970
Exposition littéraire et musicale autour de:Mallarmé, Galerie Michael Werner, Cologne, 22 January–20 February.

MTL-DTH, Galerie MTL, Brussels, 13 March–10 April.

Modèle/M. Broodthaers, Galerie Michael Werner, Cologne, 4–15 September.

Une seconde d'éternité (d'après une idée de Charles Baudelaire), Galerie Folker-Skulima, Berlin.

1971
Marcel Broodthaers: Relieftafeln—Filme, Galerie Ernst, Hannover, 6–25 March.

Figures anciennes et modernes, Wide White Space Gallery, Antwerp, 27 September–27 October.

Film als Objekt—Objekt als Film, Städtisches Museum Mönchengladbach, West Germany, 21 October–7 November.

Au-delà de cette limite vos billets ne sont plus valables, Galerie Françoise Lambert, Milan, 15 December–19 April 1972.

1972
Marcel Broodthaers: Zeichnungen, Dias, Filme, Galerie Heiner Friedrich, Munich, 6–25 May.

Tractatus-Logico-Catalogicus: L'Art ou l'Art de vendre, Galerie MTL, Brussels, 18 May–17 June.

La porte est ouverte. 27–8–1901. M.B. M.B. M.B. . . . , Galerie Michael Werner, Cologne, 15 June–4 July.

Le Corbeau et le Renard (1967–1972), Wide White Space Gallery, Antwerp, 17–30 July.

Marcel Broodthaers: La signature de l'artiste, Galerie Grafikmeyer, Karlsruhe, West Germany, 20 October–16 November.

Jack Wendler Gallery, London, 1–22 December.

1973
Programme, Wide White Space Gallery, Antwerp, 15 January–15 February.

Marcel Broodthaers: Retrospective (Octobre 1963–Mars 1973), Art & Project, Amsterdam, 17 March–14 April.

Petrus Paulus Rubens, Galerie MTL at "Le Bailli," and at 13 Avenue des Eperons d'Or, Brussels, from 20 March; simultaneous Dutch showing at Art & Project, Amsterdam.

A,B,C—Paysage d'automne, Galerie Yvon Lambert, Paris, 14–20 June.

Fumer—Boire—Copier—Parler— Ecrire—Peindre—Filmer, Galerie Françoise Lambert, Milan, from 16 June.

Peintures littéraires 1972–1973, Galerie Rudolf Zwirner, Cologne, from 7 September.

Jeter du poisson sur le marché de Cologne, Galerie Michael Werner, Cologne, 7 September–10 October.

Oeuvres importantes depuis 1963, New Smith Gallery, Brussels, 7 November–1 December.

1974
Un voyage en Mer du Nord/A Voyage on the North Sea, Petersburg Press, London, January.

Réclamé pour la Mer du Nord, Galerie Seriaal, Amsterdam, 12 April–6 May.

M.B., Galerie Folker-Skulima, Berlin, 16–30 June.

Zeichnungen, Galerie Michael Werner, Cologne, 1–30 July.

Marcel Broodthaers: Ne dites pas que je ne l'ai pas dit (Le Perroquet)/ Zeg niet dat ik het niet gezegd heb (De Papegaai), Wide White Space Gallery, Antwerp, from 19 September, and Wide White Space Gallery at "Le Bailli," Brussels, from 25 September.

Culture Internationale, Galerie MTL, Brussels, 27 September– 24 October.

1833/1974—Marcel Broodthaers: Das Manuskript in der Flasche/The Manuscript in a Bottle/Le manuscrit trouvé dans une bouteille—1833/1974, Galerie René Block, Berlin, 12 October–2 November.

1975
Films, Dias et Photos (Une contradiction entre le mouvement et le statisme de l'image), Städtische Kunsthalle Düsseldorf, 23–25 May.

Voyages autour de la mode, Galerie Grafikmeyer, Karlsruhe, West Germany, 15 June–31 July.

Ceci Cela ou Rien/This that or . . . During six months, Nigel Greenwood, Ltd., London, July 1975–January 1976.

Les poissons—De Vissen, Galerie MTL, Brussels, 4–20 December.

La conquête de l'espace. Atlas à l'usage des artistes et des militaires. Galerie MTL and Lebeer Hossmann, Brussels, 4 December 1975–10 January 1976.

1976
Marcel Broodthaers, Galerie Marzona, Düsseldorf, 15 January–16 February.

Hommage à Marcel Broodthaers (1924–1976), Palais des Beaux-Arts, Brussels, February.

Marcel Broodthaers: Filme 1957–1974/Dokumentation 1964–1975, Kunstverein Freiburg, West Germany, 23–31 August.

Marcel Broodthaers: Collected Editions, John Gibson Gallery, New York, 13 November–22 December.

Marcel Broodthaers: Arbeiten von 1965–1975, Galerie Michael Werner, Cologne, December.

1977
The Complete Editions on Paper & Books by Marcel Broodthaers, Nigel Greenwood, Ltd. and Hester van Royen Gallery, London, 5 April–14 May.

Marcel Broodthaers: Livres et éditions, Galerie Gillespie-Laage, Paris, from 31 May.

Marcel Broodthaers: "Le miroir," oeuvre originale: Editions, livres, multiples, Galerie Marika Malacorda, Geneva, 31 May–21 June.

Marcel Broodthaers: Books, Editions, Films, New 57 Gallery, Edinburgh, 15 August– 10 September.

Marcel Broodthaers (1924–1976), Multiples/Marian Goodman Gallery, New York, 27 September–20 October.

Marcel Broodthaers, John Gibson Gallery, New York, 13 November–22 December.

1978
Konrad Fischer Gallery, Düsseldorf, 11 February–4 March.

Marcel Broodthaers: Plaques/ Tekeningen/Objekten, Galerie Helen van der Meij, Amsterdam, 22 February–22 March.

Marcel Broodthaers: Editions, Galerie Catherine Issert, Saint-Paul-de-Vence, France, August.

Marcel Broodthaers: Editionen (1964–1975), Galerie Heiner Friedrich, Munich, 28 September–15 November. Traveled.

De Boeken van Marcel Broodthaers, Internationaal Cultureel Centrum, Antwerp, 22 October–20 November.

Marcel Broodthaers 1924–1976, Galerie Isy Brachot, Brussels, 9 November–9 December.

Marian Goodman Gallery, New York.

1979
Marcel Broodthaers, Galerie im Taxis-Palais, Innsbruck, Austria, 21 March–22 April.

Aktuele Kunst in Belgie: Inzicht/Overzicht, Overzicht/ Inzicht, Museum van Hedendaagse Kunst, Ghent, 24 March–29 April.

Marcel Broodthaers: Opera Grafica, Oggetti e Libri 1964–1975, Galleria Ferrucio Fata, Circolo Artistico Culturale, Bologna, 26 May–8 July.

Zeichen setzen durch Zeichen. Marcel Broodthaers. Die gesamte Graphik, Kunstverein Hamburg, 26 May–1 July.

Barry Barker Gallery, London.

1980
Marcel Broodthaers, The Tate Gallery, London, 16 April–26 May.

Marcel Broodthaers, Galerie Michael Werner, Cologne, 3 October–5 November.

Marcel Broodthaers, Wallraf-Richartz-Museum/Museum Ludwig, Cologne, 4 October–26 November.

1981
Marcel Broodthaers, Museum Boymans-van Beuningen, Rotterdam, 14 February– 22 March.

John Gibson Gallery, New York, 13 November–22 December.

1982
Marcel Broodthaers 1924–1976,
Kunsthalle Bern, 30 January–
14 March; Moderna Museet,
Stockholm, 15 May–27 June.

Marcel Broodthaers, Multiples/
Marian Goodman Gallery, New
York, 14 September–2 October.

John Gibson Gallery, New York,
14 September–10 November.

Galleria Anna d'Ascanio, Rome,
14 October–15 November.

Marcel Broodthaers,
Galerie Isy Brachot, Paris,
3 November–8 January 1983.

Galerie Marika Malacorda,
Geneva, from 3 November.

Galerie Gillespie-Laage-Salomon,
Paris, 5 November–30 December.

1983
Galerie Michael Werner, Cologne,
24 January–13 February.

Marcel Broodthaers, Marian
Goodman Gallery, New York,
5–28 May.

1984
Sabine Knust, Munich, March.

Mary Boone Gallery, New York,
2–30 June.

L'Entrée de l'exposition, Galerie
Michael Werner, Cologne,
27 September–31 October.

Marcel Broodthaers, Marian
Goodman Gallery, New York,
1–24 November.

1985
Oesterreichische Fotogalerie
im Rahmen der Salzburger
Landessammlungen,
Salzburg, Austria.

*Marcel Broodthaers:
Fotografische Bildnisse*, Neue
Galerie der Stadt Linz/Wolfgang-
Gurlitt-Museum, Linz, Austria.

Oesterreichisches Fotoarchiv,
Museum Moderner Kunst,
Vienna.

Kulturhaus der Stadt Graz,
Graz, Austria.

1986
*Marcel Broodthaers: Selected
Editions*, John Gibson Gallery,
New York, 5–30 April.

Galerie Gillespie–Laage–
Salomon, Paris, 19 April–10 May.

Galerie Michael Werner, Cologne,
24 April–30 May.

Marcel Broodthaers, Marian
Goodman Gallery, New York,
9–31 December.

1987
Marcel Broodthaers: Graphics,
Florizoone Fine Art, Nieuwpoort,
Belgium, January–February;
Le Cadre Gallery, Hong Kong,
March–April.

Marcel Broodthaers, Galerie Isy
Brachot, Paris, 4 February–
14 March; Galerie Christine et
Isy Brachot, Brussels, 29 March–
26 June.

Musée d'Ixelles, Brussels,
29 April–28 June.

Galerie Konrad Fischer,
Düsseldorf, 16 May–10 June.

*Marcel Broodthaers—L'Entrée
de l'exposition; Marcel
Broodthaers in Zuid-Limburg—
Fotos 1961–1970*,
Bonnefantenmuseum, Maastricht,
The Netherlands, 5 September–
8 November.

*Concernant la vente d'un kilog
d'or fin en lingot*, Galerie Konrad
Fischer, Düsseldorf, October.

Marcel Broodthaers, Galerie &
Edition Stahli, Zürich,
21 November 1987–30 January
1988.

1988
Gallery Marian Goodman, ARCO,
Madrid, from 11 February.

Gallery Watari, Tokyo,
21 June–30 July.

*Marcel Broodthaers: Le salon
noir 1966*, Galerie Ronny Van De
Velde & Co., Antwerp,
16 September–15 October.

The Museum and The Décors

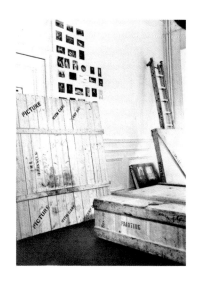

Musée d'Art Moderne, Départment des Aigles, Section XIXème Siècle, rue de la Pépinière, Brussels, 27 September 1968– 27 September 1969. Installation view

Musée d'Art Moderne, Département des Aigles

1968
Section XIXème Siècle, rue de la Pépinière, Brussels, 27 September 1968–27 September 1969.

M.U.SE.E .D'.A.R.T. CAB.INE.T D.ES. E.STA.MP.E.S. / Département des Aigles (Poèmes Industriels. Tirages Limités et Illimités sur Plastique), Librarie Saint-Germain des Prés, Paris, 29 October–19 November.

Section Littéraire, rue de la Pépinière, Brussels, 1968–1970.

1969
Section XVIIème Siècle, A 37 90 89, Antwerp, 27 September–4 October.

1970
Section XIXème Siècle (Bis), Städtische Kunsthalle Düsseldorf, 14–15 February.

Section Folklorique (Cabinet de Curiosité), Middelburg, The Netherlands.

Section Documentaire, Le Coq, Belgium.

1971
Section Cinéma, Haus Burgplatz 12, Düsseldorf, Winter 1971– Fall 1972.

Section Financière. Musée d'Art Moderne à vendre 1970 bis 1971 pour cause de faillite, Galerie Michael Werner at the Cologne Kunstmarkt, 5–10 October.

1972
Section des Figures (Der Adler vom Oligozän bis Heute), Städtische Kunsthalle Düsseldorf, 16 May–9 July.

Section Publicité, Documenta 5, Kassel, 30 June–8 October.

Musée d'Art Moderne, Département des Aigles, Section d'Art Moderne, Documenta 5, Kassel, 30 June–29 August.

Musée d'Art Ancien, Département des Aigles, Galerie du XXème Siècle, Documenta 5, Kassel, 1 September–8 October.

Décors

1974
Marcel Broodthaers: Catalogue-Catalogus, Palais des Beaux-Arts, Brussels, 27 September–3 November.

Marcel Broodthaers: Eloge du sujet, Kunstmuseum Basel, 5 October–3 November.

1975
Invitation pour une exposition bourgeoise, Nationalgalerie, Berlin, 25 February–6 April.

Le privilège de l'art, Museum of Modern Art, Oxford, 26 April–1 June.

Décor: A Conquest by Marcel Broodthaers, Institute of Contemporary Arts, London, 11 June–6 July.

L'Angélus de Daumier, Centre National d'Art Contemporain, Hôtel Rothschild, Paris, 2 October–10 November.

Selected group exhibitions

Installation view, Museum van
Hedendaagse Kunst, Ghent

1964
*Lauréats du Prix Jeune Sculpture
Belge 1964*, Palais des
Beaux-Arts, Brussels,
1–12 February.

1965
*Pop Art, Nouveau Réalisme,
Etc. . . .* , Palais des Beaux-Arts,
Brussels, 5 February–1 March.

*Academy: A Lesson of National
Pop Art*, Happening, Palais des
Beaux-Arts, Brussels, 5 February.

1966
*2ème Salon Internationale de
Galeries-Pilotes: Artistes et
découvreurs de notre temps*,
Musée Cantonal des Beaux-Arts,
Palais de Rumine, Lausanne,
Switzerland, 12 June–2 October.

Des Salles/Raume, Galerie
Saint-Laurent, Brussels,
9 July–15 September.

Au pied de la lettre, Happening,
rue de la Pépinière, Brussels,
8 December.

1968
*Three Blind Mice: De Collecties
Visser, Peeters, Becht*, Stedelijk
van Abbemuseum, Eindhoven,
The Netherlands,
6 April–19 May. Traveled.

Wide White Space Gallery at
Parkhotel Hessenland, Kassel,
West Germany, 26 June–5 July.

*Eerste Triennale voor
Plastische Kunst in Belgie*,
Stadshallen, Bruges,
11 July–8 September.

*Lignano Biennale 1: Rassegna
Internazionale d'Arte
Contemporanea*, Lignano, Italy,
25 August–6 October.

Prospect 68, Städtische
Kunsthalle Düsseldorf,
20–29 September.

1969
*Triennale der Zuidelijke
Nederlanden: Jonge Kunst uit
Zuid-Nederland en Vlaanderen
(2)*, Stedelijk van Abbemuseum,
Eindhoven, The Netherlands,
3 April–18 May. Traveled.

between 2, Städtische Kunsthalle
Düsseldorf, 20–22 June.

Konzeption/Conception,
Städtisches Museum Leverkusen,
Schloss Morsbroich,
Leverkusen, West Germany,
24 October–November.

1970
18.IV.70, 66 rue Mouffetard,
Paris, 18 April–May.

*La métamorphose de l'objet, art
et anti-art 1910–1970 /
Metamorfose van het Objekt,
Kunst en Anti-Kunst 1910–1970*,
Palais des Beaux-Arts, Brussels,
22 April–6 June. Traveled.

*3e Salon Internationale de
Galeries-Pilotes: Artistes et
découvreurs de notre temps*,
Musée Cantonal des Beaux-Arts,
Palais de Rumine, Lausanne,
Switzerland, 21 June–4 October.
Traveled.

Information, The Museum of
Modern Art, New York,
2 July–20 September.

Letterlijk en Figuurlijk, Zeeuws
Museum in de Vleeshal van het
Stadthuis, Middelburg, The
Netherlands, 10 July–30 August.

between 5, Städtische Kunsthalle
Düsseldorf and Kunstverein für
die Rheinlande und Westfalen,
Düsseldorf, 9–18 October.

1971
Multiples: The First Decade,
Philadelphia Museum of Art,
5 March–4 April.

2. Biennale Nürnberg 1971: Was die Schönheit sei, das weiss ich nicht: Kunstler—Theorie—Werk, Kunsthalle Nürnberg, Nuremberg, 30 April–1 August.

Tweede Triennale Brugge, Provincie West-Vlaanderen, Stadshallen, Bruges, 15 July–15 September.

Prospect 71, Städtische Kunsthalle Düsseldorf, 8–18 October.

1972
Amsterdam-Paris-Düsseldorf, The Solomon R. Guggenheim Museum, New York, 5 October–3 November.

Peintres et sculpteurs belges contemporains/Hedendaagse Belgische Schilders en Beeldhouwers, Palais des Beaux-Arts, Brussels, 26 October–3 November.

Actualité d'un bilan, Galerie Yvon Lambert, Paris, 29 October–5 December.

1973
Bilder—Objekte—Filme— Konzept, Städtische Galerie im Lenbachhaus, Munich, 3 April–13 May.

Medium Fotografie: Fotoarbeiten bildender Künstler von 1910 bis 1973, Städtisches Museum Leverkusen, Schloss Morsbroich, Leverkusen, West Germany, 18 May–5 August.

M. Broodthaers, J. Charlier, J. Geys, B. Lohaus, G. Mees, Panamarenko, M. Roquet, Palais des Beaux-Arts, Brussels, 25 May–24 June.

Prospect '73: Maler/Painters/ Peintres, Städtische Kunsthalle Düsseldorf, 28 September–7 October.

30 Internationale Künstler in Berlin: Gaste des Deutschen Akademischen Austauschdienstes, Berliner Künstlerprogramm, Beethoven-Halle, Bonn, 14–27 December.

1974
Carl Andre, Marcel Broodthaers, Daniel Buren, Victor Burgin, Gilbert & George, On Kawara, Richard Long, Gerhard Richter, Palais des Beaux-Arts, Brussels, 9 January–3 February.

3. Triennale Brugge, Provincie West-Vlaanderen, Stadshallen, Bruges, 22 June–1 September.

Kunst bleibt Kunst: Projekt '74 Köln: Aspekte internationaler Kunst am Anfang der 70er Jahre, Kunsthalle Köln, Cologne, 6 July–8 September.

1975
Funkties van Tekenen/Functions of Drawing, Rijksmuseum Kröller-Müller, Otterlo, The Netherlands, 24 May–4 August.

Von Pop zum Konzept: Kunst unserer Zeit in belgischen Privatsammlungen, Neue Galerie—Sammlung Ludwig, Aachen, West Germany, 4 October–9 November.

1976
Openingstentoonstelling van het Museum van Hedendaagse Kunst, Museum van Hedendaagse Kunst, Ghent, May.

La Biennale di Venezia 1976: L'ambiente e partecipazione, Venice, 18 July–10 October.

Raume: Andre, Broodthaers, Buren, Hollein, Nauman, Richter, Rückriem, Städtisches Museum Mönchengladbach, West Germany, 29 August–3 October.

Prospect retrospect: Europa 1946–1976, Städtische Kunsthalle Düsseldorf, 20–31 October.

1977
Herdenkingstentoonstelling Andre Beullens, Marcel Broodthaers, Amadeus Cortier, Museum van Hedendaagse Kunst, Ghent, 9 June–25 July.

Marcel Broodthaers—James Lee Byars, Multiples Gallery, New York, 27 September–18 October.

Europe in the Seventies: Aspects of Recent Art, The Art Institute of Chicago, 8 October–27 November. Traveled.

1978
Aspekte der 60er Jahre: Sammlung Reinhard Onnasch, Nationalgalerie, Berlin, 2 February–23 April.

Marcel Broodthaers, Jan Dibbets, Gilbert & George, Galerie MTL, Brussels, 9–19 February.

La Biennale di Venezia 1978: Dalla Natura all'Arte, dall'Arte alla Natura, Venice, July.

Poetische Aufklärung in der europäischen Kunst der Gegenwart bei Joseph Beuys, Marcel Broodthaers, Daniel Buren, Jannis Kounellis, Mario Merz, Gerhard Richter: Geschichte von Heute und Morgen, InK. Halle für Internationale Neue Kunst, Zurich, 26 November 1978– 21 January 1979.

1979
Wahrnehmungen, Aufzeichnungen, Mitteilungen: Die Erweiterung des Wirklichkeitsbegriffs in der Kunst der 6oer und 7oer Jahre, Museum Haus Lange, Krefeld, West Germany, 21 January–18 March.

Hanne Darboven, John Baldessari, Marcel Broodthaers, Jon Borofsky, InK. Halle für Internationale Neue Kunst, Zurich, 14 August–24 September.

Photographie als Kunst 1879–1979: Kunst als Photographie 1949–1979, Tiroler Landesmuseum Ferdinandeum, Innsbruck, Austria; Neue Galerie am Wolfgang-Gurlitt-Museum, Linz, Austria. Traveled.

1980
Belgique Pays-Bas: convergences et parallels dans l'art depuis 1945, Palais des Beaux-Arts, Brussels, 20 June–10 August. Traveled.

La Biennale di Venezia 1980, Venice, June.

1982
'60–'80: Attitudes/Concepts/ Images, Stedelijk Museum, Amsterdam, 9 April–11 July.

Tableaux: Nine Contemporary Sculptors, Contemporary Arts Center, Cincinnati, 17 September–6 November.

Documenta 7, Kassel, West Germany, 19 June–28 September.

1983
Der Hang zum Gesamtkunstwerk: Europäische Utopienzeit 1800, Kunsthaus Zürich, 11 February– 30 April. Traveled.

Bücher, Bilder, Objeckte aus der Sammlung Reiner Speck: To the Happy Few, Museum Haus Lange and Museum Haus Esters, Krefeld, West Germany, 15 May–10 July.

1984
Von Hier Aus: Zwei Monate neue deutsche Kunst in Düsseldorf, Messehallen, Düsseldorf, 29 September–2 December.

Little Arena: Drawings and Sculptures from the Collection of Martin and Geertjan Visser, Rijksmuseum Kröller-Müller, Otterlo, The Netherlands, 13 October–25 November.

1985
L'oeil musicien: Les écritures et les images de la musique (Capriccio, musique et art au XXème siècle), Palais des Beaux-Arts, Brussels.

1986
Sonsbeek 86: International Sculpture Exhibition, Arnhem, The Netherlands, 18 June–14 September.

Sammlung Etzold: Ein Zeitdokument, Städtisches Museum Abteiberg Mönchengladbach, West Germany, 12 October 1986– 20 April 1987.

Individuals: A Selected History of Contemporary Art 1945–1986, Museum of Contemporary Art, Los Angeles, 10 December 1986–10 January 1988.

La Biennale di Venezia, Arte e Scienza, Venice.

Forty Years of Modern Art 1945–1985, The Tate Gallery, London.

1988
De l'animal et du végétal dans l'art belge contemporain, Neue Galerie-Sammlung Ludwig, Aachen, West Germany, 15 January–13 March.

Galerie Lucien Bilinelli, Brussels, 18 February–22 March.

Brennpunkt Düsseldorf, Malmö Konsthall, Sweden, 20 February–3 April.

Zeitlos, Hamburger Bahnhof, Berlin, 22 June–25 September.

Nouveau Réalisme–Raum für Wechselausstellungen and *Konzept-Kunst der 6oer und 7oer Jahre–Graphisches Kabinett*, Städtisches Museum Abteiberg Mönchengladbach, West Germany, 10 July–28 August.

a-Historical Soundings, Museum Boymans-van Beuningen, Rotterdam.

Galerie Isy Brachot, Brussels, 6 September–1 October.

Filmography

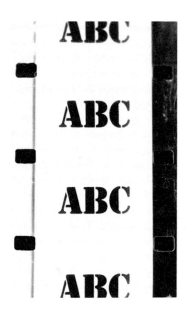

Un jardin d'hiver (A.B.C.) 1974
Frame enlargements

La Clef de l'Horloge (Un poème cinématographique en l'honneur de Kurt Schwitters), 1957–1958
16mm, b/w, sound, 7 min., Brussels.

Le chant de ma génération, 1959
16mm (appropriated film), b/w, sound, Brussels. (Lost.)

Actualités reconsidérées, 1959
16mm (appropriated film), b/w, sound, Brussels. (Lost.)

Le Corbeau et le Renard (d'après La Fontaine), 1967
16mm, color, 7 min. (projected on printed screen), Brussels.

Objet, 1967
16mm, b/w, 10 min. (unfinished footage mounted by Maria Gilissen), Brussels.

Musée d'Art Moderne, Département des Aigles, Section XIXème Siècle (Partie 1: Une discussion inaugurale), 1968
16mm, b/w, 12 min., Brussels.

Signalisation, 1968
16mm, b/w, 3 min. (unfinished footage mounted by Maria Gilissen and Jean-Louis Dewert, 1985), Brussels.

La pipe, 1968–1970
four versions were made:
1. *La pipe (René Magritte)*, b/w
2. *La pipe (Figure Noire)*, b/w
3. *La pipe (Figure Blanche)*, b/w
4. *La pipe (Bild-Figur-Gestalt-Figure)*, color (tinted blue)
35mm and 16mm, 3 min. each, Brussels.

Défense de fumer, 1969
16mm, b/w, 1 min., Brussels.

La pipe satire, 1969
35mm, b/w, 2 min., Brussels.

La pluie (Projet pour un texte), 1969
16mm, b/w, 3 min., Brussels.

Un voyage à Waterloo (Napoleon 1769–1969), 1969
16mm, b/w, 12 min. (unfinished footage mounted by Maria Gilissen, 1985), Brussels.

Ceci ne serait pas une pipe (Un film du Musée d'Art Moderne), 1970
35mm, b/w, 3 min., Brussels.

Un film de Charles Baudelaire, 1970
two versions were made:
1. *Un film de Charles Baudelaire (Carte politique du monde)*
2. *Un film de Charles Baudelaire (Carte politique du monde ou système de signification)*
35mm, color, sound, 7 min. each, Brussels and Paris.

Un film du Musée d'Art Moderne, 1970
35mm, b/w, 4 min., Brussels.

La lune, 1970
35mm, color, 2½ min., Brussels.

MTL-DTH, 1970
16mm, color, 5 min., Brussels.

Musée-Museum, 1970
16mm, b/w, 12 min. (projected on
a map of the world), Brussels.

*La signature (Une seconde
d'éternité),* 1970
35mm, b/w, 1 sec., Berlin.

Le poisson (Projet pour un film),
1970–1971
35mm, b/w, 7½ min.,
Brussels and Cologne.

*Au-delà de cette limite vos billets
ne sont plus valables,* 1971
16mm, b/w, 7 min., Paris.

C'est-je-parole-regret, 1971
16mm, color, 7 min., Brussels.

Crime à Cologne, 1971
35mm, b/w, sound, 3 min.,
Cologne.

Histoire d'amour (Dr. Huysmans),
1971
16mm, color, sound, 3 min.,
Brussels.

*Musée d'Art Moderne,
Département des Aigles, Section
Cinéma,* 1971
program of films:
1. *Charlie as Filmstar*
(appropriated footage)
2. *Brussels* (appropriated footage)
3. *La Discussion*
4. *Belga Vox* (appropriated
footage)
5. *20th Century Fox*
(appropriated footage)
6. *20th Century Mode*
(appropriated footage)
all 16mm (projected on printed
screens), Düsseldorf.

O-X, 1971
16mm, b/w, 3 min., Düsseldorf.

Paris (Carte postale), 1971
16mm, color, 2 min., Paris.

Tableau Magritte, 1972
35mm, b/w, 3 min., Brussels.

Mauretania (Avec mer), 1972
two versions were made:
1. *Mauretania (AOX-XOA)*
2. *Mauretania (Fig. 0-Figures
Fig. A)*
16mm, color, c. 2 min.,
Düsseldorf.

*Musée d'Art Moderne,
Département des Aigles, Section
Publicité et Section d'Art
Moderne,* 1972
16mm, b/w, 12 min. (unfinished
footage mounted by Maria
Gilissen and Jean-Louis Dewert,
1986), Kassel.

*Musée d'Art Ancien, Département
des Aigles, Galerie du XXème
Siècle,* 1972
16mm, color, 7 min. (unfinished
footage mounted by Maria
Gilissen and Jean-Louis Dewert,
1984), Kassel.

*Ah, que la chasse soit le plaisir
des Rois,* 1972
16mm, color, 8 min., Brussels.

*Die Farbe/La couleur/The
Colour,* 1972
16mm, color, c. 2 min.,
Düsseldorf.

Chère petite soeur (La tempête),
1972
16mm, color, 5 min., Brussels
and Cologne.

*Rendez-vous mit Jacques
Offenbach*, 1968–1972
program of films:
1. *La pipe (Figure Blanche)*
2. *Chère petite soeur (La tempête)*
3. *Gare Central*
4. *Écriture*
5. *Histoire d'amour (Dr.
Huysmans)*
6. *La pluie (Projet pour un texte)*
7. *La signature (Une seconde
d'éternité)*
8. *Crime à Cologne*
9. *Ah, que la chasse soit le plaisir
des Rois*
16mm, b/w and color, sound,
30 min., Brussels and Cologne.

*Kassel Wilhelmshöhe (Hercules
mit Kaskaden)*, 1972
16mm, b/w, 5½ min. (unfinished
footage mounted by Maria
Gilissen and Jean-Louis Dewert,
1982), Kassel.

Analyse d'une peinture, 1973
16mm, color, 7 min., Brussels.

*Une peinture d'amateur
découverte dans une boutique
de curiosités*, 1973
16mm, color, 7 min., Brussels.

*Le même film, revu après
critiques*, 1973
16mm, color, 5 min., Brussels.

The Last Voyage, 1973–1974
16mm, color, 4 min. (unfinished
footage mounted by Maria
Gilissen, 1976), London and
Brussels.

A Voyage on the North Sea,
1973–1974
16mm, color, 4 min., London.

Eau de Cologne, 1974
35mm, color, sound, 3 min.,
Cologne.

Un jardin d'hiver (A.B.C.), 1974
35mm and 16mm, color, sound,
7 min., Brussels.

*Les nouvelles aventures des Pieds
Nickelés (Nouveaux trucs—
Nouvelles combines)*, 1974
35mm, color (unfinished),
Brussels.

*Figures of Wax (Jeremy
Bentham)*, 1974
16mm, color, sound, 16 min.,
London.

*Berlin oder ein Traum mit
Sahne*, 1974
35mm, color, sound, 10 min.,
Berlin.

New York, 1974–1975
Part 1. Mounted by Marcel
Broodthaers, 1975
Part 2. Mounted by Maria
Gilissen, 1984
Part 3. Destroyed in laboratory
16mm, color and b/w, 3 min.

Monsieur Teste, 1974–1975
35mm, color, 4 min.,
Brussels and Paris.

The Battle of Waterloo, 1975
35mm and 16mm, color,
sound, 10 min., London.

Selected Bibliography

Below is a listing of monographic catalogues. For a comprehensive Broodthaers bibliography, see *October*, no. 42 (Fall 1987), pp. 198–210.

Moules Oeufs Frites Pots Charbon (Antwerp: Wide White Space Gallery, 1966).

Le Court-Circuit/Marcel Broodthaers (Brussels: Palais des Beaux-Arts, 1967).

MTL-DTH (Brussels: Galerie MTL, 1970).

Film als Objekt—Objekt als Film (Mönchengladbach: Städtisches Museum Mönchengladbach, 1972).

Der Adler vom Oligozän bis Heute (Düsseldorf: Städtische Kunsthalle Düsseldorf, 1972), 2 vols.

Marcel Broodthaers: Catalogue–Catalogus (Brussels: Palais des Beaux-Arts, 1974).

Marcel Broodthaers: Eloge du sujet (Basel: Kunstmuseum Basel, 1974).

Invitation pour une exposition bourgeoise (Berlin: Nationalgalerie, 1975).

Le privilège de l'art (Oxford: Museum of Modern Art, 1975).

L'Angélus de Daumier (Paris: Centre National d'Art Contemporain, 1975), 2 vols.

A Programme of Films by Marcel Broodthaers (London: The Tate Gallery, 1977).

Marcel Broodthaers: Books Editions Films (Edinburgh: New 57 Gallery, 1977).

Marcel Broodthaers: Editionen (1964–1975) (Munich: Galerie Heiner Friedrich, 1978).

Marcel Broodthaers (London: The Tate Gallery, 1980).

Marcel Broodthaers (Cologne: Galerie Michael Werner, 1980).

Marcel Broodthaers (Cologne: Wallraf-Richartz-Museum/ Museum Ludwig, 1980).

Marcel Broodthaers (Rotterdam: Museum Boymans-van Beuningen, 1981).

Marcel Broodthaers 1924–1976 (Stockholm: Moderna Museet; Bern: Kunsthalle Bern, 1982).

Marcel Broodthaers: Catalogue des Livres/Catalogue of Books/ Katalog der Bücher 1957–1975 (Cologne: Galerie Michael Werner; New York: Marian Goodman Gallery; Paris: Galerie Gillespie–Laage–Salomon, 1982).

Marcel Broodthaers 1924–1976 (Paris: Galerie Isy Brachot, 1983).

Marcel Broodthaers: L'Entrée de l'exposition (Cologne: Galerie Michael Werner, 1984).

Marcel Broodthaers (New York: Marian Goodman Gallery, 1984).

Marcel Broodthaers: Oeuvres majeures, provenant d'une collection privée à Anvers (Brussels: Yves Gevaert, 1984).

Marcel Broodthaers (New York: Mary Boone Gallery, 1984).

Marcel Broodthaers: Fotografische Bildnisse (Linz, Austria: Neue Galerie der Stadt Linz/Wolfgang-Gurlitt-Museum, 1985).

Marcel Broodthaers (New York: Marian Goodman Gallery, 1986).

Marcel Broodthaers (Cologne: Galerie Michael Werner, 1986).

Marcel Broodthaers Graphics (Nieuwpoort, Belgium: Florizoone Fine Art; Hong Kong: Le Cadre Gallery, 1987).

Marcel Broodthaers (Paris and Brussels: Galerie Isy Brachot, 1987).

Marcel Broodthaers in Zuid-Limburg (Maastricht, The Netherlands: Bonnefantenmuseum, 1987).

Marcel Broodthaers: Le salon noir 1966 (Antwerp: Gallery Ronny Van De Velde & Co., 1988).

Acknowledgments

An international undertaking such as this one has required the cooperation of numerous individuals and institutions on both sides of the Atlantic. It has been our good fortune to have had the partnership of the Palais des Beaux-Arts and the generous support of the Commissariat général aux Relations internationales de la Communauté française de Belgique. In particular Jan Debbaut, director, and his assistant Dominique Favart at the Palais des Beaux-Arts; Valmy Feaux, Ministre-Président, and Arlette Lemmonier, Attaché des Arts plastiques of the Executif de la Communauté française; Roger Dehaybe, Commissaire général, and Catherine de Croës, Attaché à la diffusion des Arts of the Commissariat général aux Relations internationales de la Communauté française de Belgique, were stead-fast in their support. We also relied upon the good offices of the Belgian Embassy in Washington and would like to thank Ambassador Herman Dehennin, as well as Andrea Murphy and Jan DeRuyt for their enthusiasm and able assistance. Jan van Kerkhove, Senior Cultural Advisor, the American Embassy in Brussels, was a constant source of support throughout the organization of the exhibition.

Our American partners in this venture are also acknowledged with gratitude: Richard Koshalek, Mary Jane Jacob, and Alma Ruiz, the Museum of Contemporary Art, Los Angeles, Phillip Johnston, Museum of Art, Carnegie Institute, and John Caldwell, formerly of the Carnegie.

Marcel Broodthaers's dealers—Michael Werner, Cologne, Isy Brachot, Brussels, and Marian Goodman, New York—provided welcome assistance on countless occasions.

The staff of the Walker rose to the challenge on various fronts during the past two years and those who worked for the exhibition are acknowledged on a subsequent page. We relied at length upon the advice of Martin Friedman, an old hand at international exhibitions. Bruce Jenkins, who contributed the splendid essay on Broodthaers's films to the catalogue, has also been a most generous cohort. Special thanks also go to Larry Rinder, a former Walker intern; our present intern, Joan Rothfuss; Craig Davidson, designer; Carrie de Cato and Sharon Howell, registars; and Steve Ecklund and Mark Kramer, Exhibition Crew Managers. Mary Polta and David Galligan played unusually large and helpful roles in the proceedings and we are much indebted to them for their patience, wisdom and support.

We would also like to thank the following individuals who have contributed in a variety of ways to this project: Ann Bitter, Marie-Puck Broodthaers, Benjamin Buchloh, Johannes Cladders, Jef Cornelis, Chris Dercon, Marc Felix, Pol Lauwers, John Mowitt, Anne Rorimer, Emily Sano, Sheila Schwartz and Kristina Szymorowski.

This exhibition would not have been possible without the involvement and cooperation of Marcel Broodthaers's widow, Maria Gilissen, who worked closely with Michael Compton and me from the project's inception. It has been a great personal pleasure to come to know Maria and her family over these many months and we hope her tremendous faith in our exhibition has been rewarded. Her willingness to entertain various points of view in the catalogue with respect to her late husband's work, even though they were contrary to her own perceptions, is appreciated.

Finally, as is the case with most exhibitions, the generosity of the lenders is wholeheartedly acknowledged. With the loan of their precious objects, they have enabled us to introduce to America the work of one of Europe's most prominent postwar artists. We offer our deepest thanks to them.

Marge Goldwater

Lenders to the Exhibition

Milantia and Charles Berkovic
Bonnefantenmuseum, Maastricht, The Netherlands
Anna and Otto Block
Mr. and Mrs. Isy Brachot
Galerie Isy Brachot, Brussels
Marie-Puck Broodthaers
Diego Cortez
De Decker-Lohaus Collection
Galerie Willy D'Huysser, Brussels
Lili Dujourie
Liliane and Michel Durand-Dessert, Paris
Gerald S. Elliott
Galerie Konrad Fischer, Düsseldorf
Pénélope Fiszman
M. Van Gijsegem
Mr. and Mrs. Toussaint Gilissen
Françoise and Bernard Giron
Marian Goodman Gallery, New York
Jost Herbig
Benjamin Katz
Robert M. Kaye
Galerie Jule Kewenig, Cologne
Uli Knecht
Mr. and Mrs. Kok-Broodthaers
J. H. Komkommer
David Lamelas
Raymond J. Learsy
Z. Mis
Musée d'Ixelles, Brussels
The Museum of Modern Art, New York
National Gallery of Scotland, Edinburgh
Monique Perlstein
Sylvio Perlstein
Anne-Marie and Stéphane Rona
Harry Ruhé
The Sonnabend Collection
Dr. Speck Collection
H. Tob
Galerie Ronny Van De Velde & Co., Antwerp
Sylvie Van Hiel
Vereniging voor het Museum van Hedendaagse Kunst, Ghent
Visser Collection
Galerie Michael Werner, Cologne
Seven private collections

Travel Schedule

Walker Art Center
Minneapolis, Minnesota
9 April–18 June 1989

Los Angeles Museum of
Contemporary Art
Los Angeles, California
9 July–22 October 1989

Museum of Art,
Carnegie Institute
Pittsburgh, Pennsylvania
20 January–18 March 1990

Palais des Beaux-Arts
Brussels, Belgium
15 April–24 June 1990

Photo Credits

Unless otherwise indicated, photographs by Maria Gilissen, Brussels. Numbers refer to page numbers.
Courtesy Galerie Isy Brachot, Brussels 57, 68, 154, 155, half title page; Maarten Brinkgreve, Courtesy Harry Ruhé (back cover); Balthasar Burkhard, © Agentur für geistige Gastarbeit, Tegna, Courtesy documenta archiv, Kassel 14, 192, 193; Courtesy Anny De Decker 38, 61; Phillipe de Gobert 123, 128, 132, 143, 161, 166, 188; Phillipe de Gobert, Courtesy Galerie Willy D'Huysser, Brussels 112; Phillipe de Gobert, Courtesy Palais des Beaux-Arts, Brussels 194, 195; Courtesy Galerie Willy D'Huysser, Brussels 113; Courtesy documenta archiv, Kassel 108; R. Friedrich, Courtesy Nationalgalerie, Berlin 202, 203; Maria Gilissen, Courtesy Galerie Michael Werner, Cologne 174; Courtesy Marian Goodman Gallery, New York 144; Glenn Halvorson, Courtesy Belgische Radio en Televisie 181, 182, 183; Glenn Halvorson, Courtesy Walker Art Center 6, 35, 189; Cor Hageman, Courtesy Ronny Van De Velde and Co., Antwerp 129; V. Harrandt and G. Leipelt, Courtesy Kunsthistorisches Museum, Vienna 88; Heirman-Graphics, Courtesy Palais des Beaux-Arts, Brussels 194, 195; Anton Herbert, Courtesy Marian Goodman Gallery, New York 63; Ruth Kaiser, Courtesy Städtisches Museum Abteiberg Mönchengladbach 138; Ruth Kaiser, Courtesy Johannes Cladders 180, 181, 183, 192, 193; Steve Kasher, Courtesy Marian Goodman Gallery, New York 28; Walter Klein 70; Courtesy Kunstmuseum Basel 196, 200; Courtesy Los Angeles County Museum of Art 85; David Lamelas, New York 158; MNAM, Courtesy Centre G. Pompidou, Paris 206, 208, 209; Courtesy The Museum of Modern Art, New York 162; Courtesy The Museum of Modern Art/Film Stills Archive, New York 103, 108; Courtesy Museum van Hedendaagse Kunst, Ghent 133; Courtesy National Gallery of Scotland 121; J. Romero, Courtesy Maria Gilissen 186, 187; F. Rosenstiel, Courtesy Benjamin Katz (endsheets); F. Rosenstiel, Courtesy Dr. Reiner Speck 139; F. Rosenstiel, Courtesy Galerie Michael Werner, Cologne 170; Adam Rzepka, Courtesy Liliane & Michel Durand-Dessert, Paris 135; Schmitz-Fabri, Courtesy Galerie Michael Werner, Cologne 41; © Schwitters, Courtesy Moderna Museet, Stockholm 95; Smithsonian Institution Libraries 89; Georges Thiry, Courtesy Ronny Van De Velde & Co., Antwerp 37; Manfred Tischer Courtesy Galerie Michael Werner, Cologne 45, 122, 136, 137, 148, 197–199

certaines galeries
prenant 75%.
Ce que c'est ?
En fait, des objets.
Marcel
Broodthaers

Galerie St Laurent
rue Duquesnoy
Du 10 au 25 avril
Vernissage
vendredi 10
de 6 à 8 heures

Moi aussi, je me
suis demandé si
je ne pouvais pas
vendre quelque
chose et réussir
dans la vie. Cela
fait un moment
déjà que je ne suis
bon à rien. Je suis
âgé de quarante
ans...